ARCHITECTURE'S PRETEXTS

Architecture's Pretexts considers ideas from one medium that might have been appropriated and transformed by others; highlighting their uniqueness and limitations. More specifically, this book addresses the manner in which this translation occurs across different forms of creation, construction, and expression.

The intention is to address broader questions of representation and construction of meaning across media that eventually impact processes of design formulation. By integrating knowledge and modes of thinking from multiple means of expression, they are able to advance their understanding in ways that would be impossible through a unitary line of inquiry.

Aarati Kanekar is an Associate Professor of Architecture at the University of Cincinnati. She received her diploma in architecture from CEPT, masters from the Massachusetts Institute of Technology, and PhD from the Georgia Institute of Technology.

ARCHITECTURE'S PRETEXTS

Spaces of Translation

Aarati Kanekar

Routledge
Taylor & Francis Group

LONDON AND NEW YORK

First published 2015
by Routledge
711 Third Avenue, New York, NY 10017

and by Routledge
2 Park Square, Milton Park, Abingdon, Oxon OX14 4RN

Routledge is an imprint of the Taylor & Francis Group, an informa business

© 2015 Taylor & Francis

British Library Cataloguing in Publication Data
A catalogue record for this book is available from the British Library

Library of Congress Cataloging-in-Publication Data
Kanekar, Aarati.
 Architecture's pretexts : spaces of translation / Aarati Kanekar.
 pages cm
 Includes bibliographical references and index.
 1. Architectural design. 2. Idea (Philosophy) in art. 3. Influence
(Literary, artistic, etc.) I. Title.
 NA2750.K36 2015
 720.1´08-dc23 2014016616

ISBN: 978-0-415-89891-1(hbk)
ISBN: 978-0-415-89892-8 (pbk)
ISBN: 978-1-315-74972-3 (ebk)

Acquisition Editor: Wendy Fuller
Editorial Assistant: Grace Harrison
Production Editor: Alanna Donaldson

Typeset in Bembo
by HWA Text and Data Management, London

In memory of my father, Kumar Kanekar

CONTENTS

FIGURES

TABLES

ACKNOWLEDGEMENTS

This book draws from graduate seminars and studios I taught on inter-media translations, however, my fascination with the relationship between arts started decades back with architectonic, combinatorial, and shape-based ideas apparent in literary works, especially Calvino's novels. This interest eventually led to my doctoral work that concentrated on *The Divine Comedy* across art forms and for this I'm most indebted to John Peponis. This book owes much to his influence on my thinking about architecture. I was fortunate to have met Ronald Lewcock as a graduate student at MIT; he has been an integral part of my academic life in the U.S. and has had huge influence on this work. Kenneth Knoespel played an important part in the initial stages of this research and I appreciate the literary perspective he brought to it. To the late Tom Schumacher for his generosity and support of the early research specfically on the Danteum, my gratitude. Richard P. Martin's willingness to appreciate and encourage a work from another discipline has been invaluable, and I'm thankful to him for consistently being supportive of my endeavors. I'm much obliged to Sonit Bafna and Samiran Chanchani for their help during the early formation of this work.

Various school directors at SAID/DAAP over the years helped make this work possible – Daniel Friedman who gave me the opportunity to run elective studios and seminars that were important in the understanding of design through translations; Michael Pride, Gordon Simmons, Jay Chatterjee, and William Williams, all facilitated this work. When Patricia Kucker asked me to teach a class for a graduate seminar for students coming to architecture from other disciplines, it gave further impetus to this work. I am deeply appreciative of colleagues at DAAP who have contributed directly and indirectly to this work, especially Patrick Snadon, Terry Boling, Udo Greinacher, Michael McInturf, Vincent Sansalone, Liz Riorden, Nnamdi Elleh, Tom Bible, Jeff Tilman, Rebecca Williamson, Edson Cabalfin, and Kim Paice. DAAP librarian Jennifer

Krivickvas provided enthusiastic support in the tracking of some of the research material and Elizabeth Meyers helped wade through the murky waters of image copyrights.

I am thankful to Wendy Fuller, my editor, whose interest in my graduate seminars instigated this book – she was a paragon of patience with my tardiness when this work remained on the back burner – and to Grace Harrison for finally seeing it through. Several students contributed to this work with much enthusiasm by taking elective studios on inter-media translations that took Calvino's novels, Duchamp's art, and Greenaway's movies, as the starting point for diagramming, designing games, and architectural projects. They endured seminars where I was trying to tease through issues of representation and spatial construction of meaning, and to them I'm much obliged. My thanks to current and former students who directly helped with this research, especially Joseph Clarke and Kory Beighle for all their invaluable assistance; Andrew Fox and Mark Talma helped with the drawings.

I'm grateful to Peter Eisenman, Peter Zumthor, Perry Kulper, Mark and Laura Smout, and Thomas Flechtner for their generosity in sharing their work. I'm also thankful to the Gemeentesmuseum, Fondazione Aldo Rossi, Artists Rights Society for the use of images. T&F and the editors at the *Journal of Architecture* allowed me to reprint a previously published article in volume 10, issue 2 April 2005 "From Building to Poem and Back: The Danteum as a Study in the Projection of Meaning Across Symbolic Forms" as a chapter in this book, for which I'm much obliged.

I'm thankful to all my teachers in India and the U.S., especially at CEPT, Ahmedabad; MIT, Cambridge; and GA Tech, Atlanta, who taught me how to look at, and think about, architecture. This book would have been inconceivable without the contributions of the individuals and institutions mentioned above. The shortcomings and failings of this work are of course entirely mine. There are several colleagues and friends who are not named here but whose contributions while not direct have not been forgotten. I am eternally grateful for their support, encouragement, advice, inspiration, and knowledge.

To my family who in their own way have been part of this journey and contributed to it, I owe my deepest gratitude. Most of all I'm grateful to my parents who gave me the freedom to pursue my interests that were far from their comfort zone. They tolerated my impractical musings and had an implicit belief in my ability to take this journey. I dedicate this work to them.

ILLUSTRATION CREDITS

The author and publishers would like to thank the following individuals and institutions for giving permission to reproduce material in the book. Every effort has been made to contact copyright holders for the images and illustrations, but if any errors have been made we would be happy to correct them at a later printing.

2.2, 2.3, Base drawing from E. M. Antoniadis, *Ekphrasis of Hagia Sophia*, Volume 1 [Athens: P. D. Sakellarios, 1907]

2.4, bpk Berlin/(Biblioteca Apostolica Vaticana)/Art Resource NY

2.5, 2.6, bpk Berlin/ (Kupferstichkabinett/Staatliche Museen zu Berlin)/Jörg P. Anders /Art Resource NY

2.7, 2.8, bpk Berlin/(Kupferstichkabinett/ Staatliche Museen zu Berlin)/ Philipp Allard /Art Resource NY

2.9, Top: E. M. Antoniadis, *Ekphrasis of Hagia Sophia*, Volume 1 [Athens: P. D. Sakellarios, 1907]; Bottom: Gustave Dore (photo credit Album/Art Resource, NY)

2.10 © Salvador Dalí, Fundació Gala-Salvador Dalí, Artists Rights Society (ARS), New York 2014

3.2 © Eredi Aldo Rossi, courtesy Fondazione Aldo Rossi

3.3, 3.7, 3.8, 3.9. 3.12, 3.13, courtesy Eisenman Architects

4.1b, 4.10, 4.12, 4.14, photograph courtesy Thomas Flechtner

4.2, 4.3, 4.4, 4.5, 4.6, courtesy Peter Zumthor

4.5, 4.6, photograph Roland Halbe

5.1, Gemeentemuseum, The Hague

5.2, 5.3, 5.4, 5.5, courtesy Perry Kulper

5.6, 5.7, 5.8, 5.9, 5.10, 5.12, 5.13, 5.16, courtesy Smout Allen

6.6, photograph Kevin Carpenter

Unless otherwise noted all illustrations are the copyright of the author. Some drawings from this book that are in color can be accessed on the following link: http://homepages.uc.edu/~kanekaa/

1

INTRODUCTION

On Translation and the Spatial Construction of Meaning

> Understanding a sentence is more akin to understanding a piece of music than one might think. Why must these bars be played just so? Why do I want to produce just this pattern of variation in loudness and tempo? I would like to say "Because I know what it's all about." But what is it all about? I should not be able to say. For explanation I can only translate the musical picture into a picture in another medium and let the one picture throw light on the other.[1]
>
> Ludwig Wittgenstein

This book is based on the idea that we have a richer understanding of a medium by shining a light on it through another. My endeavor is in understanding architecture through the filter of other symbolic forms such as poetry, literature, music, painting, theater, and cinema. Here I use symbolic form as described by Cassirer: these forms, which include myth, language, art are formative to our understanding and not just representative of ideas that already exist.[2] The book addresses issues of construction, translation, and the transformation of meaning across media. As suggested by the roots of the word translation – "to transfer" or "carry across" there is an aspect of crossing boundaries, accentuating differences, and slippage in perception. There is always an element of metamorphosis when meaning is translated between one symbolic form and another so that the body of the work undoubtedly becomes modified when perceived from different vantage points. It is, as Walter Benjamin posits in *The Task of the Translator*, the essential feature of a translation, "a translation issues from the original—not so much from its life as from its afterlife."[3] So the translation becomes not a reproduction but a reincarnation of the original, taking on a life of its own in a new language or mode of expression: "The task of the translator consists in finding that intended effect upon the language into which he is translating which produces in it the echo of the original."[4] Translation then offers a productive

dialogue that allows for new interpretations and associations. Discussions in translation theory have long focused on the relative autonomy of the translated text vis-à-vis concepts of "equivalence" and "function" that are widely accepted as cornerstones of translation studies.[5] In the preceding quotation, Benjamin's "afterlife of the original" has a parallel with Borges' idea of a translator's "creative infidelity" when he writes, "it is [the translator's] infidelity, his happy and creative infidelity, that must matter to us."[6] These ideas obviously question the concept of equivalence and are indicative of what is perhaps the more interesting and significant aspect of any translation, at least as it pertains to intermedia translations – its autonomy. While much of translation theory naturally focuses on linguistic translations within literature and poetry, the question of autonomy becomes more pressing when we consider these with respect to translations between different media and, more specifically, if we consider the question of correspondence, accuracy, and fidelity to the original. Roman Jacobson's "intersemiotic translation" or transmutation is probably closer to this notion when discussing this transference or transposition between media.[7] While there is no denying that various forms of artistic expression contribute in their own diverse ways to influence architectural thinking, throughout this book the cases analyzed show that there is an internal logic that dictates the expression of the work within each medium. Underlying the set of essays presented in this book is an appreciation and study of the inherent logic that any medium possesses. Therefore, the term "translation" used throughout this book takes into consideration the fact that meaning is contingent on the medium of expression. Kittler's phrase, "a medium is a medium is a medium," is intrinsic to this discussion. Nevertheless, he goes on further to question the issue of "translation" stating that, "therefore it [a medium] cannot be translated. To transfer messages from one medium to another always involves reshaping them to conform to new standards and materials."[8] This notion has been instrumental in the use of the word "transposition" instead of "translation." One can argue that "translation" itself inherently involves a transfer and reshaping when a shift in medium is involved. Related to this is the question of what gets translated and how. However, before addressing this let me clarify why translation is significant in architecture.

Significance of Translation in Architecture

In the creation of architectural meaning, it has been generally understood that syntactic devices contribute towards the constitution of social or cultural relationships, the accommodation of activities and programmatic requirements, and the delivery of functional performance. Symbolic and figurative modes, on the other hand, operate in the representation of meaning. The cases discussed in this book are based on the understanding that syntactic or relational devices play a significant role even in terms of representation of meaning. For example, the design of a church expresses ideas of religion not only through symbolic

figures such as the cross or the dome symbolizing heaven but also through syntactic relationships and the perceptions that are generated from them as in the relationship of the altar to the manner in which one navigates through other spaces from the church entrance. Over and above the potential representation of cultural ideas, forms and syntactic relationships are of course meaningful in themselves, to the extent that we can recognize them and understand them. It is precisely because forms, insofar as they are recognizable and understandable, are already meaningful, that they can also be used to represent additional meanings.

Dealing with the relationship between a specific medium of expression and its translation to architecture offers one way to bring the general questions raised here into sharper focus. Usually, studies of how meaning is represented in architecture are made more difficult, because of the nature of concepts that architecture tries to represent. It is difficult to establish representation of meaning when expressing concepts such as religion, power, justice, myth, and so on. And, although they are commonly understood, their definition remains diffused over a large number of texts and discourses, so that special scholarship is needed before we can describe their structure, and, therefore, before we can even begin to explore their representation in architecture in any systematic way. Although it is commonly accepted that broader ideas such as religion are represented in the design of churches, justice in the design of courts, monuments designed in honor of war veterans or even social and political figures have other underlying concepts, we are not sure exactly what is represented and exactly how, even if in some architectural works more specific ideas are represented, such as myth and history in the Parthenon, Newtonian physics represented in Boullée's design of Newton's Cenotaph, the philosophical ideas of Anthroposophism as represented in Rudolf Steiner's Goetheanum at Dornach. The representation is held to be there by conventional acceptance, but the means and structures through which it is constructed elude our understanding. It is the specificity in construction of the design "brief" and the interaction between the "charge" and the "brief" that seems to be important in these cases.[9] This book will attempt to address issues concerning the intelligibility of compositional structure and formal meaning in architecture. In order to focus on this, the forthcoming chapters concentrate on specific architectural projects that are either inspired by and/or based upon works in other arts, or specific conceptual ideas that are shared between some architectural projects and works in another art form which can help understand architecture.

The Construction of Spatial Meaning

Of particular interest in this book is the question of spatial construction of meaning. The term "spatial meaning" is used to refer to implicit or explicit spatial relationships as dimensions of the construction of meaning in any medium as well as significance attributed to space by a work.[10] The aspect of giving form or shaping the imaginary is a significant aspect here. Any understanding of formal

devices in the construction of meaning in art is inevitably connected to the issue of externalization of art or what Bruno Latour terms as mobile immutability. For him, this presence of absent things is achieved through what he calls two-way connections established through many contrivances such as perspective, projection, map, log book, etc. which allow translation without corruption. [11]

Although many philosophers and scholars consider art an intuitive process, its externalization is essential in order to understand and analyze it. Similarly, meaning, which may already be present in the imagination, needs to be externalized for it to be analyzed. The externalization of art is implicitly linked to its medium of expression and it is this logic of the medium that becomes extremely significant in its conception and construction. While the material and making is paramount, one should not consider that the externalization is limited to the particular medium used for its tangible embodiment, which could vary from stone to metal in sculpture, or include various different materials in the case of architecture, but more importantly, it embraces form, rhythms, patterns, lines, shapes, in other words, the conceptual logic, or the manner in which a composition is put together – its constructional logic. Some scholars, like Adolf Hildebrand, have called these the "architectonic" elements of art. These "architectonic" elements are important not only in the visual arts but even in non-visual arts such as music, poetry, and literature. These are levels of articulation that have also been referred to as "substance of expression" by scholars like Louis Hjelmslev. [12]

There are features inherent and implicit within verbal and visual arts, even those that appear to be as different as literature and poetry seem to be from painting and architecture. In fact, theater directors who translate literary texts into plays on the stage often bring these aspects to our attention. The famous stage director, Peter Brook, made a very significant observation: "The sort of play that Shakespeare offers us is never just a series of events: it is far easier to understand if we consider the plays as objects – as many-faceted complexes of form and meaning in which the line of narrative is only one amongst the many aspects – and cannot profitably be played or studied on its own." [13]

The idea of formal construction in the generation of meaning is common both to visual arts like painting, sculpture, and architecture, and to non-visual arts like literature and music. This is especially apparent through the compositional pattern, the formal logic, and the experiential attribute that is observed across these arts. In visual arts this formal structuring varies from the figurative and almost iconic, to the non-figurative and abstract – consider Venturi's duck on the one hand, and on the other hand, Eisenman's combinatorics in his house series. In non-visual arts this could take the form of thematic structure, as well as compositional structure. For example, without the strength of diction and verse that it displays Dante's *Divine Comedy* would never have its impact and richness. The conceptual and formal means of expression here are not mere technicalities to externalize the imagination but part and parcel of the artistic intuition. Whether it is a sonnet, a haiku or any other form of verse, specific

formal structures are followed to create meaning or new structures are generated which give meaning.

In visual and non-visual arts the idea of "construction," in the conceptual sense of the term, is linked to the synchronic understanding and viewing of a work of art as a complete whole. Even in modern literature the reader tries to construct meaningful patterns within the most disparate work to allow it to be viewed as a complete whole.[14] This aspect of "grasp[ing] a writer's total pattern" to "see what he means" is pointed out by Northrop Frye when writing on the issue of rhythm and pattern in temporal arts, like music, and spatial arts, like painting, and comparing these to literature.[15] All arts, according to this view can be conceived temporally or spatially, wherein the spatial conception is linked to synchronic understanding, as against the temporal conception, which is diachronic. Literature, from this point of view, seems to fall between music and painting: "its words form rhythms which approach a musical sequence of sounds as one of its boundaries, and form patterns which approach the hieroglyphic or pictorial image at the other."[16] This brings an additional dimension in the analysis of visual and non-visual arts – temporal and spatial aspects that are embedded within each. It is, therefore, possible to see parallels between reading a piece of literature and experiencing architecture as activities that can be comprehended as sequential unfolding that is diachronic in nature, while their mental or conceptual understanding is achieved by reconstruction of the whole, which by default is synchronic. Frye refers to this feature in literary creation when he writes of "the sequence of events that hold our attention being shaped into unity," in a narrative text, "we expect a certain point near the end at which linear suspense is resolved and the unifying shape of the whole design becomes conceptually visible. This point was called *anagnorisis* by Aristotle, a term for which "recognition" is a better rendering than "discovery.""[17] The neat separation of the arts of time and of space that Lessing propounds is questioned here even when one considers Eisenstein's discussion of montage in different arts and the marking of time in still pictures. Nevertheless, there are certain comparable aspects within spatial and temporal arts wherein unlike other visual and plastic arts, such as painting and sculpture, which can usually be perceived and experienced synchronically, architecture is distinct in that there is generally an aspect of sequentiality of experience when one moves through space, and except for the panopticon where all spaces could be perceived from a singular spot, there is an element of the diachronic in architectural experience. This then is comparable to the reading of a story or novel in literature wherein there is a progression or sequentiality is involved (or to other temporal arts, such as music, dance, and cinema that also unfold over time).

Diachronic unfolding can be seen very explicitly employed in the design of gardens like Stourhead, which is possibly the best-known example of the use of allegorical narrative in the design of the romantic landscape garden.[18] The unfolding of events along a specific path or route is a device often used by architects since ancient times. Besides this, there have been projects wherein the

distinction between sequencing and narrative is employed creatively. Tschumi's *Manhattan Transcripts* exploits the internal logic of sequencing as a device in the construction of meaning. Writing about the project, he says, "the sequence of images can be compared to the progress of a novel or a piece of music."[19]

In both architecture and literature, treated as examples of visual and non-visual arts with spatial and temporal dimension respectively, there is a notion of logical construction. In architecture, it lies in the experiencing of different parts of the building and spaces in succession and the conceptual understanding of the whole by mental reconstruction. This, in turn, could be seen as corresponding to the sequential reading of literary creation and the putting together of various aspects of the story, i.e. the events, characters, etc., which in some sense is analogous to Northrop Frye's distinction of the author's narrative as a linear movement from his meaning, which he sees as the integrity of his completed form. A counter argument to this notion of the shared logic of construction between architecture and literature has been made by some critics who distinguish between the narrative mode of literary expression and the presentative mode of visual expression.[20] For them, the relationship between elements in architecture is perceived in a different manner from the way a syntactical expression in literature is perceived, and, therefore, the elements of architectural expression are believed to create a simultaneous effect whereby the eye does not follow a specific sequence that is seen in literary expression. While the analogy between architecture and language has been widespread,[21] that between architecture and literature or poetry has been relatively little argued. It has generally been raised when the question of style is debated. It has also often been observed that architects use the analogy between literature and architecture to legitimize the poetics of their architectural composition. An example of this is Ledoux's statement that "architecture is to masonry as poetry is to belles-lettres."[22]

It is certainly not the case that one finds the analogy to literary creation only in writing on architecture; in fact, in the field of literary criticism too there are studies on the architectonic aspects of literature. Of the various studies revolving around architecture and literature, some of the most direct ones related to the architectonic aspects of literature can be seen in the work of Tzvetan Todorov and Joseph Frank.[23] While Todorov deals with the issue of putting together various aspects of the story – the logic of construction, for example – Frank deals with the issue of spatial form in literature, especially in terms of the temporal logic and the compositional structure. The seminal works of Northrop Frye and Roman Jakobson, although not directly related to the spatial aspects, can be seen as dealing with the architectonic characteristics of literature.[24] Besides these, there have been a whole range of studies looking at the architectural and spatial images in literature, specifically of the work of Joyce,[25] the novels of Jane Austen,[26] ancient epics,[27] the representation of the city in Dickens, Balzac, Hugo, Benjamin, Baudelaire, and many others.[28]

Studies comparing visual arts, for example, architecture compared with painting and sculpture are not unusual.[29] In fact, there have been many instances

when one branch of the visual arts has drawn inspiration from another, and in some cases, in a single work, architecture, sculpture and painting are intrinsically inter-linked to form a whole. In comparison, fewer studies have been undertaken between visual and non-visual arts, and although there have been studies of the relationship between music and architecture these have tended to be formal in nature, concentrating especially on the proportion, rhythm, and number, common to both. Fewer works, until the nineteenth and twentieth centuries, compared literature and architecture.[30] The translation and representation of fictional narratives in theater, music, paintings, and even sculpture is quite widespread, but the same cannot be said about their representation in architecture. For example, the story of *Romeo and Juliet* has been expressed through the last four centuries in different art forms; these range through literature, poetry, and drama, to numerous classical music compositions by famous composers such as Tchaikovsky, Prokofiev, and Berlioz. But only in the last century have architectural projects attempted to represent it.[31] Similarly, Dante's *Divine Comedy* has been the subject of numerous drawings, etchings, engravings, and paintings, including the famous series done by Botticelli, but with the exception of a few sculptural monuments to Dante that have some aspects of the *Divine Comedy*, as yet there has been only one attempt to transform it into architecture.[32]

The very fact that these works have been transformed into another medium of expression begs the question as to why so many artists have felt the need to add images to an existing text or why so many musical composers have felt the need to transform a play? Is it that abstract and implicit ideas in one media are concretized and made explicit when translated in other medium of expression, each of the ideas acting like a trigger for the expression in another media? Or is there an underlying need to "spell out" which according to McLuhan is what translation is really concerned with and follows the idea that the "Content of any medium is always another medium."[33]

Inter-Mediality in the Twentieth Century

The idea of inter-mediality has been a preoccupation in the twentieth century and can be observed in the work of artists, designers, musicians, and poets at the end of the nineteenth century and turn of the twentieth century. This became most evident in the work of the Constructivists. The Constructivist movement, as we have come to realize now, was much wider in its impact than a mere artistic movement, which was just concerned with aesthetics, as previously thought.[34] One discovers a tremendous exchange of ideas between artists, designers, sculptors, poets, writers, and musicians in this period. Constructivism imbibed the notion of rules and principles for constructing effects, something inherently present in language, and used it much more explicitly and in a far more self-conscious manner than previously done by the Russian Formalists. Concepts such as "devices laid bare", the "exposure of process of making being the true aim of perception", and the "interdependence of criticism and writing"

(analysis and synthesis) became the cornerstones of constructivism that went across arts, be they Mayakovsky's poetry, Tatlin's sculptures or architecture, or Sergei Eisenstein's film-making. There was a shared understanding between the arts, which emphasized the process of "making", in other words conceptualizing and constructing the form. This becomes especially significant if one considers that an implicit aspect of translation is how the form of expression that each medium necessitates embodies content. Constructivism ultimately concerned the choices that artists, architects, sculptors, designers, poets and writers, and musicians made at an aesthetic and philosophical level.

Consider for instance the intellectual and artistic exchange between Tatlin and Malevich, and the poet Khlebnikov that demonstrates the intermedial aspect of this period in Russian history. *Zangezi*, Khlebnikov's poem, translated into a stage production by Tatlin wherein he designed the sets and costumes, is an excellent example of this exchange. Besides *Zangezi*, there was of course the opera *Victory over the Sun*, for which Matyushin wrote the music, Khlebnikov the prologue, Kruchenykh the libretto, and for which Malevich designed the sets and costumes. Also, costumes as well as set designs for Meierkhol's production of *The Death of Tarelkin* done by Stephenova, and Popova's development of structure for *The Magnanimous Cuckold*, which were further expanded upon by Vesnin, demonstrate the degree of intermedial work of the Constructivists that ranged from the design of textiles, furniture, agitational kiosks, collages, photomontages, posters and pamphlets, costumes, and sets, to architecture, sculpture and painting. In fact, one of the most ambitious projects in which the Constructivists participated was the re-making of the entire city of St. Petersburg – which was in parts wrapped up – and this sycophantically represented the society of which they were a part. Here, parts were iconic of the whole. The new environment that was created was reflective of the simple linguistic question that was at the root of their inquiry: "Can a language as unfamiliar be the medium for communicating an unfamiliar message?"[35]

Language of Symbolic Form

The language of arts and form of expression has been a point of concern for scholars besides designers and artists – notably for a number of theorists and philosophers ranging from Cassirer and Langer to Goodman. Cassirer's work is especially relevant due to the comprehensive understanding of symbolic forms and offers us a point of departure from which to examine translations across art forms. The very notion that a given structure of meaning in art mutates across media unavoidably raises the question of symbolic form. It is a commonplace assumption that meaning can only arise in and through the manipulation of symbolic form. Language is often taken as the primary symbolic form, as Cassirer has stated, "we must … understand what speech means in order to understand the 'meaning' of the universe."[36] The idea that language is a precondition for perceiving a meaningfully arranged world of phenomena goes back to Saussure

and his very powerful metaphor of the two waves of potential thought and potential sound, both inarticulate, unintelligible and unmemorable, until we take a "cut" across them. The "cut" is nothing other than the sign, a complex structure that involves the production of discrete sounds and discrete meanings through the establishment of a conventional association between pairs of them.[37] The metaphor points to the fundamental constitutive function of language as it underlies the rules of grammar and syntax that allow us to express more complicated patterns of meaning. More precisely, the metaphor suggests that relational patterns, both between meanings and between sounds, are the foundation on which individual words emerge as discrete, recognizable, and usable units.

Cassirer has extensively argued that the constitutive function is not limited to language, but underlies all symbolic systems, including art. While in language the presence of discrete words is evident, in other cases the emphasis is indeed on relational patterns, and not on the discrete units themselves. Any translation from non-visual arts such as literature and music into visual arts indeed grapples with the problem of transference between what Susanne Langer would term as discursive and presentational forms.[38] This notion of discursive and presentational forms has some similarities to Nelson Goodman's concepts of allographic and autographic.[39] However, the case of architecture is especially intriguing since it cannot neatly fit into a package of "presentational" form. On the one hand, the construction drawings in architecture are allographic, a set of instructions, follow a notational system that can be replicated but conceptual drawings, for instance Rossi's sketches, are autographic, much like paintings. Things get even trickier when it comes to built work; certain aspects when replicated are acceptable but when the entire Parthenon is replicated as in Nashville it is a copy and, much like a copy of a painting, not considered authentic.

Goodman, talking about "worldmaking" as a function of symbolic forms, says that:

> much but by no means all worldmaking consists of taking apart and putting together, often conjointly: on the one hand, of dividing wholes into parts and partitioning kinds into sub-species, analyzing complexes into component features, drawing distinctions; on the other hand, composing wholes and kinds out of parts and members and subclasses, combining features into complexes, and making connections.[40]

In the case of built space, arrangement is indeed the primary means for constructing signification. This arises from the relational patterns established by unfolding a limited repertoire of elementary forms. This means that architecture can be seen as a manifestation of syntactic combinatorial structures that unfold into patterns, which generate and transform meaning. But, of course, buildings are not only organizations of space; they are also spatial arrangements of visual form, and spatial arrangements of potential patterns of movement, occupancy, co-presence and co-awareness. Goodman's formulation is useful because it can encompass many of these aspects of architecture.

But first and foremost, Goodman's view of worldmaking is of special interest here because he suggests that worldmaking as we know it always starts from worlds already on hand; the making is really remaking. This may apply not only within but also between media. Language, as the first cut through the world, grounds and positions us, creates the very horizon of our understanding. The presence of diverse media implies multiplicity and multifariousness. Our worlds are constituted from many premises. This in a manner of speaking is rather like a mesh in which multiple constructs intersect and through which one could take any number of further cuts to explore and extend meaning.

Architecture as a Symbolic Form

Against this background of language of arts, the question arises whether a particular and coherent pattern of meaning can extend across symbolic forms. From the point of view of architectural design the question is not merely theoretical but also very applied. For example, the idea of a theme park claims to describe coherent arrangements of spaces and visual forms driven by some explicit narrative. Very often sounds, light, stage management, and scripts for behaviors are also involved. The theme park encapsulates the aspiration that different media can coalesce into a single product.

Of course, the idea of the theme park is a particular and perhaps an extreme statement of an aspiration that is rather commonly found in the history of architecture. That architecture has traditionally interacted with sculpture and painting is the defining commonplace of all the approaches to the subject, which classify architecture as a visual art. More interestingly, from the point of view of this book, architecture is normally studied as an expression of ideas that permeate other aspects of culture and are expressed in other media (expression of ideas such as religion, justice, etc.). However, when we look carefully at instances where architecture is purported to express such ideas, we do not find simple relations of translation or transcription between ideas and form. Dislocations, distortions, and transformations also occur, and very often to good effect. Robin Evans, for example, finds that the centralized Renaissance church cannot be interpreted as a clear mapping of cosmological and theological beliefs in a symmetrical, centrifugal, and clearly articulated architectural form.[41] Rather, he argues that the multiplicity of centers generated by the geometry of the building serves to diffuse important conceptual dilemmas as to the theological significance of center. The otherwise conflicting views of radiation and envelopment, ascribing to God and to man the central position, are thus reconciled in a seemingly single-minded, but actually very rich form. The slippages, dislocations, and transformations that occur are indeed a new dimension of meaning. This is where creative license comes into play; these are Borges' "infidelities" and Benjamin's "afterlife," essential triggers for a new expression that give the new work autonomy. In doing so, they bring into focus aspects that were implicit in the original work and at times truly hidden and resurrect the original in new and unexpected ways.

While specific forms of artistic expression contribute in their own diverse ways to influence architectural thinking, throughout this book the cases analyzed show that there is an internal logic to the medium of architecture. The chapter on the translation from poem to building intends to show that transpositions go back and forth between media and part and parcel of the thought and criticism of an age. Here the relationship between poetry and architecture might have been traveled in both directions and in multiple ways. It argues that design formulation as being intrinsic to the medium of expression. With Eisenman's "Moving Arrows Eros and Other Errors" project structural and narrative ideas in "Romeo and Juliet" when translated to an architectural project raise questions of the synchronic and diachronic nature of architectural representation and its reading. The analysis of Zumthor's Swiss Sound Box is about translation as it embodies ideas of music into architecture rather than an analogy. Here architecture is more like a device or instrument and it is the performative aspect as with any instrument that is significant. The pavilion has instrumental attributes that contribute to the creation and enhancement of sound. Music is created through the ordering of this sound and is structured by the pavilion. In the discussion of cinematic ideas in architecture, the attention is on the manner in which specific operations shared between media highlight certain conditions with the discourse. Here the focus is on Koolhaas' Kunsthal, Khlebnikov's *zaum* language and *Zangezi* as portrayed in Tatlin's set design to discuss the operation of montage not in terms of an image but in an analytical dimension that uncovers a multiplicity of meanings. Finally, the book considers the role of representation in the medium of architecture especially mapping as a language of representation and as a mode of translation. In doing so it examines how notational replete and dense notational systems work in tandem to generate design ideas; it considers how mapping as a device becomes a generator of the brief and thereby a significant instrument of design formulation.

Notes

1 Ludwig Wittgenstein, *Philosophical Grammar* translated by Anthony Kenney (Berkeley: University of California Press, 1974), p. 41.
2 Ernst Cassirer, *The Philosophy of Symbolic Forms*, translated by Ralph Manheim (New Haven: Yale University Press, 1955).
3 Walter Benjamin, "The Task of the Translator" in Hannah Arendt (ed.), *Illuminations* (New York: Schocken Books, 1968), p. 73.
4 Benjamin, The Task of the Translator, p. 76.
5 Lawrence Venuti discusses this when tracing the history of translation studies in the introductory section of *The Translation Studies Reader* edited by him (London, New York: Routledge, 2000).
6 Jorge Luis Borges, "The Translators of the Thousand and One Nights" in Lawrence Venuti (ed.) *The Translation Studies Reader* (London, New York: Routledge, 2000).
7 Roman Jakobson, "On Linguistic Aspects of Translation" in *On Translation, Harvard Studies in Comparative Literature, No. 23* edited by Reuben Brower (Cambridge, MA: Harvard University Press, 1959).

8 Friedrich A. Kittler, *Discourse Networks 1800/1900* translated by Michael Metteer (Stanford University Press, 1992), p. 265.

9 Here I'm using the art historian Michael Baxandall's explanation of "charge" and "brief" wherein he says: "The Charge is featureless. Character begins with the Brief." The "charge" essentially refers to the typology or function and it is the local and circumstantial conditions that formulate the design brief. Michael Baxandall, *Patterns of Intention: On the Historical Explanation of Pictures* (New Haven: Yale University Press, 1985), p. 44.

10 For a thorough discussion of this topic refer to John Peponis, "Spatial Construction of Meaning: Formulation" in *Journal of Architecture*, Volume 10, April 2005, pp. 119–133.

11 Bruno Latour, "Visualisation and Cognition: Drawing Things Together" in H. Kuklick (ed.) *Knowledge and Society: Studies in the Sociology of Culture Past and Present*, Volume 6, Jai Press, p. 7.

12 Louis Hjelmslev, *Prolegomena to a Theory of Language*. Translated by Francis J. Whitfield (Madison: University of Wisconsin Press, 1961), pp. 56–58.

13 Peter Brook, *The Empty Space* (New York: Atheneum, 1978), p.91.

14 Refer to Joseph Frank's analysis of Flaubert and Joyce's work in his article "Spatial Form in Modern Literature" in *The Essentials of the Theory of Fiction*, edited by Michael J. Hoffman and Patrick D. Murphy (Durham: Duke University Press, 1996), pp. 63–76.

15 Northrop Frye, *Fables of Identity: Studies in Poetic Mythology* (New York: Harcourt Brace & World, 1963).

16 Northrop Frye, *Fables of Identity*, p. 14.

17 Northrop Frye, *Fables of Identity*, p. 25.

18 Kenneth Woodbridge argues plausibly that the circuit of walk within the garden parallels Aneas's journey in Book VI of the Anead.

19 Bernard Tschumi, *The Manhattan Transcripts* (London: Academy Editions, St. Martin's Press, 1981).

20 This discussion on the limits of arts can be traced back to Aristotle and is further debated in the Enlightenment period by Lessing in his important work *Laocoon: An Essay on the Limits of Painting and Poetry* (Baltimore: The Johns Hopkins University Press, 1984).

21 For a complete review refer to the article by Jacques Guillerme "The Idea of Architectural Language: A Critical Inquiry" in *Oppositions 10* (Fall 1977): pp. 21–26.

22 Ledoux as quoted by Jacques Guillerme in "The Idea of Architectural Language: A Critical Inquiry" in *Oppositions 10*.

23 Refer to Tzvetan Todorov's essay "Reading as Construction" and Joseph Frank's "Spatial Form in Modern Literature" in *The Essentials of the Theory of Fiction*, edited by Michael J. Hoffman and Patrick D. Murphy (Durham: Duke University Press, 1996).

24 Northrop Frye's *The Anatomy of Criticism* (Princeton: Princeton University Press, 1957) and Roman Jakobson's *Selected Writings. v. 2. Words and Language* (The Hague: 's.-Gravenhage, Mouton Press, 1972).

25 Clive Hart, *Structure and Motif in Finnegan's Wake* (Evanstown: Northwestern University Press, 1962).

26 Isabel Allen, "Creating Space Out of Text: Perspectives on Domestic Regency Architecture or Three Essays on the Picturesque" in *Journal of Architecture* Volume 2: No. 1: Spring 1997 (London: E & FN Spon, RIBA, 1997).

27 Anthony Antoniades, *Epic Space: Towards the Roots of Western Architecture* (New York: Van Nostrand Reinhold, 1992).

28 Pike, Burton, *The Image of the City in Modern Literature* (Princeton: Princeton University Press, 1981).

29 Refer to Rowe and Slutzky, "Transparancy: Literal and Phenomenal" in *Mathematics of the Ideal Villa and Other Essays* (Cambridge: MIT Press, 1989); or Panofsky. *Studies*

in Iconology: Humanistic Themes in the Art of the Renaissance (New York: Harper & Row, 1972). Significant work on Cubism and architecture and DeStijl Movement and its influence on architecture has been published.

30 Refer to Rudolf Wittkower's *Architectural Principles in the Age of Humanism* (London, A. Tiranti: 1952), Lionel March "Dr. How's Magical Music Box" and "Proportion is an Alive and Expressive Tool" in *R.M. Schindler* edited by L. March and J. Sheine (London: Academy Editions, 1993).

31 For details refer to Peter Eisenman's *Moving Arrows Eros and Other Errors* (London: AA Publications, 1986).

32 The Danteum was designed by Guisseppe Terragni in 1938 and would have been built in Rome had the war not occurred. For details refer to the chapter on Literature.

33 Marshall McLuhan, *Understanding Media: The Extensions of Man* (Cambridge: MIT Press, 1994, 1964), p. 8.

34 For details refer to Christina Lodder, *Russian Constructivism* (New Haven: Yale University Press, 1983) and Catherine Cooke, *Russian Avant-Garde: Theories of Art, Architecture and the City* (London: Academy Editions, 1995).

35 Catherine Cooke, *Russian Avant-Garde*, p. 23.

36 Ernst Cassirer, *An Essay on Man: An Introduction to a Philosophy of Human Culture* (New Haven: Yale University Press, 1944), p. 111.

37 Ferdinand de Saussure, *Course in General Linguistics*, edited by Charles Bally and Albert Sechehaye (New York: McGraw-Hill, 1966 & 1959), pp. 111–113.

38 For details on Discursive and Presentational Forms refer to Susanne Langer, *Philosophy in a New Key: A Study in the Symbolism of Reason, Rite, and Art* (Cambridge: Harvard University Press, 1942, 1951, 1957).

39 Nelson Goodman, *Languages of Art*, Hackett Publishing, 1976.

40 Nelson Goodman, *Ways of Worldmaking* (Indianapolis: Hackett Publishing, 1978, 1984), p. 7.

41 Robin Evans, *The Projective Cast* (Cambridge: MIT Press, 1995).

2

THE SPACE OF POETIC ALLEGORY

Translating *The Divine Comedy* – Terragni's Danteum as a Study in the Projection of Meaning across Symbolic Forms

Thus, as you direct your gaze towards the eastern arches, you behold a never-ceasing wonder. And upon all of them, above this covering of many curves, there rises, as it were, another arch borne on air, spreading out its swelling fold, and it rises to the top, to the high rim upon whose back is planted the base of the divine head-piece of the center of the church. Thus the deep bosomed conch springs up into the air: at the summit it rises single, while underneath it rests on triple folds; and through fivefold openings pierced in its back it provides sources of light, sheathed in thin glass, through which, brilliantly gleaming, enters rosy-ankled Dawn…[Verse 398]

Rising above this into the immeasurable air is a helmet rounded on all sides like a sphere and radiant as the heavens, it bestrides the roof of the church. At its very summit art has depicted a cross, protector of the city. It is a wonder to see how [the dome], wide below, gradually grows less at the top as it rises. It does not, however, form a sharp pinnacle, but is the firmament which rests on air… [Verse 489]

At the very navel the sign of the cross is depicted within a circle by means of minute mosaic so that the Saviour of the whole world may forever protect the church; while at the base of the half-sphere are fashioned forty arched windows through which the rays of fair-haired Dawn are channeled…[Verse 506]

Paul Silentiarios[1]

Guiseppe Terragni's unbuilt Danteum project has long been the prime example for discussing narrative space due to its direct relationship to Dante's poem *The Divine Comedy*. The project is of special interest precisely because it takes the poem as its architectural design program. However, in this particular case, the relationship between poetry and architecture might have been traveled in both directions and in multiple ways. The verses at the beginning of this chapter, so deliberately focused upon the geometry of the church, are part of a lengthy

hexameter hymn celebrating the restoration of Hagia Sophia on its re-dedication in 563 by Justinian's court poet Paul the Silentiary.[2] Another hymn written in Syria only 50 years after the building of Hagia Sophia described the cathedral of Nisibin-Edessa (Nizip-Urfa) as follows:

> Small though it is it resembles the universe. Its vault expands like the heavens and shines with mosaics as the firmament with stars. Its soaring dome compares with the Heaven of Heavens, where God resides, and its four arches represent the four directions of the world, with their variegated colours like the rainbow. Its piers are like the mountains of the earth; its marble walls shine like the light of the image not man-made, the God-head; three windows in the apse symbolize the Trinity, the nine steps leading to the chancel represent the nine choirs of the angels.[3]

The poet thus concludes that the building represents heaven and earth, the apostles, the prophets, the martyrs, and indeed the Godhead. Such descriptions offered in hymns suggest that intersections between poetry and buildings were part of the Byzantine and early Christian cultural tradition that precedes Dante's *Divine Comedy*. Should these hymns be considered in relation to the poem, they might well be read as descriptions of Dante's *Paradiso*. *The Divine Comedy* would lend itself to a comparison with buildings because it is extremely visual and descriptive of both physical and more abstract geometrical settings. In addition, much of the scholarship on the *Comedy* points to the manner in which rhythmic sounds, symbolic numbers, geometry, and proportion interlock within a structured composition to create a multi-dimensional poetic space, traversed by a panoramic and didactic journey and associated with transfigurations of the human body. These considerations raise the interesting possibility that Dante might have drawn at least partial inspiration from the real architectural masterpieces that he saw around him and that the poem might thus express spatial motifs that were familiar to its readers, over and above its theological, ethical, moral, and philosophical content. After all, Dante wrote *Paradiso* when he was exiled in Ravenna and completed it when he was an ambassador to Venice; both cities are home to pre-eminent Byzantine structures.[4] In this sense, Terragni might have traveled in the opposite direction a bridge between architecture and poetry that was already familiar to Dante.

Before Terragni ever interpreted it as a program of architectural design, *The Divine Comedy* had been an inspiration for works in numerous media including painting, sculpture, and music, thus exemplifying Walter Benjamin's notion of the "afterlife" as an essential feature of a translation.[5] The translation becomes not a reproduction but a reincarnation of the original, taking on a life of its own in a new language: "The task of the translator consists in finding that intended effect upon the language into which he is translating which produces in it the echo of the original."[6] This chapter considers various echoes of *The Divine Comedy* and the metamorphoses of its expanded body across verbal, visual,

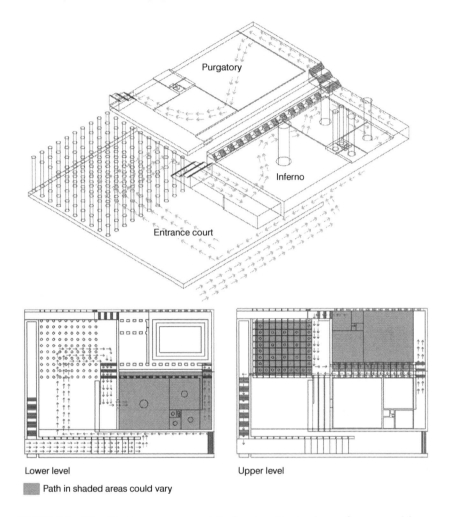

Lower level

Upper level

Path in shaded areas could vary

FIGURE 2.1 The Danteum: axonometric drawing (top); plans of upper and lower levels (bottom)

and spatial media, while allowing that some of the spatial motifs that were incorporated in the poem have their origins in a similar translation from works in other media, including architecture. The possibility that the *Divine Comedy* might contain Dante's response to the architecture around him has not been extensively discussed in the literature and will be discussed further.

Terragni designed the Danteum project for the 1942 Exposition in Rome.[7] He chose to represent Dante, the poet, by representing his creation, the poem. As already noted, this explicit connection to the *Divine Comedy* gives the project its special significance. The hermetic closure of the building as a whole evokes less the form of a statue, the typical mode of representation which reconstitutes presence, and more the tomb/cenotaph, which normally monumentalizes

absence. The drawings reveal a deceptively simple box-like building whose plan is organized in four parts: first, an entrance court open to the sky; adjacent to it, an area with a dense regular grid of marble columns; on one side of these spaces, two rooms intended as representations of Inferno and Purgatory; on the second floor, over the grid of columns, Paradise represented by a similar grid of glass columns. In addition to the architectural drawings, a set of watercolors by Terragni shows the interior spaces and the façade. An accompanying text, the *Relazione Sul* Danteum, sets to explain design intentions; it begins with general rhetoric on monumentality, symbolism, fascist ideals and how to adhere to these. Its special interest lies in suggesting explicit and specific connections to the *Comedy*. Particular design decisions are justified by analogy to aspects of the formal compositional structure of the poem, including numerical relationships, as will be discussed later.

The Danteum project raises larger questions than the ones addressed in the *Relazione*. Going beyond Terragni's own account of his design intentions, this chapter questions how the internal logic of architecture, as a symbolic medium, transforms aspects of the poem: How might architecture enrich our understanding of the *Comedy* in ways which would otherwise not be available? This is discussed in three parts: part one considers the possibility that architecture underlies the poem already; part two examines visual images based on the poem; part three looks at the Danteum to see how meaning has been projected and transformed. Since this is an unbuilt project, a computer model of the Danteum is used to examine some potential experiential dimensions of the building.

The Building in the Poem

The Divine Comedy is organized in three parts, Inferno, Purgatory, and Paradise, set in an ascending spatial hierarchy. A similar hierarchy is expressed in religious architecture. The labyrinth patterns on church floors have commonly been seen as representations of the underworld while the vaults are taken to represent the heavens.[8] Scholars have suggested more particular analogies between spatial motifs present in the poem and in churches. Thus, Croce likened the structure and symbolism of the Celestial Rose in canto 30 and 31 of *Paradise* to the rose windows of gothic cathedrals which are in turn often seen as cosmic symbols.[9] The labyrinthine underworld or a rose-like celestial world is part of a long-lasting structure of meaning, which permeates architecture and poetry alike. The comparison between the poem and architecture, however, can also be pursued at a deeper structural level, as also indicated by Croce. The relationship between particular episodes and the overall setting described in the poem resonates with the manner in which "the picturesque sculptures and decorations ... were not independent, artistic wholes in themselves, but rather architectonic parts determined and inspired by the spirit of the edifice."[10]

Against this background, the contention that the *Divine Comedy* bears a particular connection to the Byzantine church becomes more compelling on

several grounds; first the geography of Dante's life lends the hypothesis some plausibility, as noted earlier; second, there are specific similarities between the spatial hierarchy of the iconography present in the Byzantine church and the spatial form of Dante's *Paradise*; third, there is an analogy between ritual movement in the church and the narrative trajectory in the poem; fourth, from a more formal point of view, the geometry of the Byzantine church, with the emphasis on circles, spheres and circular arcs that can be viewed from converging or diverging perspectives, resonates more readily with the geometry which is implicit in Dante's text, acting almost as a direct visualization of some spatial patterns described in the poem. In the following discussion, Hagia Sophia is taken as an exemplification of a more abstract model for Byzantine churches. In this context, it must also be noted that Terragni refers to the design of Basilica Maxentius to explain the scale and underlying geometry of the plan; the Basilica was comparable to the Hagia Sophia and closely resembled it in plan.[11]

Numerical relationships are important to the structure of the poem[12] and, as we will see, to Terragni's design of the Danteum; they are also deeply embedded in the design of the church. The square base of the dome of Hagia Sophia measures 100 × 100 Byzantine feet and there are 100 cantos in *The Divine Comedy*.[13] The narthex is 33 Byzantine feet (the age of Christ) in width and there are 33 cantos in each section of *The Divine Comedy*.[14] These numerical relationships are further evidence that poem and building are subject to the same underlying tradition of formal meaningfulness. However, the more specific arrangement of space in the church holds greater interest from the point of view of the poem.

The "atrium" and the "narthex" together represent the earthly realm – the creation of earth and being on earth. The main "naos", the square under the dome, represents heaven and paradise, while the "omphalion" at the southeast quadrant of the "naos" represents the center of the earth, said to be in Jerusalem. The "bema" represents the most sacred space beyond heaven (similar to Dante's Empyrean), and heaven itself. Within the "bema," the altar represents the sacrifice of Jesus and the transformation of wine and bread into his blood and flesh that are offered to the faithful to provide eternal life. In the depth of the "bema." inside the conch is the "synthronon," the twelve seats and a throne, where Jesus and the twelve apostles will sit when the kingdom of God comes. The "prothesis" to the left of the "bema," where bread and wine are brought prior to the transformation, may represent the place of the birth of Jesus.[15]

The regulation of presence and movement in the Hagia Sophia restricts different categories of people to specific areas in the church. Only the king and the priests could venture beyond the central domed space, the ambo, and the altar itself. Others were restricted depending on their position in the ecclesiastical hierarchy.[16] There were four categories of people according to the extent of their admittance into the church. Those that were "crying and repenting" were kept to the outer-narthex; those in "the process of reception" were allowed in the narthex itself; those "kneeling to receive pardon" were allowed in the area between the

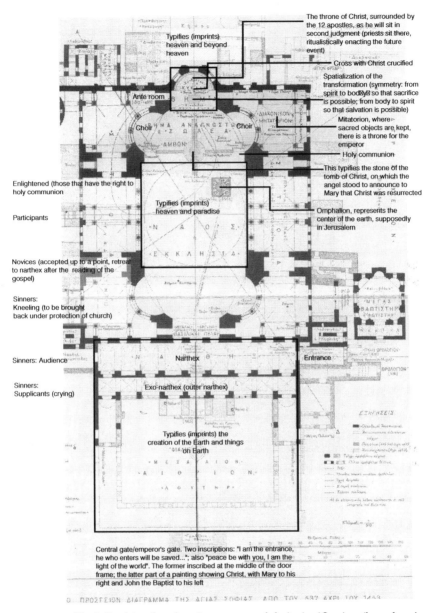

The throne of Christ, surrounded by the 12 apostles, as he will sit in second judgment (priests sit there, ritualistically enacting the future event)

Typifies (imprints) heaven and beyond heaven

Cross with Christ crucified

Spatialization of the transformation (symmetry: from spirit to body so that sacrifice is possible; from body to spirit so that salvation is possible)

Ante room

Choir Choir

Mitatorion, where sacred objects are kept, there is a throne for the emperor

Holy communion

AMBON

This typifies the stone of the tomb of Christ, on which the angel stood to announce to Mary that Christ was resurrected

Enlightened (those that have the right to holy communion

Typifies (imprints) heaven and paradise

Omphalion, represents the center of the earth, supposedly in Jerusalem

Participants

Novices (accepted up to a point, retreat to narthex after the reading of the gospel)

Sinners: Kneeling (to be brought back under protection of church)

Sinners: Audience Narthex Entrance

Sinners: Supplicants (crying)

Exo-narthex (outer narthex)

Typifies (imprints) the creation of the Earth and things on Earth

Central gate/emperor's gate. Two inscriptions: "I am the entrance, he who enters will be saved..."; also "peace be with you, I am the light of the world". The former inscribed at the middle of the door frame; the latter part of a painting showing Christ, with Mary to his right and John the Baptist to his left

FIGURE 2.2 Hagia Sophia: plan showing spaces and their signification (base drawing from E. M. Antoniadis, *Ekphrasis of Hagia Sophia*, Volume 1, Athens: P.D. Sakellarios, 1907)

dome and the narthex and had to return to the narthex at a particular point in the liturgy; "novices" and those "co-standing" were allowed up to a point under the main dome and had to retreat to the narthex after the reading of the gospel; they were not allowed to receive holy communion. The "baptized" and those

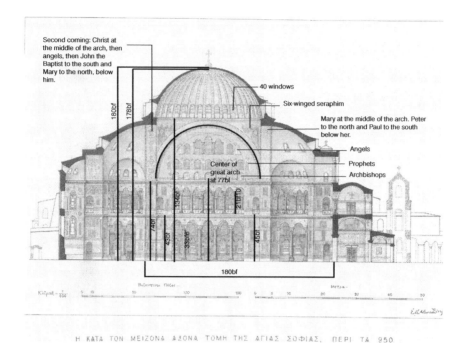

Second coming: Christ at the middle of the arch, then angels, then John the Baptist to the south and Mary to the north, below him.

40 windows

Six-winged seraphim

Mary at the middle of the arch. Peter to the north and Paul to the south below her.

Angels

Prophets

Archbishops

Center of great arch at 77bf

Η ΚΑΤΑ ΤΟΝ ΜΕΙΖΟΝΑ ΑΞΟΝΑ ΤΟΜΗ ΤΗΣ ΑΓΙΑΣ ΣΟΦΙΑΣ, ΠΕΡΙ ΤΑ 950.

FIGURE 2.3 Hagia Sophia: section showing celestial hierarchy (base drawing from E. M. Antoniadis, *Ekphrasis of Hagia Sophia*, Volume 1, Athens: P.D. Sakellarios, 1907)

"pardoned" were in the main area, the square under the dome. They had a right to Holy Communion. Important people stood by the eastern pillars. Beyond this area was the most restricted space accessible only to priests and the emperor. This spatial hierarchy is essentially organized along a horizontal progression from the earthly to the heavenly realm. The same progression underlies the narrative of *The Divine Comedy*. Scholars writing on the Hagia Sophia, and Michelis in particular, point out that this progression is linked to a transition from the darker narthex to the areas with enhanced light within the church.[17] The dome, in particular, draws attention towards it because it is inundated with light. The aisles and nave have less light. The association between the hierarchy of acceptance into the Church and the gradation of light resonates with the association between light and purity, or darkness and punishment, in the poem.

A second spatial ordering is revealed in the longitudinal section, particularly when the relationship between building shape and iconography is taken into account. In the Hagia Sophia the iconographical scheme follows a hierarchy similar to that of Dante's Paradise: Christ at the center of the dome; the Seraphim angels with six wings on the four supporting squinches; on the side walls and in a vertical order from top to bottom there are angels, then seven prophets, church leaders, and seven archbishops; on the great western arch is the Virgin Mother with Peter to the north and Paul to the south, while the great eastern arch has

the preparation for the second coming of Christ, John the Baptist to the south and the Virgin Mother on the north; the arches over the altar depict archangels Michael in the north, Gabriel in the south, Saint Mandilios in the middle, and the Virgin Mother on the conch holding Jesus. This iconographical scheme is not unique to Hagia Sophia by any means and is quite common to other Byzantine churches such as that of Dafni and Hosias Lukas. Hierarchy in the mosaics of any Byzantine church is exhibited through form and sequence. For instance, Christ Pantocrator is in the heavenly sphere of the cupola, the Evangelic cycle is in the squinches, the theologians in the higher vaults, and finally the cycle of saints in the lowest – the terrestrial zone of the church. The higher an image is placed in the interior of the church, the more sacred it is considered to be. Centrality and distance from the physical ground plane seem to be especially significant. This centripetal geometry, which is also common in the medieval church,[18] is of particular interest when explored in relation to the spatial scheme constructed in *The Divine Comedy*. As Robin Evans has pointed out, the universe as described in Dante's *Convivio* was the astronomers' nest of spherical shells, while in *The Divine Comedy*, much like the centralized churches, the same universe was disclosed as successive rings along an axis of descent or ascent, the axis being the route of Dante's journey as well as the line of his narration of it.[19] Evans thus imagines two kinds of projections deriving from the same underlying model, a complete nest of spheres seen from outside and a partial view of the same seen from the inside. The partial view from within is what we, who live inside the system, are permitted to have. It cuts through the heavier inner lower levels to the ethereal outer higher levels. This is the point of view created both in the *Divine Comedy* and in the Byzantine church.

The Paintings of the Poem

A study of most folios that have the complete set of illustrations for *The Divine Comedy* by an individual artist show the Inferno to be visually the most compelling of the three realms.[20] Artists who have chosen to depict only certain parts of the *Comedy* have specifically singled out Inferno. To a certain extent this bias can be justified through the very vivid use of visual imagery in the description of this realm when compared with that of Purgatory and Paradise.[21] Moreover, the imagery described is an extreme version of landscapes seen on earth with an added dimension of suffering. The Inferno also entails intense descriptions of the boundary conditions between successive circles of Hell and of the difficulties involved in making the transition across them. In the much more abstract description of Paradise, transitions are not associated with the crossing of describable boundaries.

This difference in the three realms is immediately apparent if one considers Botticelli's folio. While his drawings of Inferno are vivid in all their gory details, in Paradise he seems to be almost at a loss as to what to paint, so much so that drawing after drawing of this realm depicts Dante and Beatrice in a vacant circle

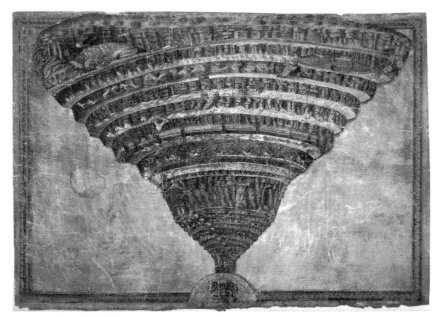

FIGURE 2.4 Botticelli's drawings of Inferno (the drawings of Sandro Botticelli for Dante's *Divine Comedy*: after the originals at the Berlin museums) Inferno detail of the 8th circle (photo: bpk Berlin/(Kupferstichkabinett/Staatliche Museen zu Berlin)/ Jörg P. Anders /Art Resource NY)

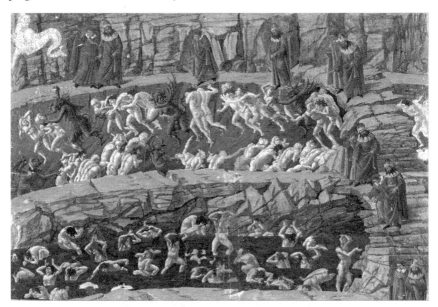

FIGURE 2.5 Botticelli's drawings of Inferno (the drawings of Sandro Botticelli for Dante's *Divine Comedy:* after the originals at the Berlin museums) topography of the Inferno (photo: bpk Berlin/(Biblioteca Apostolica Vaticana)/Art Resource NY)

FIGURE 2.6 Botticelli's drawings of Paradise (the drawings of Sandro Botticelli for Dante's *Divine Comedy*: after the originals at the Berlin museums): Paradise circle X, (photo:bpk Berlin/(Kupferstichkabinett/Staatliche Museen zu Berlin)/ Jörg P. Anders /Art Resource NY)

FIGURE 2.7 Botticelli's drawings of Paradise (the drawings of Sandro Botticelli for Dante's *Divine Comedy:* after the originals at the Berlin museums): Paradise circle XI, (photo: bpk Berlin/(Kupferstichkabinett/Staatliche Museen zu Berlin)/Philipp Allard /Art Resource NY)

FIGURE 2.8 Botticelli's drawings of Paradise (the drawings of Sandro Botticelli for Dante's Divine Comedy: after the originals at the Berlin museums): Paradise circle XXIV (photo: bpk Berlin/(Kupferstichkabinett/ Staatliche Museen zu Berlin)/ Philipp Allard /Art Resource NY)

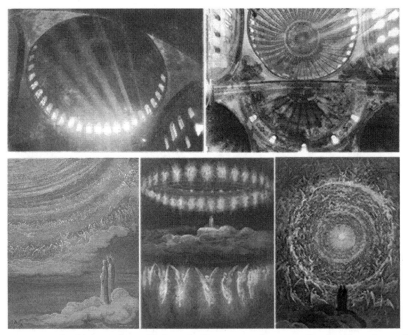

FIGURE 2.9 Architectural motifs in painting – top: photographs showing the main dome of Hagia Sophia; bottom: Gustave Dore's images of Paradise. (top: E. M. Antoniadis, *Ekphrasis of Hagia Sophia*, Volume 1, Athens: P. D. Sakellarios, 1907; bottom: Gustave Doré (photo credit Album/Art Resource, NY)

fluttering like butterflies. This is especially true for cantos where there are no references to specific images such as the ladder, the cross, or the eagle. At the same time his drawings of Inferno show many architectural elements like walls, towers, and gates (used in a very figurative manner), all of which are entirely absent in his drawings of Paradise. As if to compensate, the latter have a clearer architectonic structure arising from the formation of distinct geometric shapes, usually projections of circles, within which Dante and Beatrice are placed. Botticelli's folio, therefore, is an especially fascinating document with respect to the issue of translation across symbolic forms. It reveals many of the limitations involved in the translation from description to depiction even when description is already focused upon visual and spatial patterns.

Some of the same issues arise when we examine the work of other artists. The depiction of the Inferno is the most vivid; Purgatory, except for certain cantos that have lush landscapes, is stark, and Paradise becomes an exercise in geometry, as seen in some fourteenth/fifteenth century Italian illustrations. Perhaps to compensate for the topographical vagueness of Paradise some illustrators diverge from the text by introducing planetary gods and their abodes, which are actually not mentioned in Dante's text. Pope-Hennessy specifically

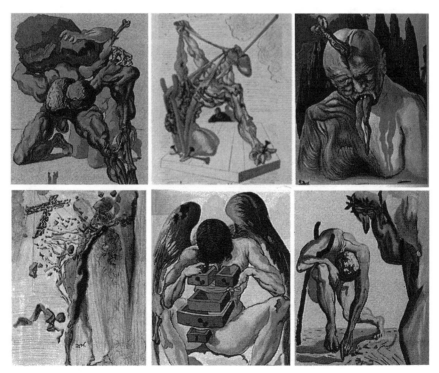

FIGURE 2.10 Selection from Dalí's paintings of Inferno, Purgatory, and Paradise showing the monumentalization and transfiguration of the body (© Salvador Dalí, Fundació Gala-Salvador Dalí, Artists Rights Society (ARS), New York 2014)

notices the difference between the literal representations generally inspired by the text of the *Inferno* and *Purgatory* and the less explicit representations supported by the text of *Paradiso* in his comparison of the latter with Giovanni di Paolo's paintings of paradise, which he describes as "composed of a chain of factual images."[22] Much later, in the nineteenth century, Doré offers another interesting point of comparison; he succeeds in providing Paradise with figural form, but in doing so he creates an impression of looking up at the heavenly dome inside a cathedral. In his case, the relationship between poem and painting seems to be structurally mediated by architecture.

Modern depictions of *The Divine Comedy* place emphasis on characters and events rather than the surrounding landscape.[23] Take for instance Dalí's, drawings showing Charon carrying the souls on the River Acheron, or the appearance of Dis in Inferno; or "The Fallen Angel", "The Heaven of Mercury" and "The Preparation for the Final Prayer," inspired by scenes in Purgatory; or indeed his drawings of Paradise: they all describe human character rather than the setting.[24] The human body, not landscape, seems to draw all attention. This attitude is in complete contrast to the fourteenth/fifteenth-century illuminations where landscape was used as a mnemonic device. The emphasis in all of Dalí's watercolors is upon the transfiguration of the body. The drawings of Inferno give prominence to the monumentality of the suffering-body; one almost feels that a sculpture is placed on a stage set for the benefit of a viewing audience.[25] In canto I of Purgatory, "The Fallen Angel," the focus is on looking inward into oneself, which is represented by the empty drawers of the angel, and Paradise canto XV, "Dante's Ecstasy," shows the underlying connection of the body with the divine, with light shooting out from the cross towards the angelic form, which is either form, or disintegrating towards the cross. These paintings do not represent familiar states but seek to transform modes of perception that have typically become associated with the poem.

Terragni's architectural project can be read more easily as a metaphorical statement about the transfigurations of the human body than as an attempt to represent or to stage the environmental settings described in the poem. In this context, the difficulty of depicting paradise is resolved in an ingenious way that directly bears on the dual function of physical structures in architecture, both as devices which transform and organize space and as material constructions subject to the laws of physics.

The Poem in the Building

Personification of the Column

More than Homer's *Odyssey* and Virgil's *Aeneid*, *The Divine Comedy* provides a complete geography and spatialization of the world of the dead; in the other two epic journeys, the visit to the underworld constitutes only one episode, however central to the overall narrative. Yet, the uniqueness of *The Divine Comedy* resides

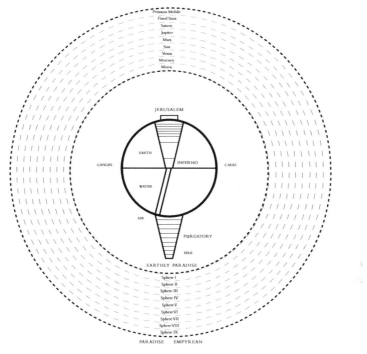

FIGURE 2.11 Schematic drawing showing Inferno, Purgatory, Paradise

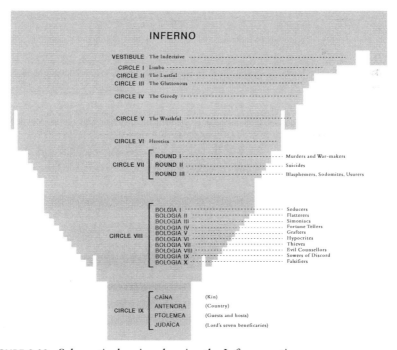

FIGURE 2.12 Schematic drawing showing the Inferno section

in more than spatialization. In addition to bringing together epic poetry, myths and philosophy in a new way, the poem gives explicit and pervasive prominence to the poet as subject.[26] The oscillation between depictions of settings and depictions of the transfigured body that were discussed earlier can be see in a new light if set against this curious dichotomy whereby the same poem is both an act of description of previously vague poetic and mythological geographies or spaces, and an act of self discovery. The poetic map becomes a medium through which emotions are expressed. The Danteum succeeds in capturing this particular and rather central aspect of the poem. As a building it is certainly a setting. What it provides, like all buildings, is a pattern of embodied experience. What it speaks of, however, is the condition of the body.

This statement will be supported by a study of the project but not by Terragni's own account. In the *Relazione*, Terragni concentrates on the compositional and numerical similarities between the *Comedy* and the Danteum. The entire *Divine Comedy* is replete with numbers that had symbolic meaning attributed to them. Terragni's insistence regarding the adoption of particular numbers is clearly aimed at establishing a relation to this symbolic tradition. This is particularly apparent in his statement that, "architectural monument and literary work can adhere to a *singular* scheme without losing, in this union, any of each work's essential qualities only if both possess a structure and a harmonic rule that can allow them to confront each other, so that they may then be read in a geometric or mathematical relation of parallelism or subordination."[27] His explanation of the divisions within each of the spaces in the Danteum places emphasis on the ideological significance in the choice of certain numbers like 7. Both the spaces dedicated to the Inferno and Purgatory have 7 recursive divisions. This bears no persuasive connection to the poem. Dante's Inferno has nine rings and his Purgatory seven ledges plus two terraces and Earthly Paradise. Nevertheless, Terragni justifies his choice of 7 divisions for both Inferno and Purgatory by suggesting that in the Inferno souls are punished for transgressions provoked by the seven sins, and that Dante has extended this notion further into what he calls "some finer-grained subdivisions." In emphasizing 7, Terragni seems influenced by what he takes as the broader symbolic attributes of the number, which historically stands for completeness, a combination of the spiritual, or the soul (3), and the worldly, or the body (4), and for creation – the Sabbath, the day of rest after creation – seven days of the week, seven ages of the world, seven sins, among others.

The golden-section rectangle was chosen as the fundamental geometrical principle which operates through the entire project. The choice of this form is questionable since it has no connection with *The Divine Comedy*. In point 6 of the *Relazione* document he writes, "there is only one rectangle that clearly expresses the harmonic law of unity in the Trinity, and this is the rectangle known historically as the "golden"; the rectangle, that is, whose sides are in the golden ratio (the short side is to the long side as the long side is to the sum of the two sides). *One* is the rectangle, *three* are the segments that determine the golden ratio." In applying the golden-section rectangle Terragni imagines that he brings

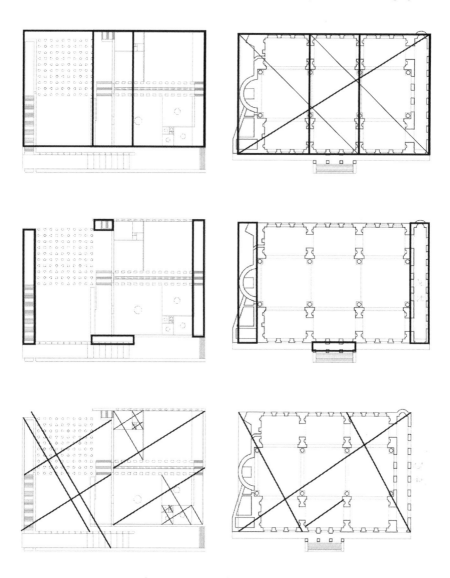

FIGURE 2.13 Proportional comparisons of the Danteum and the Basilica Maxentius based on Schumacher's drawings

the concept of the infinite into the design: the rectangle can be decomposed successively into a square and a smaller golden rectangle. He also sees this scheme as relating his work to ancient monuments of the Assyrians, Egyptians, Greeks, and Romans. Lionel March's work on number in architecture has underscored that such prioritization of "the extreme to mean ratio" is a modern construct imposed onto history.[28] Its apparent applicability in the Basilica Maxentius suited Terragni since this was seen as a reminder of the unity of church and empire.[29] Moreover, this relationship enabled him to determine the dimensions of the

Danteum, as he explains, "the long side of the Danteum was equal to the short side of Basilica." Thus the Basilica Maxentius helped him determine the form, dimension, and the orientation of the Danteum. Once resolved, the numerical law of one and three that he perceived in *The Divine Comedy* was integrated by the "superimpos[ition of] two rules, one geometric, the other numerical...to achieve equilibrium and logic in the selection of dimensions, spaces, heights, and thickness for the purpose of establishing a plastic [arti]fact of absolute values, spiritually chained to Dantesque compositional criteria."[30] Schumacher's analytical drawings take Terrangni's statements as a point of departure and show the fit of the Danteum in the Basilica and the adherence of both buildings to the same proportional system and pattern of overlapping squares. Schumacher's analysis also suggests that the retaining wall of the basilica is in dialogue with the freestanding wall of the Danteum, and highlights additional similarities such as the narrow spaces at the margins of both buildings.

The application of one and three is observed all through the Danteum and is further justified by what Terragni calls the "symmetrical" division of the poem, wherein three *canticles*, each containing 33 *cantos* and an extra *canto* in the first *canticle*, results in a total of 100 – the symbol of perfection (a square of ten which can also be interpreted as $(3 \times 3) + 1$). A similar rule is employed in the marble coursing of the building, where there are three courses of equal height and one string course that corresponds to the level of each of the three rooms. In addition to this, for Etlin the relation of the golden-section rectangle to ancient architecture echoes certain ideas of Mathila Ghyka with which Terragni and Lingeri were familiar, so much so that illustrations of construction with the logarithmic spiral of the whirling squares were directly borrowed from Ghyka's books.[31] In particular, the articles on Corbusier's use of the golden-section rectangle in Villa Stein and the Mundaneum project were well received by Sartoris, who wanted to draw connections between this practice, Mediterranean architecture, and contemporary Rationalist architecture. These ideas were debated in the Rationalist circles that Terragni was a part of. Terragni's use of the "the extreme to mean ratio" as the generating figure for the project and his justification for its use was a completely new construct by him and did not prefigure in any of the writings on the *Comedy* or in the work itself. This could be considered as a metamorphosis of Dante's shaping of the three realms, which in itself is a transformation of pre-existing ideas. Its function seemed more to provide intellectual as well as perceptual reassurance that there was an overall unity to the project despite the pronounced difference in treatment of the three major rooms that correspond to the three realms.

The emphasis on numbers and numerical relations establishes a purely formal link between poem and building, which cannot really offer an account of the main design idea. At best it lends apparent credibility to the claim that both works are governed by similar abstract principles of wider import. From the point of view of design, numbers seem to explain the manner in which the project is elaborated and detailed but not the manner in which it is generated.

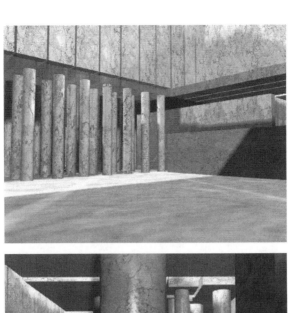

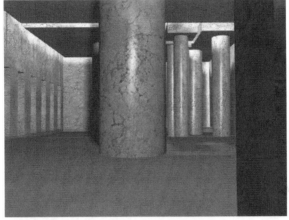

FIGURE 2.14 Poetics of the column in the Danteum: from top to bottom: the forest of columns in the courtyard, the compressed stone columns in Inferno, the transparent glass columns in Paradise

What the Danteum does above all else, as architecture, is stage the column; not the column as a structural element, but the column as a device that organizes space, or as a figure that makes claims over space in its own right. In staging the column as a means and also as an end of spatial organization the Danteum sets itself up to face both the classical tradition for which the column is the main bearer of the definition of the orders of architecture, and the modern perception of the column as a minimal structural element that frees the organization of space. The visitor would first confront 100 travertine columns placed on a 10 × 10 grid on the deep side of the courtyard. These can be taken to represent the forest in which the poet is lost at the beginning of the poem; or they can be taken to represent a human multitude, a society, if we allow the column to stand for the human body.[32] The dense spacing of the columns would result in groups of visitors being separated as they traverse the area.

The second view of columns, in the room representing the Inferno, is predictably more dramatic. Seven columns of decreasing radius are centered on an arrangement of squares successively inserted within golden-section rectangles, so as to suggest a spiral. The first and largest column is facing the entrance, while the smallest is further back. Each column supports a corresponding and detached portion of the ceiling, at variable heights, in proportion to column radii; light comes in through the gaps thus created, as if to emphasize the fracture of the overall structure. The floor sections are also sunk by proportional increments, creating horizontal discontinuity. The dislocation of floor and ceiling sections creates a sense of shear distortion under the effects of weight. The play of light, scale and materials creates a crushing atmosphere of heaviness and darkness.[33] The columns could be considered as representing the shades. A secondary effect of the disposition of the columns is to strongly differentiate the surrounding space, much as the Inferno is a strongly differentiated landscape.

Columns are entirely absent in the room representing Purgatory. The floor steps up in proportional intervals, over square sections arranged according to principles similar to those applied in the Inferno. The room is open to the sky; there are only small zones covered by slabs and a pattern of beams that resonates with the arrangement of the floor. Thus, one is given the strong impression that the absent columns could be provisionally replaced by the transient bodies of visitors and distributed over this stratified environment as if in the landscapes of Purgatory.

The 33 glass columns representing Paradise are the most daring architectonic innovation envisaged by the design of the Danteum. The floor separating these columns from the forest of columns below would itself be made of glass blocks. Glass beams would mark the grid lines on the ceiling. Transparency and light would create an ethereal feel. As the columns become transparent and dematerialized, so the views of other visitors would become blurred, refracted and reflected, to potentially create a pattern of co-presence at undecipherable intervals of distance. The columns themselves could represent the pure souls of angels described in the Comedy.

The possibility that columns stand for people is supported by a sketch of one of the earlier schemes for the Danteum, where Terragni wrote "Virgil" next to a column.[34] In his study of the Danteum, Schumacher adopts this interpretative connection and links it to the humanist tradition. But in order to fully appreciate the significance of Terragni's manner of staging the column it is important to consider how bodies feature in the poem. Throughout the *Comedy*, great stress is placed on the contrast between Dante's body and the souls of the dead, some of whom long for their living body while suffering.[35] In the Inferno bodies are classified in a strongly discontinuous landscape, as if to create a map of both sin and punishment. The map is stable given that those suffering are placed at one position and under one punishment for all time. In Purgatory the bodies are indirectly referenced by their shadow, or its absence.[36] In Paradise space is only differentiated according to the intensity of light and the presence of bodies, however dematerialized.[37] Thus, the body forms the map in Paradise, while the map situates the body in the Inferno. A continuing tension between what is being described and what is being narrated ensues. The manner in which columns stand as figures and as devices that organize space resonates with this tension. As figures, they are part of a narrative; the physical conditions that they exemplify, metaphorically express feelings; their relationships situate subjects within spatial settings.

The personification of columns is not uncommon in Byzantine architecture. Procopius stresses the stones with which columns are clad, especially their color.[38] Paul the Silentiary also extols the colors of materials that clad the columns, particularly silver which gives the impression of light emanating from them.[39] The main function of architecture in the Byzantine church, however, is to represent a cosmology and an order of faith and of acceptance into a faith. It is precisely this aspect of buildings that seems to provide the architectonic principle as well as some of the organizing spatial motifs and images for the poem, as discussed previously. In the Danteum, by contrast, rhetorical emphasis shifts towards the description of subjective conditions. If the churches of the high Byzantine tradition express certainty about the cosmos as a precondition for claiming authority over the subject, the Danteum foregrounds passions as points of departure for exploring aspects of a cosmos. The building that results from the poem is thus quite different not only in form but also in underlying affective motivation from the building that might have been tacitly embedded in the poem. The two buildings express divergent ways of constituting poetic space that are in tension within the poem.

Structures of experience

As a building designed to recollect a poetic journey, the Danteum is surprisingly unresponsive to our normal ideas of an architectural promenade or procession. The plan as a whole suggests that boundaries, not continuities, are the prominent concern. It defines a tightly knit system of overlapping distinctions:

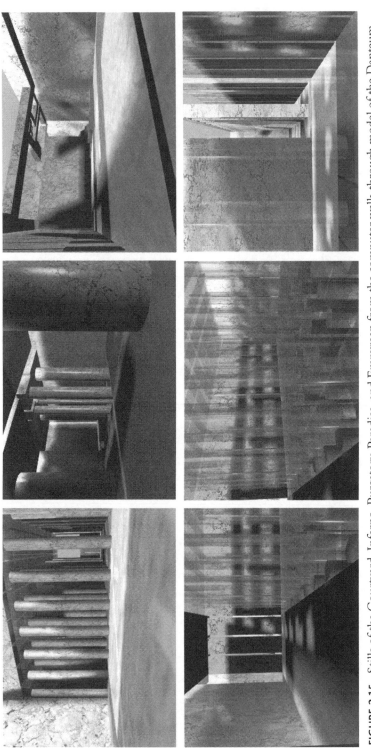

FIGURE 2.15 Stills of the Courtyard, Inferno, Purgatory, Paradise, and Empyrean from the computer walk-through model of the Danteum

seen from above, the overall arrangement suggests a four-way partition whereby the courtyard quadrant is used to complete the orthogonal shape defined by the other three quadrants corresponding to the realms of Inferno, Purgatory and Paradise; looked at in its own right, the ground floor suggests a lateral bisection into the side of earthly life and the side of the underworld; the section emphasizes more the hierarchical layering between heaven and earth. As with all buildings, progression from one area to the next is possible, but thresholds are handled so as to emphasize discontinuity rather than flow, consistent with the corresponding organization of the poem: the concluding verse of Inferno "…and thence we issued forth to see again the stars", for example, is directly picked up by the manner in which the first perception of the Purgatory room includes a framed open view to the sky, just as one comes out from the darker and fractured space of Inferno; similarly, the last verse of Purgatory, "… pure and ready to rise to the stars" resonates with the stair leading from Purgatory to Paradise.

Within each of the realms, however, the Danteum seems to provide a strong sense of immersion. One is not merely situated inside a space, as with a church; rather, one is placed between the columns, brought to circulate around them, drawn to meander through them; even in Purgatory, one is brought to occupy the bases of absent columns. As previously suggested, columns are simultaneously boundaries and figures. Their perceptual prominence, both visual and haptic, is all the more obvious as the floor under one's feet is continuously brought into question, as if to destabilize any expectation normally associated with the design of buildings. At the same time, each of the realms affords panoramic overviews, almost like a landscape that presents itself both as a relatively stable horizon and as a network of places yet to be explored. The tight control of overall geometry, the adherence to a proportional system, and the consistent treatment of wall surfaces would seem to suggest a unifying intellectual rigor aimed at containing what is otherwise such a strongly diversified collection of intense spatial experiences.

The Empyrean, therefore, emerges as the most enigmatic space in the building. It is the only space that a visitor could miss if, having explored Paradise, she chose to take the stairs leading back to the entrance. At the same time, it is the only space that mediates between all three realms. Directly connected to Paradise, it affords views into both Inferno and Purgatory positioned as it is over their shared boundary. From the Empyrean, the architectural journey is suddenly revealed in overview and the conceptually simple organization of the building can be fully understood. The rigorous experiential sequence from Inferno to Paradise is now complemented by a more holistic glimpse from the point of view of heaven. Intellectually, the understanding of Heaven is the key to the understanding of Hell. According to many Dante scholars, this is evidenced in the *Vita Nuova*, which they consider as an antechamber to *The Divine Comedy*.[40]

Should one take an alternative route, an ascent from the entrance directly up to Paradise and through to the Empyrean, as if entering *The Divine Comedy*

from *Vita Nuova*, a unique experience would be generated. The flight of steps lead to a space seemingly suspended in air, due to the translucent floor and glass roof, a space leading to a floating axial extension, the Empyrean. There would be views through the slits in the walls, down towards the enigmatic spaces of Purgatory and Inferno. Still visible, the solid floor of the courtyard would offer a contrast to the elevated floor of Paradise. The Empyrean would thus appear as a representation of the congregation of believers, a space that can be shared with God and that could be entered directly from the profane world, avoiding the horrors of the long journey of redemption. Seen in this manner, the building would emphasize not so much a gradual ascent with nested spiraling motions, but rather a classificatory order of conditions that can be contemplated from a distance. The point here is not to suggest that, had the building been built, both potential directions of entry would be equally open to visitors. Rather, the issue is one of resolving a necessary paradox. The journey across the three realms culminates in Paradise, but the visit to any building leads back to the point of entry: a potential anti-climax. By offering the overview from the Empyrean, Terragni constructs a manner in which the building can be remembered, not merely as a journey that had to end but as an insight that might last, not merely as a succession of views but also as a tension between points of view and modes of experience. After all, the poem itself ends with an apparent pause, with an awareness of cyclical motion replacing the cumulative experience of the journey: "… my desire and my will were revolved, like a wheel that is evenly moved, by the Love which moves the sun and the other stars."

Non-Referential Meaning

The fact that some of the central myths of a culture are recorded over many different works in different symbolic media is rather familiar. Thus, it is not particularly surprising that an individual work of art of special significance can acquire an extended body comprising subsequent re-statements in media other than the original. The question we have to ask is not why the *Divine Comedy*, having already served as a point of departure for paintings or sculptures, was also to serve as a point of departure for architectural design. This question only calls for a circumstantial and historical answer that is very much linked to the status of the poem in Italian culture at the time as well as to the aims of both client and architect. The possibility that the poem, prior to inspiring specific architectural designs, was itself inspired by architectural precedents expressing some of the same underlying mythological themes simply confirms that some manner of transmutation from one medium to another is not only possible, but perhaps even expected. What we have to ask instead is how a given work changes as the symbolic medium changes. If meaning is to some extent dependent upon the medium in which it is constructed or expressed, then translations across media without transformation, loss, or accretion are impossible. Hence the more particular questions raised at the outset of this chapter: what does our

knowledge of the *Divine Comedy* contribute to our understanding of Terragni's design and what does the latter contribute to our new understanding of the *Comedy*? To some extent these questions are related to yet another question which can perhaps be answered more clearly. In what exactly consists the act of design formulation that produces the Danteum?

It would be tempting to accommodate much of the preceding discussion within a referential theory of meaning. The 100 travertine columns refer to the 100 cantos of the poem, the 33 columns of Paradise refer to the corresponding 33 cantos, and, of course, the three main rooms refer to the corresponding realms described in the poem. There would of course be problems as noticed earlier: the seven columns in the hall of Inferno do not correspond to the nine main categories of sin that Dante uses to structure his narrative; the seven vacant podia in the hall of Purgatory correspond much better to the seven terraces described by Dante but leave out the four categories of sinners in the ante-purgatory. However one responds to such inconsistencies, an emphasis upon such lexical reference fails to deal with the specific qualities of the architectural form created. Architecture is looked at only in order to return back to the poem. More importantly, the relationships of the architectural elements to each other and the configurational patterns established in architecture are not taken into account.

One possible response would be to seek relationships of reference not at the lexical level of individual units but rather at the level of relationships. For example, the distortions of columns in Inferno, both in proportion and in the relative elevation of their bases and capitals, could refer to the suffering described in the poem. Even this argument, however, leaves something to be desired. It disallows that the distortions of the columns offer direct intuitions of suffering that are comparable, if not equivalent, to the intuitions communicated through words. If we accept, as suggested in this chapter, that such intuitions are indeed intimated, reference would not be based on some arbitrary and conventional association as is typical with linguistic symbols, but rather on the power of the arrangement of columns to exemplify, and not merely to denote, the idea of distortion, and, through that, to metaphorically express suffering. If the argument were extended in this way, however, the relation of reference between building and poem would lose its import. The columns exemplify distortion and, if we read the metaphorical association between column and body, potentially express suffering regardless of their power to evoke the particular part of *The Divine Comedy*.

The power of Terragni's design resides in imbuing the building with formal properties which can thus express feelings, percepts, insights and conditions of the self. The reference to the poem is retrospectively secondary. If the Danteum has anything to contribute to our understanding of the *Comedy*, it is precisely those independent intuitions that give us access to what is being described by the words and independently made present by the poetry. The same applies to the work of Botticelli or Dalí mentioned earlier. The link between the poem and the building is most important at the moment when the key specific

metaphor that drives the design gets established: the metaphor that allows us to think about the body through designing and arranging columns. It is less important at the moment when some fundamental metaphors that underpin all human thought are recognized as relevant to both architecture and poetry. The metaphors, for example, allow us to think about experience and learning as a journey, of understanding as seeing, of theory as panorama and of subjectivity as point of view. Precisely because these metaphors are so pervasive they may help us to understand how taking the poem as a program of design is at all possible but they do not help us to recognize in what ways design formulation is specific.

Once such specific and generic metaphors are set in place, the design is developed not through reiterations of reference but through its own intrinsic logic. At the deepest level of design formulation Terragni recognized that a monument is an extreme moment for architecture and, therefore, associated the design of the Danteum with a reflexive questioning of architecture's fundamental premises: ground, structure, support, stability, boundary. Given the decision to stage the column as both organizational device and figure, the fundamental design move seems to reside in associating the treatment of columns with the de-stabilization of our normal expectations regarding ground and sky, floor and ceiling. It is precisely because these expectations are violated that the walls, boundaries and thresholds acquire greater power as frames of reference. Also, given this basic act of formulation, other decisions follow naturally, including, for example, the decision to use the forest of 100 columns in order to support a floor made of glass blocks and 33 columns made of glass. A referential theory of meaning, therefore, cannot account for the power of the Danteum, even though reference is so central to the program of design. The power of the Danteum, from the point of view of this argument, resides in demonstrating how architecture can speak through arrangement even in the absence of any pre-established vocabulary of elements that would be equivalent to words.

The Danteum can speak of the body metaphorically, by virtue of exemplifying a particular architectural body and by virtue of engendering a particular spatial experience literally. Its greater success is perhaps its ability to bring together in a new way two aspects of the poem that have sometimes been drawn apart in other media: the description of an objective setting and the expression of a subjective condition. In part, this arises from the dual nature of the columns as figures and as spatial devices. In their latter capacity columns refract, reflect, rescale, reposition and redistribute the bodies of visitors at the same time as they exemplify their own metamorphoses and reconfigurations. Rather than primarily reside in what is denoted, meaning arises from what is being constructed in the medium of architecture. If the building can contribute to the long chain of allegory that permeates the poem, it can do so because like all good allegories it shows something that is quite rich in its own right.

Notes

1 This chapter was published in *Journal of Architecture* volume 10, issue 2 April 2005 (RIBA & Routledge) pp. 135–159 entitled "From Building to Poem and Back: The Danteum as a Study in the Projection of Meaning Across Symbolic Forms." Note: All English quotations of *The Divine Comedy* are from Charles Singleton's translations. C. Singleton, *The Divine Comedy*, Bollingen Series LXXX (Princeton, Princeton University Press, 1970) Paul Silentiarius, "Description S. Sophiae" in Cyril Mango ed. *The Art of the Byzantine Empire 312–1453: Sources and Documents*, Dumbarton Oaks, Harvard University (New Jersey, Prentice-Hall, 1972) pp. 82–83.

2 This poem has been a great resource for most historians writing on Hagia Sophia and Byzantine churches in general since it gives the fullest account of the building as it was in Justinian's rule.

3 Richard Krautheimer, *Early Christian & Byzantine Architecture* (Baltimore, Penguin Books, 1965), pp. 160–161.

4 There are records of Dante being an ambassador in Venice, so he was obviously familiar with the Italian Gothic and Byzantine cathedral of San Marco. It is well known that he was in exile at Ravenna and wrote the Paradise section of *The Divine Comedy* there. Boccaccio's *Trattatello in Laude di Dante* describes various other wanderings of the poet including his initial study at Bologna, various Tuscan localities, in exile when he initially fled to Verona, then Bologna, Padua, Rome, Romany, and finally Ravenna. Refer to Giovanni Boccaccio, *The Life of Dante*, in Vicenzo zin Bollettino tr. volume 40 Series B, Garland Library of Medieval Literature (New York & London, Garland Publishing, 1990).

5 Walter Benjamin specifically discusses this idea in "The Task of the Translator" where he writes, "a translation issues from the original – not so much from its life as from its afterlife" in Hannah Arendt (ed.) *Illuminations* (New York, Schocken Books, 1968) p. 73.

6 Benjamin, "The Task …," op. cit., p. 76.

7 Both Giuseppe Terragni and Pietro Lingeri were officially the architects of this project, but Schumacher's extensive analysis attributes the seminal ideas to Terragni. Thomas Schumacher, *The Danteum* (Princeton, Princeton Architectural Press, 1993), p. 17. Etlin does not agree with this and claims both to be equally involved in the design process, Richard Etlin, *Modernism in Italian Architecture, 1890–1940* (Cambridge, MIT Press, 1991) pp. 517–568. In this chapter I refer to Terragni as being the designer purely for convenience since the subject of authorship is not of prime concern.

8 Sussane Lang, "Cosmology and Cartography: The Occident" in *Encyclopedia of World Art*, volume III, 1960, p. 841.

9 Lang, "Cosmography …" op. cit., p. 841.

10 Benedetto Croce, *The Poetry of Dante* (New York, Henry Holt and Co., 1922), p. 99.

11 Refer to points 7, 10, and 13 in Terragni's *Relazione Sul Danteum* document as published in Thomas Schumacher, *The Danteum: A study in the Architecture of Literature* (Princeton, Princeton Architectural Press, 1985), pp. 127–149.

12 John Guzzardo, *Dante: Numerological Studies*. American University Studies, Series II Romance Languages and Literature Volume 59 (New York, Peter Lang, 1987); Charles Singleton, "The Poet's Number at the Center" in *MLN*, 80 no. 1 (1965), pp. 1–10; J. Logan, "The Poet's Central Numbers," in *MLN* 86, no. 1 (1971), pp. 95–98. Also see Vincent Foster Hopper, *Medieval Number Symbolism* (New York, Columbia University Press, 1948).

13 All measures are in Byzantine feet. E.M. Antoniadis, *Ekphrasis of Hagia Sophia, Supplement* (Athens, B. Gregoriades & Sons Co., 1983), p. 52. Other significant numbers include 40, 12, and 7. Here the number of windows around the original dome was 40; it is also the number present in the diameter (in Byzantine feet) of the cylindrical opening; the diameter of the four exedras; it is present in the length from

column to column of the corner divisions of the aisles and galleries; the height of the first cornice; the mean height of the vaulting in the aisles and narthex; the number of ribs, piers and windows of the dome, and many other key dimensions. The reason for this being that this in particular is symbolic of the number of days Jesus spent in the desert in preparation for his role as teacher, the number of days he spent after resurrection and before rising to the heavens, and some other key numbers. There are also 40 columns on the ground floor of the church. The four basic piers symbolize the four evangelists. There are seven openings, arches or windows at several places on the first floor, again seven being a key number, seven days of the creation of the world among other things. Some key dimensions are multiples of 12, symbolizing the 12 apostles. For instance, the length is 300, including narthex and apse in the east. The length of the main volume inside is 240, also a multiple of 12.

14 Refer to Antoniadis *Ekphrasis of Hagia Sophia,* op. cit., for detailed measurements of the Hagia Sophia.

15 Refer to Antoniadis, *Ekphrasis of Hagia Sophia* op. cit.

16 For a detailed discussion on the changes in the liturgical rituals and planning refer to Thomas Mathews, *The Early Churches of Constantinople: Architecture and Liturgy* (University Park and London, Pennsylvania State University Press, 1971).

17 Panayotis Michelis, *Aisthêtikós: Essays in Art, Architecture, and Aesthetics* (Detroit, Wayne State University Press, 1977). Of course Hagia Sophia had to reconcile the axial motif of a basilica, indicating procession and the idea of a representation of the world based on a centralized dome supported essentially by a polygon or cross plan.

18 George Lesser, *Gothic Cathedrals and Sacred Geometry* (London, Alec Tiranti, 1957), p. 9.

19 Robin Evans, *The Projective Cast* (Cambridge, MIT Press, 1995), p. 19.

20 Interestingly, in Romanesque art, especially the tympanum reliefs of Vezelay, Autun, and Congres, Hell is much more visually exciting than Heaven (which in Congres is depicted as orderly architecture). So one can argue that Dante is in fact perpetuating a tradition.

21 Aarati Kanekar, *The Geometry of Love and the Topography of Fear: On translation and metamorphosis from poem to building* (PhD Dissertation, Georgia Institute of Technology, 2000). See appendix 1.

22 John Pope-Hennessy, *A Sienese Codex of The Divine Comedy* (Oxford & London, Phaidon Press, 1947), pp. 32–33.

23 This is also true of William Blake's paintings of *The Divine Comedy* such as those of Charon, Paolo and Francesca, the Usurers and the Angel Descending. The significance given to the body in *The Divine Comedy* is reflected in some other works based on the Comedy, including the avant-garde production of Dante on television done by Peter Greenaway and Tom Phillips. This is even true of Rodin's *Gates of Hell* based upon Dante's *Divine Comedy*, which is looked upon as a summary of his entire life and is a supreme demonstration of the expressive powers given to the human body.

24 Dalí, who was intrigued by Dante since his youth, later was to say that what fascinated him most about Dante was "his angelic vision of being," and, "the cosmic side of God, incomprehensible for man, and reflected in the mirror of the face of the angel." In 1951, the Italian government, in preparation for the 700th anniversary of Dante's birth (b.1265), commissioned Dalí to produce illustrations for a new edition of *La Divina Commedia*. Unfortunately, there was immediate opposition from two fronts: from the "patriots," who objected to the commission going to a Spaniard, and from the communists, who objected to the "waste" of the people's money. Finally, the Italian government yielded to the opposition and cancelled Dalí's commission. Dalí decided, nonetheless, to continue with the production of *The Divine Comedy* illustrations. After the Italian Government cancelled its commission with Dalí, a Frenchman, one Joseph Forêt, who had earlier published an original lithographic series by Dalí (Pages Choisies de Don Quichotte de la

Mancha, in 1957), decided to publish Dalí's *Divine Comedy*. In April 1959, wood engravers (R. Jacquet and J. Taricco) were hired by M. Forêt, to begin the process of transmogrifying Dalí's watercolor illustrations into wood blocks. This process would continue until November 1963, and would result in 3,500 engraved wood blocks representing the one hundred illustrations. (The reason for so many blocks is that each block represents either a distinct color or a line drawing.) The Publication: The completed entire edition of the Divine Comedy was to be composed of six separate volumes, two volumes for each of the three cantica: L'Enfer (Inferno); La Purgatoir (Purgatory), and La Paradis (Paradise), with Dante's Italian text translated into French (translation by Julien Brizeuxe). The first of the completed cantica, L'Enfer, was published in Paris in 1960 by Editiones d'Art Les Heures Claires (Mr. Forêt's company), in two volumes, containing a total of thirty-four woodblock prints. In 1962, the second cantica, Le Purgatoire, also in two volumes, and with 33 prints, was released. And lastly, on 23 November 1963, the final cantica, Le Paradis was issued; it too contains 33 prints.

25 Here I'm referring to Inferno illustrations of canto 4, 5, 7, 11, 15, 21, 22, 26, 28, 29.
26 Octavio Paz, *The Other Voice: Essays on Modern Poetry* (New York, Harcourt Brace Jovanovich, 1990), pp. 10–11.
27 Schumacher, *The Danteum: A study in the Architecture of Literature*, op. cit., point 5 of *Relazione Sul Danteum*.
28 Lionel March, *The Architectonics of Humanism* (Chichester, West Sussex, Academy Editions, 1998).
29 According to Etlin the basilica was one of the largest extant Roman Imperial buildings that was nearly complete when the Emperor was killed in battle in 312. It was then dedicated by the Senate to the victorious Constantine whose statue was also erected in the apse of the basilica. The significant symbolic aspect here is that Constantine had seen the vision of the Cross when he conquered Rome and the combination of all these aspects made the Basilica a particularly important symbol for the Fascists. Refer to Etlin, *Modernism in Italian Architecture,* op. cit., p. 549.
30 Schumacher, *The Danteum: A study in the Architecture of Literature*, op. cit., *Relazione Sul Danteum*, point 8.
31 Etlin, *Modernism in Italian Architecture*, op. cit., pp. 551–552, and p. 556.
32 Schumacher, *The Danteum: Architecture, Poetics, and Politics under Italian Fascism* (New York: Princeton Architectural Press, c.1993, 2nd English edition), p. 91.
33 The reference to atmosphere and feeling generated in the Danteum is projected by means of a walk-through computer model that was created.
34 For Terragni's sketch refer to Aarati Kanekar, "From Building to Poem and Back: The Danteum as a Study in the Projection of Meaning Across Symbolic Forms" in *Journal of Architecture* volume 10, issue 2 April 2005 (RIBA & Routledge) pp. 135–159.
35 Singleton, The Divine Comedy, op. cit., Inferno XII "Have you noticed how he who walks behind moves what he touches, dead souls are not accustomed to do that."
36 Singleton, The Divine Comedy, op. cit., Purgatory II. "The souls who, noticing my breathing, sensed that I was still a living being, then, out of astonishment turned pale...I saw one of those spirits moving forward in order to embrace me – his affection so great that I was moved to mime his welcome. O shade – in all except appearance empty! Three times I clasped my hands behind him and as often brought them back against my chest."
37 Singleton, The Divine Comedy, op. cit., Paradise. "...yet even as coal engenders flame, but with intensity glow outshines it, so that in the flame the coal persists...so will the brightness that envelops us be then surpassed in visibility by reborn flesh. One and the other choir seemed to me so quick and keen to say "Amen" that they showed clearly how they longed for their dead bodies – not only for themselves,

perhaps but for their mothers, fathers, and for others dear to them before they were eternal flames."

38 Procopius of Caesarea, *Buildings* (Cambridge, Harvard University Press, 1996). Here he writes: "Or who could recount the beauty of the columns (kiones) and the stones with which the church is adorned? One might imagine that he had come upon a meadow with its flowers in full bloom. For he would surely marvel at the purple of some, the green tint of others, and at those on which the crimson glows and those from which the white flashes, and again at those which Nature, like some painter, varies with the most contrasting colours."

39 Paul Silentiarius, "*Description S. Sophiae*", verse 682, op. cit., p. 87. "…and they send forth their rays far and wide."

40 Thomas Bergin, *Perspectives on the Divine Comedy* (New Brunswick, Rutgers University Press, 1967), pp. 10–11, and Charles Singleton, "Pattern at the Center' in *Dante Studies: Commedia. Elements of Structure*, originally published as Dante Studies I (Baltimore, John Hopkins University Press, 1954, reprint 1977), pp. 57–58.

3

SPACE OF NARRATIVE STRUCTURE

The Shaping of *Romeo and Juliet* – Eisenman's "Moving Arrows, Eros and Other Errors"

Every artist is a cannibal, every poet is a thief.[1]

Progetto Venezia, the 3rd International Architecture Exhibition of the Venice Biennale 1985, directed for the first time by Aldo Rossi, asked the participants to challenge and reinvent urban sites. Designers were encouraged to display their ideas and designs for the "requalification" or the transformation of specific areas of Venice and other areas of Veneto and Friuli. The exhibition poster talks about various entries wherein:

> the themes all together emphasized the relationship between history and design as well as between territory and cultural individuality and this link, which shares the features of the relationship between language and dialect, is seen through a precise and clearly identifiable world: Venice and its territory with regard to its internal relationship (town, town/capital, territory) and to its wider problems of national and international culture.

While Rossi was discussing the various themes addressed in the Biennale this description is especially interesting considering Rossi's work on the analogous city and some of the entries such as the Stone Lion winning Eisenman project "Moving Arrows, Eros and Other Errors" also known at times as the Romeo and Juliet project. Rossi's thoughts on the title of his book *A Scientific Autobiography* are similar in concept to Eisenman's ideas of the project; Rossi writes, "*Forgetting Architecture* comes to mind as a more appropriate title for this book, since while I may talk about a school, a cemetery, a theatre, it is more correct to say that I talk about life, death, imagination."[2] For Eisenman's Romeo and Juliet project this issue of typology is interwoven with fiction to make a commentary on the analogous city. The little that has been written about this influential project surprisingly does not address the relationship to Piranesi's "Campo Marzio" project and Rossi's ideas of

FIGURE 3.1 Campo Marzio, Piranesi

FIGURE 3.2 Analogous City, Aldo Rossi (© Eredi Aldo Rossi, courtesy Fondazione Aldo Rossi)

FIGURE 3.3 Moving Arrows, Eros and Other Errors, Peter Eisenman, overlapped plates 28, 29, 30 (courtesy Eisenman Architects)

the "Analogous City."[3] Keeping this in mind, let us consider Eisenman's Romeo and Juliet project with respect to two aspects: 1) the spatializing of a fictional narrative, 2) the project's relationship to Analogous City and Campo Marzio.

Cities, buildings, and spaces in general are experienced in a diachronic manner as against their mental reconstructions and their representations in the form of architectural plans, sections, and axonometric drawings that are synchronic in nature. So the narrative aspect is often linked to sequential spatial experience which is diachronic and its representational aspect (at least in the normative architectural drawings of plans, sections, elevations) is synchronic. Theoretical projects wherein the primacy is not about the embodied experience within space such as "Moving Arrows, Eros and Other Errors" becomes especially interesting in this case, since one can make an argument that the representational aspect is closely linked to the narrative aspect even though the drawings themselves are synchronic.

This project represents things described outside architecture in formal terms, whether it be the structural relationships as analyzed in different versions of

the Romeo and Juliet narratives, or a negation of issues regarding presence and origin as associated to traditional anthropocentrism.[4] When considering the spatialization of narrative, the analysis of the Moving Arrows project is particularly telling. This might seem ironic considering the fact that Eisenman chooses to focus on the three structural aspects of various versions (Da Porto, Bandello, and Shakespearean) of the Romeo and Juliet story. Nevertheless, when considering various operations in Eisenman's Moving Arrows project and comparing them to the most celebrated version of the story – that of Shakespeare, there is more than just the structural relations of division, union, and dialectical relationship that becomes evident.

In his introduction, Eisenman describes the project as having incorporated three structural aspects of the three versions of Romeo and Juliet, which include Shakespeare's tragedy, as well as earlier versions by Da Porto and Bandello.[5] Of the various versions, Shakespeare's rendition of Romeo and Juliet is perhaps the most celebrated and includes many of the significant features of Da Porto and Bandello, as well as attributes of other versions of the fictional narrative written earlier.[6] So, even though Eisenman claims to have based his project on the three essential structural relationships in various versions of Romeo and Juliet, this discussion will show that an analysis of the Shakespearean version suggests many similarities in terms of its formal structure and compositional pattern, as well as aspects of spatial logic between the literary and architectural work. Perhaps this might be unintentional, but is too coincidental to disregard and at times almost uncanny. Moreover, of all the versions, Shakespeare's is the most celebrated one and its influence on certain aspects of the project need not seem that far-fetched.[7]

The first impression of the Moving Arrows project as it was published is through a transparent acrylic square box of 30 transparent acetate sheets. The first nine sheets have the project title and introductory text to the project. These are followed by sheets with drawings in various colors that from the exterior overview resemble architectural drawings. The boxed format and the 12″ × 12″ size does not seem to be Eisenman's decision; it had conventionally been an Architectural Association publishing format for many other projects published in that period under Alvin Boyarsky's direction. The use of transparent medium, both the box and the sheets on which drawings are printed, though, was unique to this project and seemed to be a very conscious decision, so naturally one questions the significance. When one looks at the drawings on the transparent acetate sheets piled together in the box it is as though one is looking through a series of layers and getting clues – a search that can be compared to an archaeological dig.[8] They appear, as Vidler suggests, "forms produced in a seemingly implacable auto-generation of grids, surfaces and their punctuation that stems from an equally autonomous procedure called by the author [Eisenman] "scaling"."[9] Further, Eisenman defines the program for this project "to present the dominant recurring themes of the stories of Romeo and Juliet in an architectural form at the site of two castles."[10] To this charge, Eisenman formulates his own design brief which

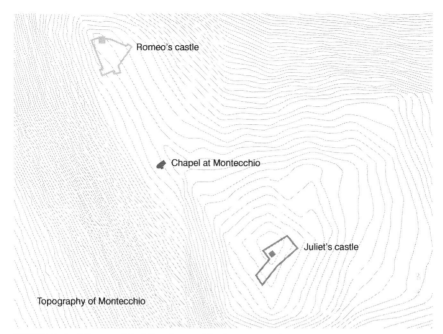

FIGURE 3.4 Montecchio Maggiore with the two castles

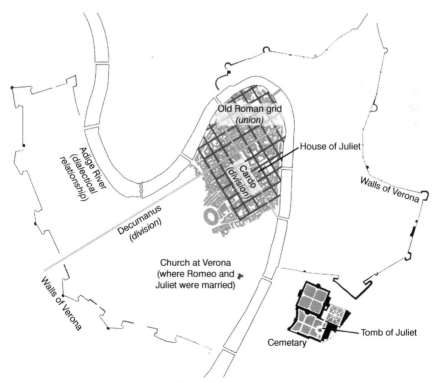

FIGURE 3.5 Verona with its significant features

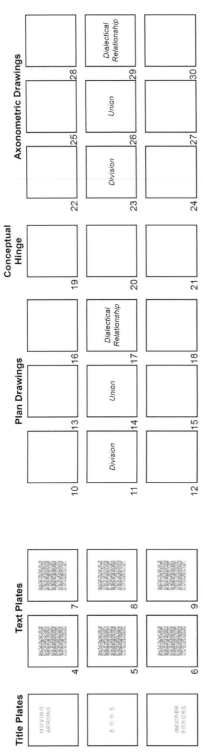

FIGURE 3.6 Composition of plates, Moving Arrows, Eros and Other Errors

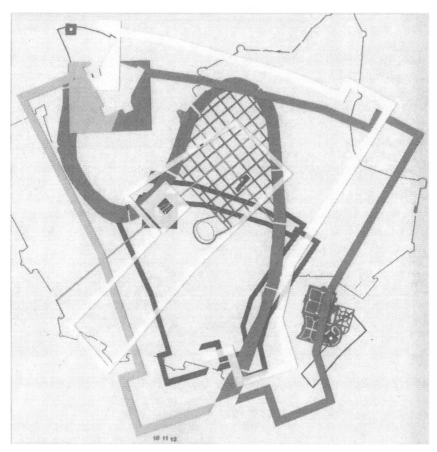

FIGURE 3.7 Moving Arrows, Eros and Other Errors (overlapped plates 10, 11, 12) (courtesy Eisenman Architects)

according to him attempts to eschew the anthropocentric organizing principles in architecture central to which are the issues of presence and origin for what, in his words, is a discourse founded in a process called "scaling." In order to do this, he uses three operations: "discontinuity, *which confronts the metaphysics of presence*; recursivity, *which confronts origin*; and self-similarity, *which confronts representation and the aesthetic object.*"[11] The design becomes a play of various elements that are seemingly real as well as fictional, including the two real castles at Montecchio that were part of the Biennale design brief; this is further developed through a process whereby three structural relations of division, union and dialectical relation in three versions of the fictional Romeo and Juliet story (Da Porto, Bandello and Shakespeare).[12] Each of these structural relations has a physical analogue that is also fictional but exists in Verona today: division as symbolized by the balcony of Juliet's house, union by the church where Romeo and Juliet get married, and dialectical relationship by the tomb where the lovers are together and yet apart. These structural relations are also manifested in the real city of

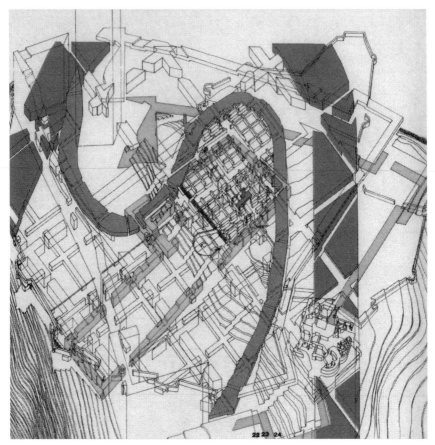

FIGURE 3.8 Moving Arrows, Eros and Other Errors (overlapped plates 22, 23, 24) (courtesy Eisenman Architects)

Verona through the cardo and decumanus that divide the city, the old Roman grid that unites it (both of which are part of the history and memory of the city and are present to this day), and the river Adige that creates a dialectical condition of division and union.

The initial set of nine drawings about the three structural relations – division, union, and dialectical relationship – are compositions in plan establishing interlocking and scaled relationships of the two castles and the city of Verona. Features within the city such as the cardo and decumanus, the Roman grid, and other artifacts, seem to establish a relationship between the three structural relations and the city, creating a play of the container and the contained that seems neither random nor real. The last set of nine transparencies are axonometric compositions that create a labyrinthine relationship between the city, its artifacts, and excavations revealing underlying traces. The relationship between the abstract plan series of the initial nine drawings and the seemingly "real" axonometric series of the latter nine acetates is established through a

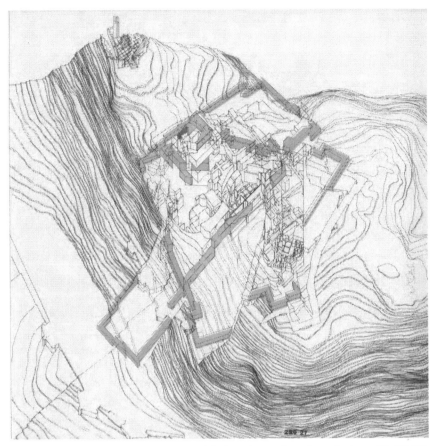

FIGURE 3.9 Moving Arrows, Eros and Other Errors (overlapped plates 25, 26, 27) (courtesy Eisenman Architects)

central set of three acetates that connects the two and is what can be considered a conceptual hinge. It is this hinge that establishes the labyrinth that is to follow in the last set of axonometric drawings.

While the use of fiction is part of the program brief, in his introduction Eisenman chooses not to exhibit the narrative aspect of the fiction, in other words the sequential expression of the story and the plot itself.[13] His decision to focus on structural relations in various versions of the Romeo and Juliet story quite clearly obviates the issue of sequence since that would implicitly involve the notion of origin and closure, both attributes of architectural discourse that he wishes to question. Even though the diachronic unfolding of events of Shakespeare's *Romeo and Juliet* is not followed in order to exhibit structural relations as explained in the introductory text to the project, it is obvious that the diachronic aspect is important in Eisenman's representational process. The drawings are expected to be perceived and understood through a sequential process of overlaying three transparent sheets to generate a synchronic reading

FIGURE 3.10 Logic of reading the structural relations

and in turn clarifying the combinatorial logic of the forms and shapes to create structural relationships.

Spatial Logic in Shakespeare's Romeo and Juliet – Dualities, Oppositions and Symmetries

An analysis of Shakespeare's plot for *Romeo and Juliet* shows that dualities and oppositional symmetries are set up throughout the play at every level, from the dramatic structure and characters, to the actual word play in the content.[14] M.M. Mahood's analysis of *Romeo and Juliet* reveals the significance of dramatic contrast within each setting, for example, during the ball scene at the Capulet house, our attention is divided between the reminiscences of the two old Capulets and the rapt figure of Romeo who is watching Juliet, in other words, youth and old age.[15] For Michael Hall, this scene where the two old men sit on one side of the stage and discuss their lost youth while the current youth dances across the stage from them is "a dramatization of the play's two dominant principles, impotence and fertility, neatly arranged in spatial as well as ideological and narratological opposition."[16] Oppositions are also set up in the characters and their dialogues; Blakemore Evans writes about

> the "low" bawdy word-play of the servants set against the "high" bawdy wit games of Mercutio and Benvolio…; the oxymoron and hyperbole of sonnet love counterpointed and balanced by the obscenely physical extremes of Mercutio and the Nurse; the conventionally mannered language of adult society in Capulet and Lady Capulet played off against the earthy amoral prattle of the Nurse and complemented by the *gravitas* of Friar Lawrence's moral pronouncements…[17]

Contrarieties of the plot are reinforced on the plane of imagery by omnipresent reminders of light and darkness, youth and age, and finally life and death itself with the rhyming of "womb" and "tomb."[18] These are reinforced with symmetries and oppositions established in both events and characters, for instance, the pairing of Romeo who is shown to be besotted with Rosaline at

the beginning of the play and Juliet who is expected to marry Paris; both Romeo and Juliet have confidants in the form of the Nurse and the Friar; Tybalt the Capulet is set against Benvolio a Montague. Events are also designed to work symmetrically within the structure of the play, even minor ones, such as the first street fight where the heads of both households are restrained by their wives. Symmetry and opposition in actual use of words and their composition within sentences abound in the play, for example Benvolio's account of the fight is in his words: "Came more and more, and fought on part and part"; or Romeo confiding about his love to the Friar uses the words, "As mine on hers, so hers is set on mine"; the Friar's warning: "These violent delights have violent ends".

The most obvious oppositional symmetries and dualities within the play are present in the compositional structure when considered in relation to the content of the acts. Scholars like Mark Rose have discussed the way Shakespeare structurally balances the two love scenes in the second and third act on either side of the centerpiece. When acts are analyzed further to understand the oppositions and symmetries in terms of the content with composition certain interesting aspects of spatial and social symmetries and oppositions emerge.[19]

Play of Numbers and Symmetry in Architectural Project

Even if coincidental, there seems to be a direct correlation between the Shakespearean play and the architectural project when we examine numerical correspondences. The total number of scenes divided in five acts in Shakespeare's *Romeo and Juliet* are 21 – which corresponds exactly to the number of drawing plates in "Moving Arrows…" that number from 10 to 30.

The title plates of the project reveal a play of triadic and dyadic relationship.[20] This play of dyadic and triadic relationships can be observed in Shakespeare's *Romeo and Juliet* at many levels that range from the compositional symmetries and oppositions, to that of characters, for example, while we have the pairings of Romeo and Juliet, Benvolio and Mercutio; oppositional pairings of the Montague and Capulet households; there are also triadic relationships of confidants such as Romeo and Juliet with the Nurse or Romeo and Juliet with the Friar.

Numerous other correspondences can be observed between the Shakespearean play and the architectural project. Besides the three basic structural relations that Eisenman writes about, one can observe that the dialectical relation between buildings and city seen through the project is comparable to the spatial logic in the play. The play of dyads and triads observed in the title can be further seen in the play of the number of forms (buildings and artifacts) on the sheets. When one examines individual sheets in the initial three groupings of division, union, and dialectical relationship, three different kinds of formal relationships are exhibited; plates 10, 14, and 18 in each group show two different shapes, i.e. the interlocking of Romeo's castle and Juliet's castle, a binary/dyadic relationship, which is an important idea of the Romeo

TABLE 3.1 *Romeo and Juliet* Act I

ACT I

Scene 1	Scene 2	Scene 3	Scene 4*
Location: Street			*Location*: Dance Hall, Capulet House
Exterior space			**Interior space**
Event: Street fight			*Event*: Hall dance
Episode: Chance meeting of other characters except Romeo and Juliet in the play ending in a fight			*Episode*: Chance meeting of Romeo and Juliet ending in love
Social encounter in open space			**Social encounter in a closed space**
Division as positive since major fight averted			Division as negative since lovers separated
	Marriage discussion: only *men* present	Marriage discussion: only *women* present	
	[Spatial intimacy - inside the Capulet House]		
For Romeo:			For Romeo:
· outside space			· inside space
· lack of love, Rosaline absent			· love declared, Juliet present
· secrecy			· openness
· closure			· separation
· distance			· proximity

*This scene is divided into two according to *The Riverside Shakespeare* version edited by Blakemore G. Evans, dividing the first Act into five scenes.

TABLE 3.2 *Romeo and Juliet* Act II

ACT II				
Scene 1*	Scene 2	Scene 3	Scene 4	Scene 5
Romeo & Juliet *Location*: Garden/orchard and balcony				Romeo & Juliet *Location*: Friar's cell
Outside – open declaration of love				**Inside – secrecy and marriage**
Separation in physical terms due to level difference, Juliet at the window at the upper level and Romeo at a lower level in the orchard				*Union* in terms of marriage
Both Romeo and Juliet part at the end of this scene as lovers				Both part at the end of this scene as husband and wife
Romeo and his friends – only *men*			Juliet and the Nurse – only *women*	

* This scene is divided into two according to *The Riverside Shakespeare* version dividing this act into six scenes

TABLE 3.3 *Romeo and Juliet* Act III

<div align="center">

ACT III

</div>

Scene 1	Scene 2	Scene 3	Scene 4	Scene 5
Location: Street				*Location:* Juliet's room
Exterior/Public				***Interior/Private***
Act ends in killings of Mercutio and Tybalt with disastrous consequences and news for Romeo				Act ends with the fixing of Juliet's wedding date with Paris with disastrous consequences and news for Juliet
Starts with a fight				Ends with the wedding night
	Capulet House	Friar's cell	Capulet House	

TABLE 3.4 *Romeo and Juliet* Act IV

	ACT IV		
Scene 1	Scene 2	Scene 3	Scene 4*
Juliet – Verbal talk about wanting death rather than wanting marriage to Paris and about going to the grave			Juliet – Physically going to the grave
Juliet discussing the actual situation with the Friar – Truth		Juliet putting on a complete facade for her parents and others – mainly all lies	Juliet's talking to herself truthfully revealing her doubts and fears and actually taking the sleeping potion

* This scene is divided into two according to *The Riverside Shakespeare* version dividing this act into five scenes.

TABLE 3.5 *Romeo and Juliet* Act V

	ACT V	
Scene 1	Scene 2	Scene 3
For Romeo:		For Romeo:
Location: Mantua, a **temporary destination**		*Location:* Grave, **final destination**
Time: **Day**		*Time:* **Night**
Least number of people in a scene – initially only Romeo, later joined by his man Balthasar		*Maximum number of people* in a given scene, all the characters in the play or more or less suggesting the entire town

TABLE 3.6 *Romeo and Juliet* the entire play

		Entire play		
Act 1	Act 2	Act 3	Act 4	Act 5
Street brawl showing *division of families*				*Reunion of families* at the graveyard
Starts with servants fighting				*Ends with Masters making up*
Starts with a *negative* – the fight and ends with Romeo falling in *love* with Juliet				Starts with a *positive* feeling of Romeo having a dream and ends in *death*
Prince Escalus appears at three crucial points in the play, the first of them is at the very beginning when the feud between the families has broken anew; he represents the governing forces of man: law, order, and justice		This is the second instance when the Prince appears, at this instance there is the second street brawl with the *killing of Mercutio*		This is the third instance, the Prince bringing the families together and talking of civic sense

	Act I	Act II	Act III	Act IV	Act V
	Starts with fight and ends with Romeo and Juliet falling in love	Ends with the secret wedding	Starts with fight and killings and ends with the wedding night	Ends with Juliet taking the sleeping potion	Starts with Romeo's positive dream, ends with death
	Ends in a positive note but staring prologue ends in a negative note about star-crossed lovers and death	Ends in a *positive* note	*Positive* and *negative* aspects *combined*	Ends in a *negative* note	Ends with killings and death but the reconciliation of families as positive to Verona
	These acts can thus be seen in the genre of *romantic comedy*			These acts can thus be seen in the genre of *tragedy*	
	Start		Recapitulation by Benvolio regarding Mercutio's killing		Recapitulation of the entire story by the Friar
			Killing of Mercutio at the dead center which turns the romance into a tragedy		

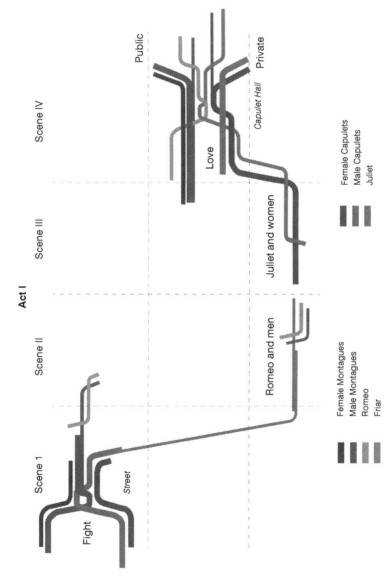

FIGURE 3.11A Visual analysis of *Romeo and Juliet* Act I

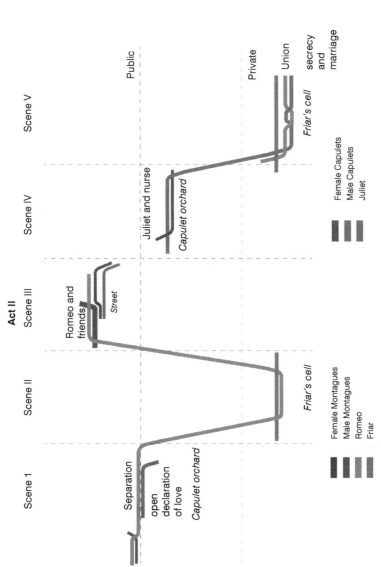

FIGURE 3.11B Visual analysis of *Romeo and Juliet* Act II

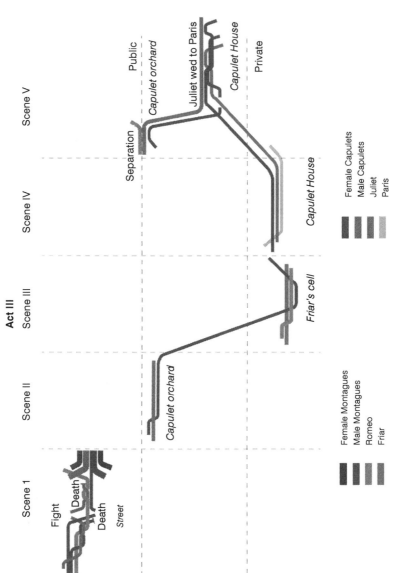

FIGURE 3.11C Visual analysis of *Romeo and Juliet* Act III

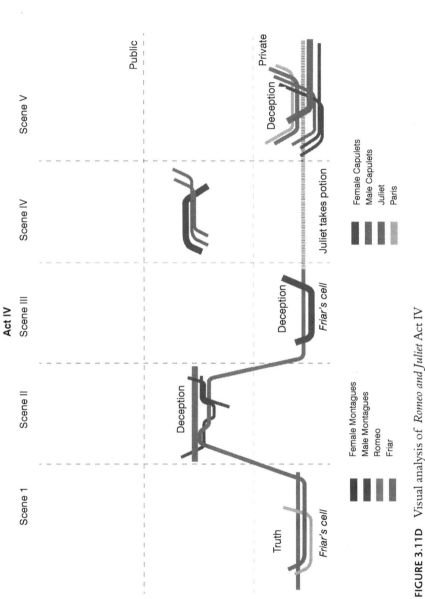

FIGURE 3.11D Visual analysis of *Romeo and Juliet* Act IV

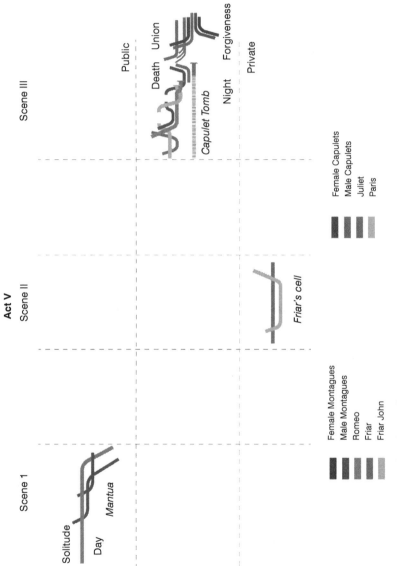

FIGURE 3.11E Visual analysis of *Romeo and Juliet* Act V

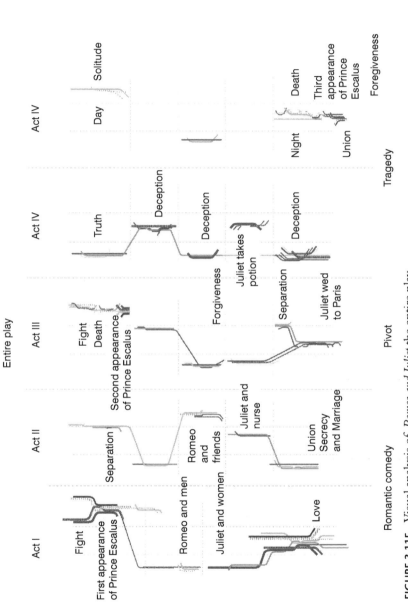

FIGURE 3.11F Visual analysis of *Romeo and Juliet* the entire play

and Juliet narrative. Plates 11, 15, and 16 show many forms placed within the overall boundary of the city. This relationship of buildings within a city can be considered as an embodiment of societal relationships. The third acetate of each of the initial three groups, i.e. nos. 12, 13, and 17, show three forms in a triadic relationship. Although the project defies typology, it takes the seminal medieval types, the castle, church, and tomb, to establish relations within the city so that it can negate them.

Spatial Settings and their Significance in the Play

When we examine locations and specific settings in the 21 scenes within the 5 acts of Shakespeare's play, 9 are in the Capulet house of which 5 are related to Juliet's room/balcony, 4 are in the friar's cell or church, 1 is in Mantua, 1 in the graveyard at the very end of the play and 6 are in located in the street or the in-between space of which 1 is in the orchard below Juliet's window.[21] These can be broadly divided into two spatial settings; 1) the settings for scenes that are linked to specific locations, i.e. Capulet house, Juliet's room, and window, the friar's cell, graveyard, etc., and 2) the scenes that are not linked to a fixed location but generally are set on the streets, i.e. the external space or space in-between two locations. Further examination reveals that only certain characters operate in specific spatial settings, for example, Juliet is always in the private realm at a specific location and never on the street, while Romeo is everywhere and never has a fixed place, so much so that in fact Romeo's presence can be traced at every location that is mentioned in the play ranging from the Capulet house, the friar's cell, the streets of Verona, to Mantua, and also the graveyard.

Examining the division of scenes it is apparent that every time Romeo and Juliet meet and exchange words it is always in the private realm, i.e. Juliet's house, the balcony or the friar's cell. Secrets like the talk about taking poison, and wedding, are also conducted in the private realm – either the friar's cell or Juliet's house. And, there seems to be a clear distinction when it comes to incidents and interactions of characters between the public and private realm, or aspects that are hidden and revealed. This feature of hidden and revealed is especially projected in the last three plates of the architectural project which fluctuate between an archaeological dig and a palimpsest.

The Street as a Significant Spatial Setting in the Shakespearean play

The street space is an important feature and can be seen as a catalyst driving the plot within the play, since the important aspect in this drama is the misunderstandings and problems that cause the tragedy and these mainly operate within the realm of the street. Take for instance the incidental meeting of servants of the two households that causes the brawl; this incident would not have happened had they not bumped into one another on the street. In another

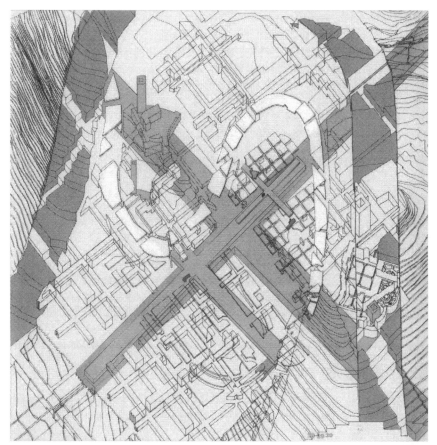

FIGURE 3.12 Moving Arrows, Eros and Other Errors (overlapped plates 28, 29, 30) (courtesy Eisenman Architects)

instance, had the servant not crossed Romeo on the street he would not have shown him the invitation to feast at the Capulet house; had that not happened Romeo would not have gone there and in turn not seen Juliet. The street space, therefore, can be seen as a setting for chance encounters that lead to critical consequences.

From the very opening scene of the play, the street is an important venue, and it is the street that incorporates the social aspect of this drama and the value of keeping the urban civility. The inaugural act of the play shows the significance of the urban setting, through the opening dialogue between the servants of the house of Capulet and the argument that arises between them and the servants of the house of Montague. The importance of the social set up is clearly portrayed in the foreboding and rather prophetic dialogue of Prince Escalus in the first act, wherein he asks both the parties to throw their weapons on the ground and hear him:

> Three civil brawls, bred of an airy world,
> By thee, old Capulet and Montague,
> Having thrice disturb'd the quiet of *our streets*
> And made Verona's ancient citizens
> Cast by their grave beseeming ornaments
> To wield old partisans, in hands as old,
> Canker'd with peace, to part your canker'd hate.
> If ever you disturb *our streets* again
> Your lives shall pay the forfeit of the peace.
>
> Act I Scene 1 (italics mine)

In the play, while civic and social life is clearly embedded within street life there are no seemingly real or imaginary descriptions of the city of Verona and Mantua (where some of the action takes place) in the play where the plot is set, or for that matter, no descriptions of the Capulet or Montague houses, so much so that, although it is the story of two households, the Montague house is never part of the setting. Romeo is never shown in his house, in fact even Romeo's father, the head of the Montague house, and his wife have dialogues that are set on the street.[22]

Of significant note here is that unplanned encounters in the street lead to grave consequences, consider for instance the killing of Mercutio, while planned encounters are hampered due to being restricted to a specific location, like the one where Friar John is not able to deliver the letter sent by Friar Lawrence to Romeo in time because of his being quarantined and confined inside the house. In Shakespeare's *Romeo and Juliet*, time and again it appears that most of the misunderstandings through the play occur while moving on the streets of Verona, in the public realm, and that the catalyst is actually the series of misunderstandings related to movement and motion that create errors and separations, something quite brilliantly captured by Eisenman, while the unions are in the private realm, i.e. either Juliet's house or the church. The similarity to the labyrinthine streets in the drawings as well as the title "Moving Arrows, Eros and Other Errors" seems to capture these tensions so well that it cannot be treated as fortuitous but deliberate by design.

On the one hand, the locational significance of Verona is established with the presence of Juliet through Romeo's banishment in the play. Consider Act 3, Scene 3 where Romeo compares banishment to death. Losing Juliet, for him is linked not just to losing Verona, but losing his freedom, although he has the freedom to be in the entire world.[23] On the other hand, the presence of Romeo at all locations can be associated with him being identified with all locations and, therefore, the entire city. This aspect is also reflected in the architectural project through the use of Romeo's castle being analogous to the city of Verona.

Throughout the play Romeo's presence is not associated with a fixed or specific location. There is no evidence of any description or incident occurring in the Montague house, except for the fact that we are always aware that the

Montague house exists since the story revolves around the two households within the city of Verona and the strife associated with them. The Montague house, therefore, could be anywhere in the city. Romeo, in not being associated with a fixed location, has in the turn the flexibility of being in various locations ranging from the main areas in the Capulet house where he attends the festivities, Juliet's room, the garden orchard in the house, the friar's cell, the tomb, to the streets of Verona, as well as Mantua, in other words, every location mentioned in the play. But interestingly, Romeo is only at home on the streets of Verona, while in most other locations he is either in disguise or in secrecy like the Capulet house and Juliet's room respectively; in other places, unwillingly, like in Mantua where he is in exile; while at the tomb, in distress, when he sees Juliet's body. The friar, who has access to all places, is generally either on the street or in his cell. Romeo's friends, Paris, and other people associated with both the Capulet and Montague households are also always on the street and on one occasion in the Capulet house during the festivities. While the Prince, in all three scenes, is shown in the street after the street brawls and killings and in a sense is the embodiment of social and urban civility.[24]

Movement and Errors

In the Eisenman project, consider the first thing that one perceives through the plexi-box – the title of the project "Moving Arrows, Eros and Other Errors" – to the Shakespearean play where errors are caused due to movement. While Eisenman uses the analogy of a moving arrow to discuss issues of memory and immanence, the association of the title to ideas implicitly related in the fictional narrative Romeo and Juliet can also be considered in a different light. One can think of arrows as causing death, and Cupid's arrows – eros.[25] This, if seen in the perspective of the various versions of the Romeo and Juliet narrative, is possible to interpret as the play between love and death and the series of errors and misinterpretations causing death in the story.

Consider the opening scene of Shakespeare's *Romeo and Juliet* which remarkably puns the word "moved" between Sampson and Gregory, the two Capulet servants:

Sampson: I strike quickly, being moved.
Gregory: But thou art not quickly moved to strike.
Sampson: A dog of the house of Montague moves me.
Gregory: To move is to stir, and to be valiant is to stand. Therefore if thou art moved thou run'st away.
Sampson: A dog of that house shall move me to stand.

<div align="right">Act I Scene 1</div>

This play around the word "move" creates dichotomy of changing and unchanging positions. "Moving" as linked to affecting e/motions when related

with the "Arrows", "Eros," and "Errors" is especially remarkable since these three words in the project title can be phonetically linked together due to the sound of R's, and this phonetic aspect is used in the play linking the first act with the second through the idea of "dog" – a dog of the house of Montague causing the movement and R as suggestive of the dog's growling.[26]

Seen from another perspective, the opening scene which plays with the word "moving" can be examined in terms of the spatial logic associated with the word. Most misunderstandings occur while moving through the streets of Verona and these create errors which have grave consequences in the play. This space of movement, the street space, is an in-between space linking specific locations in Verona. The implicit correspondence to this in the architectural project is established through the scalings and overlaps of the street as a grid and the tomb, in other words spatialization of errors due to movement causing death. The street grid which gives connections gives rise to the labyrinth which forms potential connections leading to a web of consequences of actions. The play of the in-between – the streetspace – becomes both the grid and the labyrinth and the changes in relationship between the architectural objects – castles, tombs, cemetaries, gardens, and others.

The notion of mis-readings and multiple readings causing errors is expressed in the introduction when Eisenman writes about text as having "the capacity for an infinite combination of previous texts into new texts; the three-dimensional experience yields open-ended readings. This introduces the possibility of error, of a text not leading to a truth or a valued conclusion, but rather to a sequential tissue of misreading – errors which produce the condition for each new level of reading."[27] This feature of mis-readings and multiple readings is also an agenda that is carried through in the representational mode through the use of transparent acetates that conflate and confuse readings and in a sense create an in-between space. So Eisenman chooses to exemplify not just the dyadic and triadic relationships, symmetries and oppositions, and the three structural relationships, but more importantly, misunderstandings, and misinterpretations caused due to time-lags, in other words, what in the title he calls "other errors," and, although he does not directly talk about this aspect, it is these misreadings and misinterpretations that give rise to multiple readings that seem to underlie the entire project, from the very nature of materials used for the presentation of the project, to the operational techniques employed for representation.

Besides the fictional elements (that exist in today's Verona) used in Eisenman's project, namely the church, the tomb, and Juliet's balcony, that can be directly co-related to the Shakespearean play, it is significant to note that Eisenman's project picks up the rootlessness of Romeo and his presence in every location in Verona in the Shakespearean drama and represents Romeo's castle as analogous to the city walls of Verona incorporating the entire city. In a sense, scaling them is the architectural operation that translates Romeo's omnipresence and rootlessness.

The Diachronic Play of Synchronic Forms in the Architectural Project

In "Moving Arrows…" combinatorial logic of various forms is evident in the synchronic investigation by overlapping the three layers of acetates. At the same time, the very fact that each layer can be explored separately in a numerical succession reveals the diachronic process as also being of significance. Having a singular representation of the three overlaps with elements in colors could have conveyed the same structural relationship and meaning, nevertheless this would have diminished the diachronic aspect of the process and reduced the possibilities of errors, mis-readings, and multiple readings. In order to achieve combinatorial logic one would expect distinct rules to be employed in representations. Following specific rules of the formal game, which underlie the major rule of scaling like self-similarity and recursivity, there is also a constancy of orientation followed. One does not find any mirror images or changes of orientation in this formal game. In other words, the isomorphic properties remain constant, while shape combinatorial logic is clearly manifested in terms the congruencies, fits, and orientation repetition between layers.

One can question what is present in the sequence of three layers that suggests specific structural relationships beyond the basic sheet numbering, and what it is that makes one think that the superpositions are not haphazard and have an underlying logic to them. Consider for instance the series that exemplifies division; superimposing 10 and 11 there is an obvious logic in the orientation, there is congruence of the church and a distinct fit in the positioning of the river, while overlapping 12, one finds the fit of Romeo's castle, the coincidence of the tower with the church and Juliet's castle. It is the color-coding over and above this that actually gives meaning to the three structural relations, since in terms of the shape combinatorial logic, the three groups that portray the structural relationship of division, union, and dialectical are more or less identical.[28] Color, therefore, gives semantics to the synytactical logic.

The Play of Visible and Invisible

The play of visible and invisible is apparent in the idea of layering of acetate drawings wherein there is an ambiguity of what is revealed and what is hidden, as well as in the actual content. This is much more apparent in the last three groups of the axonometric drawings where there is a play of the container and the contained, i.e. the city in the castle and the castle in the city, as well as the city on the surface and the one beneath the tomb in the form of an excavated archeological dig.

The play of visible and invisible is obvious even in the exhibition of the project. Vidler, in *The Architectural Uncanny*, writes about the manner in which the project was displayed: "In the exhibition," he writes, "the scene was carefully staged, seeming to represent one of those Renaissance drawing lessons staged

by Dürer: a series of vertical, transparent planes held up to nature as if to allow the faithful transcription of the image thus presented and framed."[29] One can therefore surmise that the transparent acetate sheets which were exhibited as screens could be also be understood as a commentary on the perspectival and the visible "real" depicted on the screens as against the plans, which is an abstraction, that focus on structural relationships and axonometric drawings that are about the excavations and relationships within the city – its hidden logic. There is a deliberate non-correspondence between display techniques that are disposed towards perspectival representation and the drawings themselves that are emphatically non-perspectival. The exploitation of affirmation by negation that Vidler sees operating in the Romeo and Juliet project, like the techniques used by Duchamp, Diderot and Magritte, can thus be seen in terms of the perspectival representation that was inherent in the manner of display.[30] The play between the perspectival wherein there is an implicit point of view and the abstract representation of the plans and axonometric overviews, reveals shifts between diachronic and synchronic understanding of the structural relations. In a sense, this is quite closely related to the Shakespearean play; throughout the play, we, the readers have more information than any of the characters, in other words, we have what can be compared to the overview, while at the same time we can follow the point of view of each of the characters within the play, their secrets, and hidden aspects that other characters are unaware of.

The project explicitly attempts to demonstrate the relative nature of architectural meaning in the sense that meaning is generated through the relational properties between forms when the three layers of acetates are put together – a very structuralist point of view. Nevertheless, the forms of all three series that demonstrate division, union, and dialectical relationship are identical; instead it is the color that gives particular meaning.[31] The use of color adds semantics to the formal logic. The formal combinatorial properties using a specific logic remain finite while they give rise to infinite possibilities of readings. In other words, this project shows a finite combination of forms or syntactic rigor that gives rise to open-ended semantic readings. What becomes more interesting with the process of scaling is the slippage, the shift of the signifier and signified, where there is a play of what the form signifies – a castle becomes a city, a city becomes a cemetery and so on; there is no single signified, a very poststructuralist commentary.

Compositional Structure

When one considers the narrative structure of Shakespeare's *Romeo and Juliet*, most would agree that Mercutio's killing is the single most significant event that propels the play to grave consequences. He can be considered as almost as central a character in the play, since his death is an event that changes the entire mood of the play and gives it the twist that changes the direction of the drama in directly hastening it towards the tragic end, so much so that his death is in

fact considered by many as the "keystone" of the plot structure.[32] In a sense, this becomes the hinge on which the structure of the play rests. The killing of Mercutio is of central significance not only in terms of the narrative content but also in terms of narrative structure in that it occurs in the middle of the play, i.e. the third act, and in fact it occurs precisely in the second scene of the third act which in terms of the total number of scenes is exactly the central one.[33]

This aspect when compared to the drawing series of Moving Arrows, can be interpreted as analogous to plates 19, 20, 21 which could be then considered as syntactical hinge in terms of their position between the first three series of plans that are about structural relationships and the last three series of axonometric drawings that are more about uncovering and revealing hidden relationships in the city.[34] Plates 19, 20, 21 then become obviously central not just in the sequential position but to the argument itself that Eisenman makes on the issue of discourse and representation. For him, this project demonstrates figuration as united with discourse in order to create architecture as text, and while representation refers outside itself to an origin, the text refers inwards to its own structure and yields to open-ended readings, thereby introducing the possibility of errors.[35] The narrative is an infinite series of infinite superpositions, and this idea is expressed through the entire project, but plates 19, 20, 21 focus emphatically on the grid that becomes the labyrinth. All three representations of the narrative concepts of division, union and dialectical relationship are expressed here. It is possible to interpret this central series of drawings as a labyrinth of consequence. Like the killing of Mercutio which is central to the play both in terms of its actual compositional position at the midpoint, as well as its significance in the development of the story, in other words the killing of Mercutio is central in sequential terms of the play in its position within the actual order of events in the narrative, so also the series of these three drawings can be thought of as incorporating all the three structural aspects of division, union, and dialectical relationship, and mediating between the abstraction of plan drawings and the seemingly concrete axonometric drawings representing a city. The labyrinth of streets in the drawings can be seen as analogous to the streets in Verona in the Shakespearean play where the misunderstandings occur and finally the killing of Mercutio that results in such grave consequences.

Analogous City

In a certain sense, characteristics of Moving Arrows can be seen to be following the tradition of Piranesi's "Campo Marzio" and Rossi's "Analogous City." Parallels between Eisenman's Moving Arrows and Piranesi's Campo Marzio project are quite telling in that both projects represent a weaving of reality and fiction, albeit in different ways. Eisenman in his critical analysis of Piranesi discusses Campo Marzio as a "figure/figure urbanism" and a "multiple palimpsest" that is "a series of overlays that mix fact with fiction."[36] One could surmise that this has had a considerable influence in his own Moving Arrows

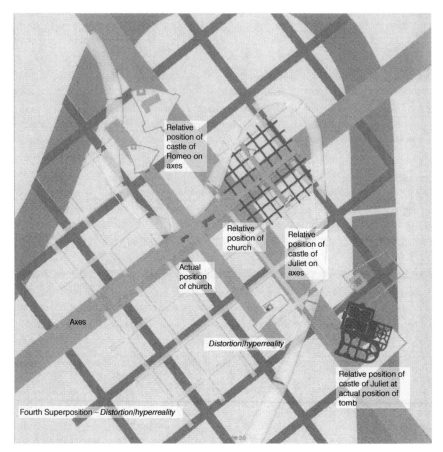

Relative position of castle of Romeo on axes

Relative position of church

Relative position of castle of Juliet on axes

Actual position of church

Axes

Distortion/hyperreality

Relative position of castle of Juliet at actual position of tomb

Fourth Superposition – Distortion/hyperreality

FIGURE 3.13 Moving Arrows, Eros and Other Errors (labelled plates 19, 20, 21) (courtesy Eisenman Architects)

project. While Piranesi weaves fact and fiction by placing ancient buildings within the eighteenth-century framework and also buildings that never existed, Eisenman collates selective locations from the fictional story onto the real city and also transplants real castles onto the fictional /real city.

It should not come as a surprise that if the Piranesian impact is evident with the Campo Marzio project on Eisenman's Moving Arrows, it would follow that Aldo Rossi's "analogous city" would undoubtedly be of significance. The role of structural linguistics in Rossi's analogous city has been discussed by others and it would only be logical given Eisenman's emphasis of structural relations of the Romeo and Juliet story in his project that some of the Rossi ideas of analogous city become the palimpsest of the manner in which fiction relates to building typology and structural organizing relations of the city. Rossi's discussions on the relationship between city, history, and memory are very much present in Eisenman's Moving Arrows but here the role of fictional elements (Juliet's tomb, balcony, etc.) in the public consciousness and collective memory as they

operate upon the structural organization of the city take predominance. The transformation of type especially through the process of scaling described by Eisenman where the cemetery analogically is the city, or the house of Juliet becomes the castle of Juliet in the cemetery of Verona as the city of Verona finally becomes the tomb of Juliet in the cemetery of Verona, is represented through what can best be termed an excavation, in a sense, almost fulfilling the way history can be found through the strata and layers of time which we actually operate upon when layering the acetate sheets to reveal it.

Operations and Ordering systems in comparison to Piranesi's Campo Marzio

When we compare the logic of ordering systems between Campo Marzio and Moving Arrows, they appear to be in complete contrast. With Moving Arrows, the fictional and real both have a physicality in today's Verona or some level of physical reality when we consider existing castles named after Romeo and Juliet. These are not deliberately fragmented in the manner Stan Allen describes when discussing the ordering system of Piranesi's work:

> In the *Campo Marzio* the seamless manner in which the known fragments of the past have been integrated into the whole composition attests to an overriding principle. The internal correspondence of the parts to one another – rather than the "truthfulness" of the parts themselves – allows these fragments to be inserted at a meaningful point into the larger order of the project. Piranesi has invented a compositional language in order to make sense of the fragment. These fragments disappear into the composition not because their fragmentary nature has been concealed or covered over, but because they have themselves redefined the rules for "fitting in." The whole and the parts submit to the same geometric rules. Piranesi demonstrates that, through the multiplication of the simple, the rationality of geometry can describe both the indecipherable fragment and the fully realized composition. But the arbitrariness of the combinations suggest that, given those rules, the permutations are endless.[37]

In Moving Arrows, there is no disappearance of the fragment within the composition; in fact, there seems to be a deliberate overlapping of the wholes for the opposite, almost moiré effect, wherein the wholes juxtapose, combine, overlap to create fragmentation.

Framing is another dimension significant to the ordering of these projects. Discussing the question of frames in Piranesi's work, Stan Allen writes:

> The marking of a boundary, the establishment of a frame appears to be a preoccupation specific to architecture. Territory, precinct, and enclosure are fundamental terms in architectural speculation. The "architectural"

is continually displaced to the periphery and the empty frame marks out the space of use and allows participation. Piranesi's particular insight is to have discovered a latent tension between the figural and the frame. The complexity, the incompleteness, and finally the emptiness of his frames would seem to confirm this.[38]

With Eisenman, the question of the frame is also tied to the transparency of the medium. One has to go outside the frame in order to "read" and make connections. Therefore, going outside the frame creates the sequence and in a way the plot. Eros in this case is more about dissolution and merging rather than reflectivity and desire.

Recursive Operations – Scaling

Even though a preliminary glance at the Moving Arrows project can seem frustrating to some, scaling provides some semblance of an ordering system and becomes one of the significant recursive operations for the project.

Recursive ideas are embedded in the fabled origins of the Romeo and Juliet story and are by no means unique to Eisenman; at a literary level Shakespeare works with various stories of star-crossed lovers, sleeping potions, and poisons that can be traced back to ancient times or the Cappelletti and Montecchi family feuds leading to civic strife that can be referred back to Dante's Purgatory. For Eisenman, working within an architectural discourse one can see traces of Piranesi's Campo Marzio and Rossi's Analogous Cities. The question of origin, history, memory, and the creation of fiction, which drive the representational operations of the Eisenman project are critiqued by Stan Allen when discussing Piranesi's Campo Marzio when he writes,

> a return to origins that calls into question the value of the origin; the idea of a critique from within; the notion of architecture's rationality being turned against itself, a critique of the instrumentality of classical reason, of geometry, of "foundations"; the elevation of the marginal and fragmentary to a constitutive position; the ambiguity of frame and subject, of structure and ornament.[39]

While Piranesi shows the passing of time through the correlation of the location of monuments and their ruined condition, Eisenman shows archeological digs and traces. It is both a palimpsest that holds traces of sites' memories and also conversely a quarry that represents possibilities of immanence and latent future transformations. There is selective erasure of history in one while the other deals selective operations of fictional structure. In both, history and memory are brought into play in an ambiguous manner and fiction is clearly a basis for them. In fact, Eisenman's own analysis of Campo Marzio points out how "Campo Marzio has little to do with representing a literal place or an actual time. The

Campo Marzio is a fabric of traces, a weaving of fact or fiction."[40] Moving Arrows, Eros and Other Errors creates new and fictional relationships with existing elements that have fictional significance but a physical reality. In fact, what Eisenman calls Campo Marzio, "a multiple palimpsest, a series of overlays that mix fact with fiction," can be easily attributed to his Moving Arrows project.

The technique of scaling that appears to be so important to Eisenman, interestingly, is something that does not seem to have a direct correspondence to the literary work. The operation of scaling, depending on how it is used, can be looked at as a defiance of panorama. It can be thought of as making the comprehension of things easier when reduced to a level where they could be grasped all at once – synchronically; "...miniature demands an intimate knowledge of its morphology...it manages to synthesize these intrinsic properties with properties which depend on a spatial and temporal context,"[41] but at the same time it is difficult to understand that totality when things are scaled beyond a certain level, in that case, it is the details and intricacies that come into focus. Moving Arrows, Eros and Other Errors plays with both these dimensions. In this project the multiple scalings seem to create a plot. This is significant, since in an architectural project the creation of a narrative plot does not work in the same fashion as in literary work, especially for an architectural project which does not have a usual diachronic dimension common to architecture, such as the unfolding of events through a promenade. The added dimension of semantics created with color-coding to the scaling process enhances this creation of a narrative in architecture.

In Fredric Jameson's words,

> scaling achieves something more fundamental and formal: namely, to unwedge multiple readings from the *Gestalt*, by projecting the lines of force of the synchronic (the grids) onto any number of diachronic axes. Scaling is therefore the equivalent in the realm of scale itself, or dimension, of what the various color schemes of the Romeo and Juliet box offered to model in the realm of temporality.

Further he goes on to say that,

> In the Romeo and Juliet box, indeed, both these processes are at work simultaneously, offering an interplay of aesthetic perceptions more complex than anything since Schoenberg's *Klangfarbenmelodie*, in which the sequence of specific instruments (flute, drum, string, trumpet) was rigorously coded according to notes in the theme, of which the recurrence of the particular sequence thus also unexpectedly constituted a repetition, but in some other dimension of the work altogether.[42]

What seems to matter in the Moving Arrows project is not so much the Roman grid of Verona, or the walls, the locations of the tomb, or the balcony, rather it

is their interactions that produce a moiré that constantly shifts meanings which are often linked to their identity – an entire process is heavily dependent on architectural representation and specifically the iterative aspect of architectural representation. The inherent paradox in Moving Arrows is that the synchronic representations (plans and axonometric) that are about structural relations are meant to be perceived diachronically to create a narrative representational space.

Notes

1 U2, "The Fly" in Achtung Baby, Island Records, 1991.
2 Aldo Rossi, *A Scientific Autobiography* (Cambridge: MIT Press, 1981) p. 78.
3 Refer to discussions on this project by Vidler, Whiteman, Eisenman, Jameson, among others.
4 Peter Eisenman, Introduction to *Moving Arrows, Eros and Other Errors* (London: AA publication, 1986).
5 Refer to John Whiteman in "Site Unscene – Notes on architecture and the Concept of Fiction" in *AA Files* 12 footnote 31 where it is implied that Eisenman considered these particular three versions of Romeo and Juliet.
6 Refer to Appendix B: Sources in *The Tragedy of Romeo and Juliet*, edited by Richard Hosley (New Haven: Yale University Press, 1954) pp. 168–172, also refer to Olin Moore's *The Legend of Romeo and Juliet* (Columbus: Ohio State University Press, 1950) and Jay Halio edited *Shakespeare's Romeo and Juliet: Texts, Contexts, and Interpretation* (Newark: University of Delaware Press, 1995).
7 For details of the various versions refer to Olin H. Moore *The Legend of Romeo and Juliet* (Columbus: Ohio State University Press, 1950), also Charlton writes on this issue in his lecture *"Romeo and Juliet" as an Experimental Tragedy*. Annual Shakespeare Lecture of the British Academy (Folcroft, PA: Folcroft Press, 1939).
8 Interestingly in the last of series of drawings Eisenman excavates beneath the cemetery.
9 Anthony Vidler, "The End of the Line" in *A+U* August 1988. Also published later in his book *The Architectural Uncanny: Essays in the Modern Unhomely* (Cambridge, MIT Press: 1992) p. 130.
10 Eisenman, Introduction to *Moving Arrows, Eros and Other Errors*, plate 6.
11 Eisenman, Introduction to *Moving Arrows, Eros and Other Errors*, plate 4.
12 According to John Whiteman in "Site Unscene – Notes on architecture and the Concept of Fiction" Eisenman considered these particular three versions.
13 Refer to the work of Russian Formalist the distinction between story and plot which is similar to what Genette draws between *recit* and *historie* in the analysis of narrative.
14 This aspect has been analyzed by scholars including comic aspects quickly turning into serious scenes of discord, between the public and private worlds, see Blakemore G. Evans (ed.) *Romeo and Juliet* (Cambridge: Cambridge University Press, 1984) pp. 8–9.
15 M.M. Mahood, "Romeo and Juliet" in *Essays in Shakespearean Criticism* edited by James Calderwood and Harold Troliver (Englewood Cliffs, NJ: Prentice-Hall, 1970) pp. 391–404.
16 Michael Hall, The Structure of Love: Representational Patterns and Shakespeare's Love Tragedies (Charlottesvile: University Press of Virginia, 1989) p. 80.
17 Blakemore G. Evans (ed.) *Romeo and Juliet* (Cambridge: Cambridge University Press, 1984) pp. 16–17.
18 Harry Levin, "Form and Formality in 'Romeo and Juliet'" in Alvin B. Kernan edited *Modern Shakespearean Criticism: Essays in Style, Dramatrugy, and the Major Plays* (New York: Harcourt Brace Jovanovich, 1970) pp. 279–290.

19 These divisions of scenes are based on the *The Yale Shakespeare: The Tragedy of Romeo and Juliet*, edited by Richard Hosley (New Haven & London: The Yale University Press, 1964) while some other editions vary in the number of scenes, the total number of acts and contents within each remain the same in all editions. Romeo and Juliet presents a complicated textual problem. The play was first published in a "bad" quarto version (Q1) in 1597. A good quarto (Q2), "Newly corrected, augmented, and amended," appeared two years later in 1599. Three other quarto editions were printed, each set up from immediately preceding edition: Q3 (1609), Q4 (undated but probably c.1622), Q5 (1637). The first folio text (1623) was set directly from a copy of Q3, with almost no attempt at correction apart from the addition of a few obvious stage directions.

20 The total number of letters in the title "Moving Arrows, Eros and Other Errors" is 30 which is the same as the total number of acetate sheets in the boxed sets (that include the introductory writing and drawing). When one considers the set of seven drawings (21 individual sheets) and one title set of three sheets both of which are expected to be read in a sequence of three overlapping sheets, a total of eight sets are supposed to be examined as an overlapping sequence of three sheets making it a numerical play of dyads and triads $2 \times 2 \times 2$. The three sheets that have the name of the project *"Moving Arrows, Eros znd Other Errors"* are divided in the following manner: the first acetate has two words "MOVING ARROWS" in two lines with six letters i.e. 2×3 each. The second has "Eros" in 1 line with 4 letters i.e. 2×2, and the third acetate has "and Other Errors" in two lines with eight letters i.e. $2 \times 2 \times 2$ in the first line and six i.e. 2×3 in the second line. The same dyadic and triadic numerical logic of letters is true for three phonetically rhyming words "Arrows", "Eros", and "Errors" in each of the three acetates. Arrows being six (2×3), Eros would be four (2×2) and Errors six (2×3) again.

21 These divisions of scenes are based on *The Yale Shakespeare: The Tragedy of Romeo and Juliet*, edited by Richard Hosley (New Haven & London: Yale University Press, 1964) while some other editions vary in the number of scenes, the total number of acts and contents within each remain the same in all editions.

22 While at times the location of the scene is a mentioned before it begins, most of the time there is no description of location where the event takes place. For example, when the street is the spatial setting, except for the fact that people of the opposing households bump into one another, or have a conversation which is suggestive of the street location, there is nothing else that particularly conforms that location. Consider the opening dialogue in Act I Scene 1 between Sampson and Gregory which goes in the following manner:

Sampson: I will take the wall of any man or maid of Montague's.
Gregory: That shows thee a weak slave, for the weakest goes to the wall.
Sampson: 'Tis true, and therefore women, being the weaker vessels, are ever thrust to the wall. Therefore I will push Montague's men from the wall and thrust his maids to the wall.

During the Renaissance there were no sidewalks and the streets were usually narrow and littered with filth, so in passing someone it was courteous to "give the wall" to the person but insulting to "take the wall" causing the person to step into the gutter in the middle of the street, hence use of the word "wall" in the conversation can be seen as suggestive of the incident occurring in a street. Refer to notes by Richard Hosley in *The Tragedy of Romeo and Juliet*, edited by Richard Hosley (New Haven, Yale University Press: 1954) p. 130.

23 *Romeo:* Ha! banishment! Be merciful, say "death," For exile hath more terror in his look, Much more than death. Do not say "banishment."
Friar: Here from Verona art thou banished. Be patient, for the world is broad and wide.

Romeo: There is no world without Verona walls, But Purgatory, torture, Hell itself. Hence banished is banish'd from the world, And world's exile is death. Then "banished" Is death misterm'd. Calling death "banished" Thou cut'st my head off with a golden ax And smil'st upon the stroke that murders me.

Friar: O deadly sin! O rude unthankfulness! Thy fault our law calls death, but the kind Prince, Taking thy part, hath rush'd aside the law And turn'd that black word "death" to "banishment." This is dear mercy and thou see'st it not.

Romeo: 'Tis torture and not mercy. Heav'n is here Where Juliet lives, and every cat and dog And little mouse, every unworthy thing, Live here in Heaven and may look on her, But Romeo may not.

24 Through all this one has to bear in mind the constraints of an Elizabethan stage production with regard to locational changes and their depiction, and this could be the reason for the lack of spatial descriptions in the play. Unlike some other literature that was not written with the intention of a dramatic performance like, for example, Homeric epics which have the panoramic and sweeping descriptions of location, or Hugo's *The Hunch Back of Notre Dame* that has both panoramic descriptions of the city and the more close up descriptions of buildings and squares, Shakespeare's *Romeo and Juliet* is not focused to that extent on the spatial aspects. In comparison with such narratives, *Romeo and Juliet* cannot be thought of in terms of making either the city, the building, or even any architectural aspect of the physical space of major significance, except for the fact of making the street space a catalyst that drives the plot to some extent.

25 In Hesiod's Theogony, the famous creation myth, Eros springs forth from the primordial Chaos together with Gaia, the Earth, and Tartarus, the underworld. The archeological uncovering of the tomb and the city with seductive revealing as well as other operations of Verona's palimpsest can be considered as an interesting play of this aspect.

26 *Nurse*:Doth not rosemary and Romeo begin both with a letter?

Romeo: Ay Nurse, what of that? Both with an R.

Nurse: Ah, mocker, that's the dog-name. R is of the – No, I know it begins with some other letter – and she hath the prettiest sententious of it, of you and rosemary, that it would do you good to hear it.

Act II Scene 3

27 Peter Eisenman, Introduction to *Moving Arrows, Eros and Other Errors* (London: AA publication, 1986) published to coincide with the exhibition.

28 Sheets 10, 14, 18 (18 is a little different since it does not have the church in the wall of Romeo's castle as an absence) are similar, so also are 11, 15, 16 (15 is slightly different than the other two in that in place of Romeo's castle there is a cavity) and the third group of 12, 13, 17.

29 Anthony Vidler, *The Architectural Uncanny: Essays in the Modern Unhomely* (Cambridge: MIT Press: 1992) p. 126.

30 Vidler, *The Architectural Uncanny*, p. 126.

31 The use of color is significant in that it gives meaning to the formal combinatorial possibilities. Eisenman, in his introduction to the project writes, "in each scaling there are present elements (in color), elements of memory (in grey), and elements of immanence (in white)." The real elements in their present form, i.e. the two castles, Romeo's and Juliet's outside of Vicenza in Montecchio are always in green and orange respectively. Elements of unification are always in blue, i.e. the grid of the city of Verona, the walls surrounding the city and the church. Considering the most man-made mark on site – the cardo and decamanus, and one of the most natural marks on site – the river, these two features are distinct in terms of the color-coding as compared with the other features on the site. The cardo and decamanus are silver, and the river gold in all drawings. This logic of color is especially significant in giving meaning to the three groups of acetates from 10 to 18, each of these groups is identical except for the order in which the drawings are organized

and sequenced, it is only through the use of color that meaning is given to the structural relationships, i.e. the notion of division in 10, 11, 12; union in 13, 14, 15; and dialectical relationship in 16, 17, 18. The use of color therefore adds semantics to the formal logic. It is these three color-codings with the shape combinatorial logic of the scheme that express the structural relations of division, union and dialectical relationship.

32 Refer to "Appendix B: Sources" in *The Tragedy of Romeo and Juliet*, edited by Richard Hosley (New Haven, Yale University Press: 1954) p. 171.

33 Act 1 is divided into 4 scenes, Act 2 has 5, Act 3 which is the central act has 5 again, Act 4 has 4 scenes and Act 5 has 3 making it a total of 21 scenes with Act 3 Scene 2 the center which is where the killing of Mercutio occurs. This division is according to *The Yale Shakespeare: The Tragedy of Romeo and Juliet*.

34 The Roman grid on which downtown Verona is built is apparent in the property blocks and street.

35 Refer to the introduction by Eisenman to *Moving Arrows, Eros and Other Errors*.

36 Excerpt from Peter Eisenman, "Notations of Affect" in Klaus Herding and Berhnard Stumpfhaus (eds.) *Pathos, Affekt, Gefühl: Die Emotioen in den Künsten* (Berlin: Water de Gruyter, 2004), p. 40.

37 Stan Allen, "Piranesi's 'Campo Marzio": An Experimental Design" *Assemblage 10*, December 1989, MIT Press, p. 97.

38 Allen, "Piranesi's 'Campo Marzio": An Experimental Design," p. 88.

39 Allen, "Piranesi's 'Campo Marzio": An Experimental Design," p. 78.

40 Peter Eisenman, "A Critical Analysis: Giovan Battista Piranesi" in *Peter Eisenman Feints* edited by Silvio Cassarà (Milan: Skira, 2006) which is an excerpt from P. Eisenman, "Notations of Affect" in Klaus Herding and Berhnard Stumpfhaus (eds.) *Pathos, Affekt, Gefühl: Die Emotioen in den Künsten* (Berlin: Water de Gruyter, 2004), p. 40.

41 Claude Levi-Strauss, *The Savage Mind* (Chicago: University of Chicago Press, 1962) p. 25.

42 Fredric Jameson, "Modernity versus Postmodernity in Peter Eisenman" in *Cities of Artificial Excavation: The Work of Peter Eisenman, 1978–1988* (Montreal: CCA & Rizzoli International Publications), p. 36.

4

SPACE OF SOUND AND MUSIC

Architecture as a Performative Instrument – Zumthor's Sound Box

> Architecture is judged by eyes that see, by the head that turns, and the legs that walk. Architecture is not a synchronic phenomenon but a successive one, made up of pictures adding themselves one to the other, following each other in time and space, like music.[1]
>
> Corbusier discussing the Modulor

Peter Zumthor when describing the qualities of architecture that are important for him writes, "Listen! Interiors are like large instruments, collecting sound, amplifying it, transmitting it elsewhere."[2] The notion of architecture as an instrument is fascinating especially when one considers his project for the 2000 Swiss Pavilion in Hanover, referred to at times as the Swiss Sound Box, which has a strong musical component to its design. Visually, the work seems to emphasize a strong tectonic and material dimension that has attributes of a fine-tuned precision instrument. What makes it distinct from the others that embody ideas of sound/music into architecture, whether it is translation from a specific musical composition such as Steven Holl's Stretto House based on Béla Bartók's 1936 composition *Music for Strings, Percussion and Celesta*,[3] or harmonic proportions shared between music and architecture as in Wittkower's study on Palladian villas,[4] is that in the Sound Box, architecture performs much like an apparatus or instrument that modulates sound/music, rather than by analogy. So while it may have some appects of the classical tradition that links music to architecture via a common mathematical foundation, in addition to the metaphorical relations between architecture and music that are apparent in this work, but most of all, it is the performative aspect as with any instrument that is of significance.

A project that offers a point of comparison to the Swiss Sound Box is the Philips Pavilion since both are expo pavilions in world fairs and both pavilions were seen by their designers as manifestations of "gesamtkunstwerk" – the synthesis of arts.

This idea of "gesamtkunstwerk" is particularly significant when we consider the issue of translation across arts since it raises the question of synthesis of arts and the potential conflict it raises with internal logic of these symbolic forms and their expression, as well as the possibility that synthesis could lead to an erasure of differences between individual arts. An analysis of how the synthesis works in the Philips Pavilion as compared to the Sound Box would give us a better understanding of how the idea of "gesamtkunstwerk" is approached in these works. The Philips Pavilion was described by Corbusier as a presentation of an electronic spectacle for the Philips Corporation. Xenakis's recollection of the initial discussion about the project as described by Treib is particularly illuminating:

> In October, 1956, Le Corbusier asked me to draw up these ideas and try to "translate them using mathematics." He handed me a sketch. Le Cobusier [proposed that], the building would be a "bottle" containing the "nectar of the visual presentation and the music." For the film spectacle, he wanted flat vertical surfaces. For the spatial effect, he wanted a tapering "bottleneck" high up in the ceiling of the pavilion where the projected image would disappear. For the desired luminous colors, he wanted concave and convex surfaces.[5]

This was eventually translated into film in the form of still images (écran), colored lighting (ambience), simplified shapes or stencils (tri-tous), illuminated 3D forms, and music that was especially composed for the event by Edgar Varèse within the architecture of the pavilion.[6] In a similar manner, the Swiss Sound Box incorporates music, lightscripts, sound, images, fashion and epicure, that represent the country and has been referred to as a "gesamtkunstwerk" – a synthesis of arts in the publication of the work that followed. Nevertheless, there are distinct differences between the two projects in the way these inter-media expressions operate and their architectural impact which this chapter clarifies. Secondly, it investigates instrumental attributes within the Swiss Sound Box and that contributes to the creation and enhancement of sound. Just as music is created through the ordering of this sound, it is structured by the architecture to enhance the visitor experience.

There have been projects such as Neil Denari's "Audio Visual Big Guitar" and Ellen Fullman's "Sonic Space of the Long Stringed Instrument" that are about the instrument as a building.[7] In these projects, the embodied experience of the instrument is critical in the auditory experience. The instrument is amplified to be a container to encompass the human body and a resonance chamber that configures space. What makes the Swiss Sound Box distinct is that it is more than a mere amplified and scaled instrument to encompass the human body – the instrument as building, rather in this case, it is the building that is an instrument – a device and an apparatus that orchestrates movement, sound, smells, vision. It is through the embodied movement within the building that soundspace is created.[8] The idea of controlled orchestration is much more pronounced if one examines the competition 1997 entry for the Swiss Sound

FIGURE 4.1A Exterior view of the Philips Pavilion, Expo 1958

Box that Zumthor calls "Battery"[9] (which could mean a power source, an artillery grouping, or a percussion section of an orchestra, but he uses it to illustrate the charged and synergetic interaction of materials).[10] This initial scheme appears as a shotgun longitudinal plan of the proposed project with three courtyards that has controlled access and outlets and choreographed movement within the enclosure. It has many of the germinal qualities and the elements of the final scheme that include the stacked timber walls, movement through passageways, and courtyards, albeit in a less elaborate manner as compared with the final project.

The Instrument and the Performance

Although the multi-media experience which involved all senses that promote the Swiss identity was an important dimension of the Sound Box it is the auditory component that is at the forefront. Even the nomenclature used by the architect is quite telling: he calls this project "Sound Box," and the voids within the stacks are called "sound spaces." While the name suggests the open chamber in a musical instrument that alters the tonal quality by modifying the way the instrument resonates, what does it mean in the architectural sense?

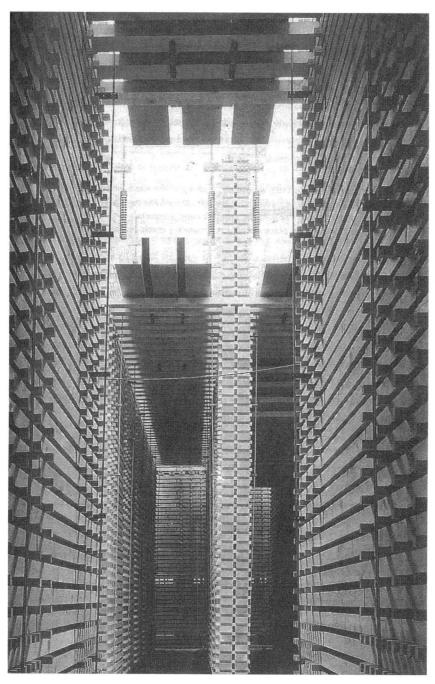

FIGURE 4.1B View of the cross court from the stacks inside the Sound Box (photograph Thomas Flechtner)

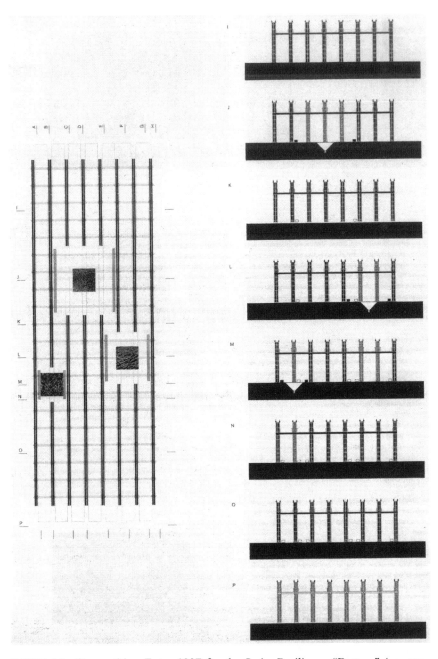

FIGURE 4.2 Competition Entry 1997 for the Swiss Pavilion – "Battery" (courtesy Peter Zumthor)

FIGURE 4.3 Zumthor's conceptual drawings of the Swiss Sound Box (courtesy Peter Zumthor)

I contend that this building exemplifies architecture as an instrument, which speaks not only to its ideation and conception, but also to its tectonic dimension – its materials and construction, as well as to the performative features.

While temporary in nature, this project has been well documented through images, drawings, and writing.[11] An official video recording was made when it was built and a publication detailed its design, construction, and important features of intermedia expressions that synchronized in tandem.[12] These range from sound, music, lightscripts, clothing, food and drink, and other aspects of display and participation during the expo. The project, which has also been referred to as an "experience for the senses," involves careful staging and direction within which all the intermedia expressions work together. In so doing, it creates a fine-tuned spatial experience where the architecture can be compared to an instrument and the entire production is much like a jazz music ensemble, wherein throughout the duration of the expo, the performance of the building and choreography of the experience is not static but undergoes what Zumthor calls "continual change and renewal" that adjusts to visitor numbers, the season, and weather conditions.

The plan has been referred to as a "pin-wheel-like formation", "labyrinth", "regular fabric-like pattern", "reminiscent of the weave and warp of textiles."[13] While one can see these characteristics in the building plan, what do they mean in how one comprehends and experiences the work? The drawings reveal 12 groups of 99 walls that are built by stacking larch logs east–west and douglas fir timber in the north–south direction. These walls are held in tension by metal springs to create longitudinal passages that are covered by metal gutters directing movement into gathering areas such as the bar in the central part of certain modules or in elliptical enclosed areas to pause and linger and open-air

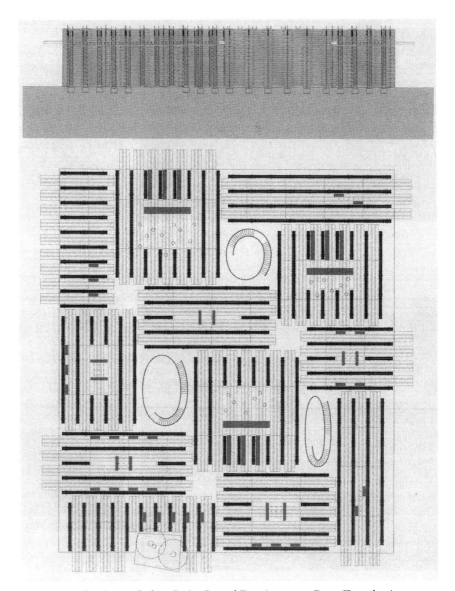

FIGURE 4.4 Section and plan, Swiss Sound Box (courtesy Peter Zumthor)

courtyards. The pavilion is composed of 12 modules that are created by the stacked timber walls and are referred to in Zumthor's drawings as "Stapel" – an orderly arranged pile – a stack – creating a compositional module. So each module is also called a stack. As shown in Figure 4.8, there is a proportional logic to the length of the timber pieces and thus the walls that impact the proportion of modules themselves. Nevertheless there is much similarity between the modules which repeat, rotate, and at times vary ever so slightly. The idea of variations on a theme is something that is seen across art forms, in music with

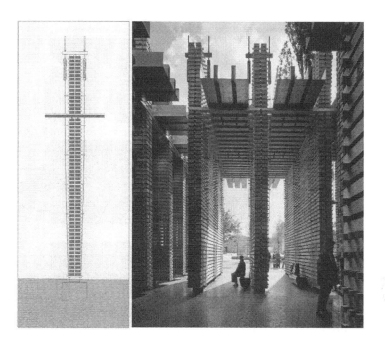

FIGURE 4.5 Section detail of the stack and view of the stacks from courtyard, Swiss Sound Box (drawing courtesy Peter Zumthor and photograph Roland Halbe)

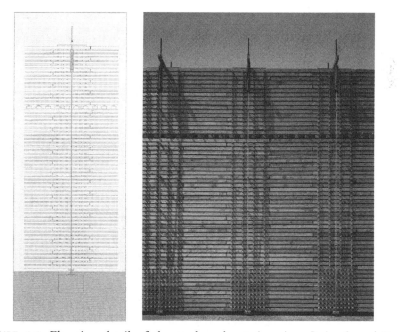

FIGURE 4.6 Elevation detail of the stack and exterior view, Swiss Sound Box (drawing courtesy Peter Zumthor and photograph Roland Halbe)

Bach's *Goldberg Variations* being probably the most famous, or in painting with Picasso's variations of Velasquez's *Las Meninas*. These modules change direction that creates the warp–weft pattern. Dramatic volumetric changes within larger areas transform the moving experience from that of being funneled through longer heightened perspectival longitudinal passages to shorter perspectival pause places, contributing to the enrichment of visitor experience.

A closer examination of the plan also reveals that the pattern of warp and weft is interspersed with three open-air courts which operate as pauses and three courts with elliptical service cores (Figure 4.9). The composition of the stacks in relation to the position of these courts seems to underscore a pinwheel, which is emphasized in the manner in which the visitors would experience rules of the lightscripts. Unlike the Philips Pavilion which had a controlled single entrance and exit, and unlike the initial design of the 1997 competition entry "Battery" where the visitors could not enter from all directions, there were multiple entries and exits into and from the Sound Box. According to Zumthor, there are "50 ways in and out" that weave their way into different areas of the building. Even though there are multiple ways in and out of the structure one is rarely able to see all the way through from one side to the other as in the previous "Battery" scheme making the building seem labyrinthine. This effect is mainly achieved due to the shift in directionality of stacks that does not allow for a continuous view all the way through, nevertheless, one can't truly call it a labyrinth since the center is not given any compositional

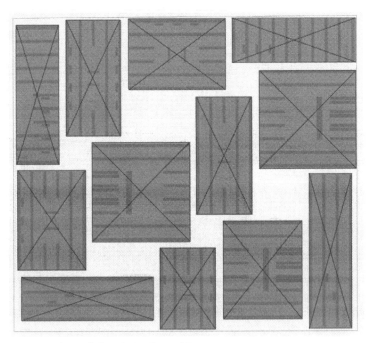

FIGURE 4.7 Stack modules, Swiss Sound Box

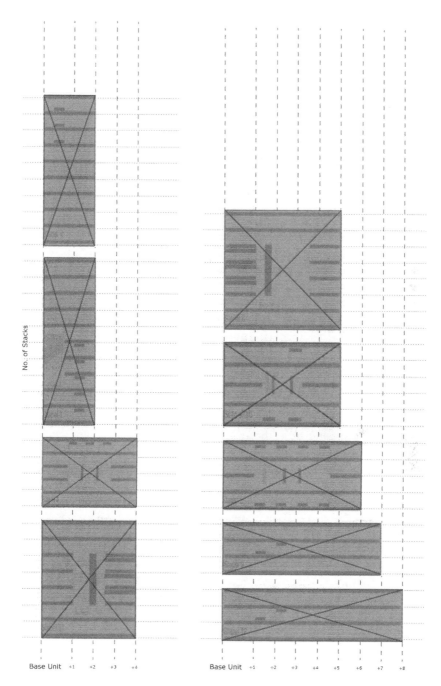

FIGURE 4.8 Stack modules, Swiss Sound Box

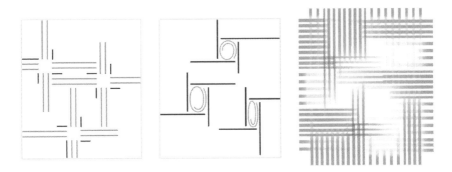

FIGURE 4.9 Swiss Sound Box plan showing pin-wheel and warp and weft

or experiential significance – a paradoxically modernist idea.[14] So while not a true labyrinth, the labyrinthine effect with the shifts of orientation contribute to raising experiential awareness of both the material envelopment and the auditory senses. This feature of seeking what lies on the other side of the wall is emphasized with the ocular since there is a tendency to try and see through the timber stack walls, which have a 45 mm gap due to the lateral timbers inserted between each layer of beams. At an auditory level, with the precisely composed and choreographed music within the pavilion (as shall be described further) there would undoubtedly be a proclivity to follow the sounds created by the musicians as they wander through the stacks or are at certain stationary positions in other stacks. Therefore, compositional features such as the "pin-wheel like formation," "labyrinth," "waft and weft," apparent in the plan become truly significant in the way in which it affects the choreography of movement within the stacks to experience the Sound Box. This is in contrast to the way the interior was experienced in the Philips Pavilion. Considering the descriptions, once inside the controlled entrance of the Philips Pavilion, it was about the emphasis of film, ambience, tris-tous, and music. The architecture became more a container for this heightened experience. With the Sound Box, the architecture directs the experience of lightscripts, music, and other arts, and more significantly, it is about movement within space and not a stationary condition. This is something that is obvious when one considers the photographs that are seen in publications of the pavilions. A majority of the photographs of the Philips Pavilion are exterior shots while a majority of the Swiss Sound Box are interior spaces.

The Accordion and the Dulcimer

There have been obvious references to the image of the timber mills with their stacked storage and Swiss timber houses that may have played an inspirational role in the design of the Sound Box but it is the performative relationship to musical instruments that is emphasized with Zumthor's statement that

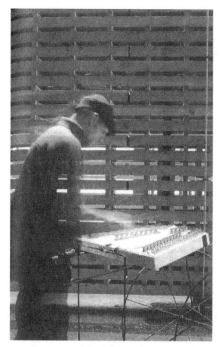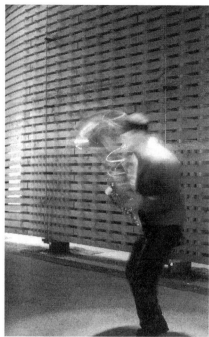

FIGURE 4.10 Musicians playing in the pavilion (photograph Thomas Fletchner)

compares tension in the Sound Box to musical instruments – "tensioned metal strings produce the tone of the dulcimer, sprung metal tongues the tone of the accordion" [15] – both instruments that have been significant in Swiss culture and conceptually important for the design of the project. Sensual characteristics and the natural qualities of the material are significant, such as smell, shrinkage and expansion due to weathering of timber, "the soundbox does not treat timber as an image or an imitation – by using veneers or fake timber construction – but rather as a material in itself." [16] This focus on the material itself impacts the tectonics of construction. Tensile rods are "used to maintain the required prestressing of the stacks," [17] and tensile forces produced by the tensile coiled springs.

Unlike many other buildings that are hermetically sealed to the external environment, the openness of the Sound Box makes weather conditions play an important role in its experience. Wind penetrating through the gaps between timbers causes organized sound and rain falling on the metal gutters resonates and funnels sound in the spaces below. In addition, the rain on the stacked walls would become a vertical sheet of water having both a visual and auditory dimension. Weathering also creates a patina on the material. Larch wood is known to have a tendency to turn deep black on the side that is facing south while the one facing north tends to turn silvery grey. Given that the timber walls being close to each other and covered with metal gutters on the roof may not have the ideal exposure, and also that 153 days at the expo during which the

pavilion was open are probably not enough to develop the patina to its eventual and ideal stage, nevertheless, at a theoretical level this feature is undoubtedly fascinating since in its ideal weathering state the silver on one side and the black on the other when viewed from a position perpendicular to the stack would give an accordion effect that almost rhythmically expands and contracts depending on the stack sizes. Besides this conceptual relationship, when it comes to material patina of the stacks due to weathering that can be compared to the accordion, The choice of the dulcimer – an ancient instrument with strings stretched over a boxed trapezoidal sounding board which are hammered by the musician using two small mallets – is quite significant in this case especially when one considers the sound of rain on the metal gutters and the stacked walls held by metal rods that would resonate in the Sound Box. Morever, the visitors who move within and the musicians who play inside, all take the role of the mallets that create the music within the Sound Box.

Choreography of Lightscripts and Movement

In the publication *Swiss Sound Box*, Zumthor shows the meticulous layout of projectors that choreograph the lightscripts that describe and give information about Switzerland. Sometimes these take the form of quotations. These are then projected on the stacked timber beams: "the scripts are written onto the stacked walls with light; the bundled light shines through special templates; the timber remains unscarred."[18] The mode in which this script is projected is undoubtedly significant in the manner in which text is used in relation to movement and perception of the space itself. Lightscripts run through the entire structure and contribute in emphasizing the stacked nature of material and construction. They add to directionality of movement within the labyrinthine experience of the pavilion. While they may seem to be independent of the architectural design, much like the musical composition for this project by Daniel Ott, the rules that dictate the positioning and size of the lightscripts is based on the architecture and its tectonic nature. According to Zumthor, "they project the deep structure of the architecture onto its own surface."[19] The logic of rules that is set-up for lightscripts also reveals the number of times certain scenarios would come about, these are generally 7 or 14.

> Rule no. 1: If the view from one of the three cross courts into the depth of the room consists of a stacked wall, a large, compact type will be used (type size: 50 cm high). This situation occurs 7 times. Rule no. 2: In each of the two corridors leading at right angles from a court towards letter of rule 1, a smaller type (type size: 2.5 cm high) forms a line of text running along the entire length of the corridor walls. The latter type size is a consequence of the proximity from which it is viewed. This situation occurs 14 times. Rule no. 3: If one of the rule no. 2 text lines leads through one of the bars or sound spaces, a medium-sized type will be projected onto the opposite wall

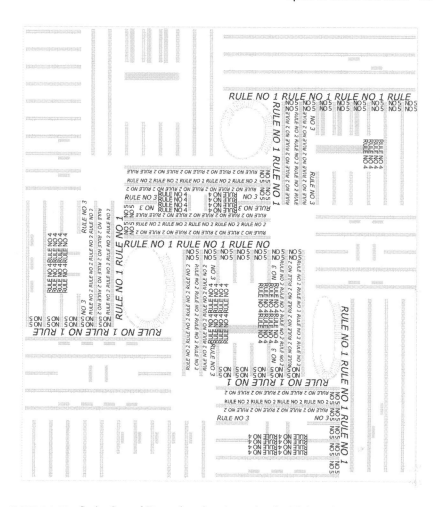

FIGURE 4.11 Swiss Sound Box, plan showing rules for Lightscripts

(type size: 5 cm high). There are 7 such cases. Rule no. 4: The rule no. 3 texts in interior rooms appear on several lines and are centered. Together, they form either double, triple or quadruple units, depending on the size of the room. Rule no. 5: Every view from a corridor onto a wall falls onto a medium-sized type (type size: c high). The spatial situation allows the viewer to either walk towards or along those texts; therefore, they may form lines that emphasize the horizontal or multi-line clusters that emphasize the vertical. Rule no. 1 is a derivation of rule no. 5.[20]

As described, these rules are also variations of others such as rule 1 which is a derivation of rule 5 very much in the spirit of the architecture of stacks, which are also variations of a theme. These rules when reviewed in plan show how the logic of the lightscripts emphasize the pin-wheel effect and add to

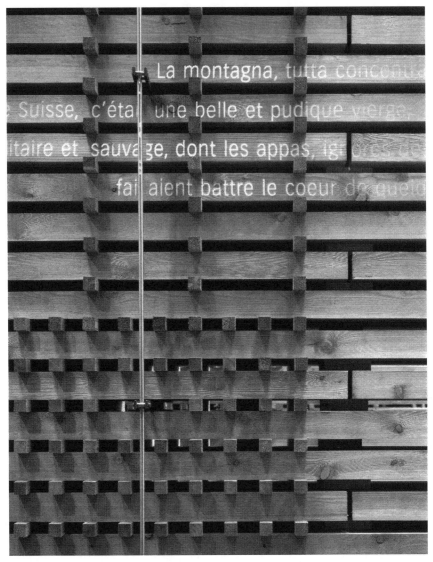

La montagna, tutta conce...
e Suisse, c'éta une belle et pudique vierge,
itaire et sauvage, dont les appas, ig... re... ce
fai aient battre le coeur d...

FIGURE 4.12 Interior photographs showing Lightscripts, Swiss Sound Box (photograph Roland Halbe)

it experientially and not just in abstract conception (see Figure 4.11). When compared to the color, stencils, and image projection within the Philips Pavilion which are not about making the interior intelligible but are about the content internal to the projections, in fact they seem more about the denial of material expression due to the focus on color ambience, stencil, and image projection. By contrast, Sound Box is about heightening the material expression, even the lightscripts in the Sound Box are closely tied to the material scale on which they are projected and about the intelligibility of the architectural interior.

Choreography of Sound and Movement

The Sound Box seems to heighten the diachronic dimension when one considers spatial sequences in this building. At one level the visitor is separated both visually and spatially with the stacked walls and, therefore, one is generally in discrete spaces and discontinuous modules. So even when there are "multiple ways" in and out, there is a very controlled choreography of movement sequence that is separated in the experience of distinct modules at a time but at the same time there is an awareness of surrounding modules through the auditory dimension. The comparison between the Philips Pavilion and the Sound Box with respect to the manner in which sound and music are distributed to trigger movement or enhance the spatial experience becomes particularly telling. In the Philips Pavilion, Xenakis and Corbusier carefully locate 300 loudspeakers that amplify both the Varèse composition and Xenakis's *Concret PH* interludes. Xenakis' essay "Notes sur un geste Electronique" describes the acoustical grid in his idea of the abstract total work of art which spatializes loudspeakers in "knots" whereby they would be considered as "geometric points" and in turn Euclidean space is transposed into acoustic space, following the logic that the auditory experience is crucial for spatial orientation.[21] This locating of sound sources in space is germinal to what Daniel Ott, who composed the music, does in the Sound Box with live musicians who are choreographed to move in specific ways in space. Ott, in his musical sketchbook entries, says that he "had this idea of *spatial music* with mobile musicians inside a continually changing *sound space* – with fast aperiodic sound chains on plucked strings. Later I modified this idea for the dulcimers in the Swiss Sound Box and customized them for the Sound spaces."[22] Here, unlike the pre-recorded distribution of sound of the Philips Pavilion it is the distribution of sound through the bodily movement of the musicians within architecture. Movement within the Sound Box is integral to the experience of visitors through the enactment of music by the performers within spaces, thereby making the architecture a device or instrument that modulates this performance. In this building the rhythm of movement of both the visitor and the performer becomes significant to the spatial experience.

Daniel Ott worked in close collaboration with Peter Zumthor and the architecture seems to have a close relation to the choreography of sound in space. Zumthor writes about basic sound saying that, "it is composed of 153 sounds and 23 eruptions. The sounds tend to spread out in space – a timbre that meanders through the room. The eruptions are loud, shrill, rhythmic, non-linear, and aperiodic – they surprise the listener. Basic sounds and eruptions appear alternately in a shifting pattern, based on a different schedule each day."[23] The notion of time is amplified and explicitly expressed through specific numbers, for instance, 153 basic sounds is the same number as the duration of the pavilion at the expo which was 153 days and 23 eruptions is analogous to the number of weeks of the expo. The encapsulation of time through sound is also registered in spatial sequences. The movement of musicians within the pavilion is also emphasized

FIGURE 4.13 Movement and perception within stacks, Swiss Sound Box

FIGURE 4.14 Stack proportions, Swiss Sound Box

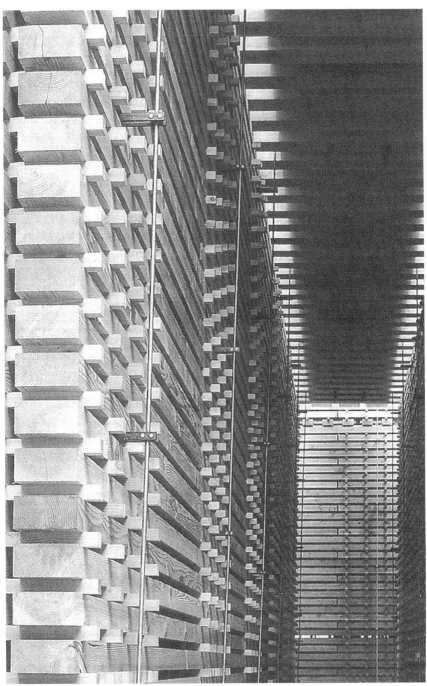

FIGURE 4.15 Passage in Stack 6, Swiss Sound Box (photograph Thomas Flechtner)

through the alternate shifting pattern between basic sounds and eruptions much like the compositional warp and weave pattern of the plan. Six basic sound musicians consisting of three accordionists and three dulcimer players, and three improvising musicians perform every day, a total of 350 musicians, therefore, play three shifts of fours hours each from 9:30 am to 9:30 pm. Beside this organization for basic sound and eruptions, there is an additional element of free play for short periods of 30 to 120 seconds when the musicians would play anything from classical to jazz, original to eccentric.[24] This organizing structure set up by Daniel Ott in consultation with Zumthor provides the framework within which the musicians and other musical directors work "as if they were playing with a modular set of bricks,"[25] but more significantly much in the way of variations of a theme that is underlying the architecture of the building whether it is the level of the design of the stacks or that of spatial organization. This is in contrast to the Philips Pavilion where Corbusier and Xenakis worked on the architecture more or less independently of Edgar Varèse's composition of the music.[26]

The careful choreography of musicians, movement, and improvisations results in a constant variation within space, as Zumthor says: "Mise-en-scène allows the musicians to change not only their location within the space but also their attitude while performing. An interplay results between spaces that are constantly being redefined and reorganized, and sounds that are constantly varied."[27] The notion of variation on a theme that can be observed in the design of stacks where certain stacks are identical but are rotated 90 or 180 degrees. Moreover, all stacks have variations in length, and this property is also present in the musical choreography as explained by Zumthor:

> The starting point is always the service unit, where the public cloakrooms and lounges are found. This is where the teams meet, and where each musician's most important property – the stop-watch – is set. When the Sound Box opens, the first six musicians leave the service unit in a row. They play the first notes of the composition and then disperse slowly around the pavilion. Now the precisely-timed three-hour plan comes into force. It is determined above all by two elements: space and time. The daily plans tell the musicians whether they are working more to the time structure or the space structure: e.g. for the first 14 minutes they can move freely around the pavilion, but after five minutes they change from sound A to sound B; at the 14th minute they meet at stack 3 and change to sound C; at the 31st minute there is a meeting at stack 7, so that the musicians can play together (the so-called folk music window). They then change to sound E and at the 36th minute the groups breaks up and the musicians move freely around the space again. The principles of the three-times-three-point catalogue apply when there is freedom of movement. At the 39th minute there is a freeze, a pause, a standstill for all participants. Time holds its breath for a moment. A great frisson runs through the pavilion. A new moment of tension is created. After 60

seconds things start to move, the wheels are in motion again. Then, after 40 minutes, the principle of inherent laws goes into effect. Four sacks are redefined in the course of 20 minutes: 1. The Slow Motion Stack: when the musicians cross the threshold to this stack they go into slow motion. Every movement they make is slowed down, which also changes the quality of their sound. 2. The Backwards Stack: on moving into this stack the musician immediately begin walking backwards. 3. The Break-Off Stack: while crossing the threshold, the musicians are playing their own native music, but suddenly break off. He tries again, but each time he crosses this threshold the music breaks off again. 4. The Hieronymus Bosch Stack: as in the painter's world, funny things happen to the musicians here. They move into this stack and start to play their dulcimer with their mouths; they may suddenly use their accordion like a mirror and see themselves reflected there; deep ditches open up in front of them and they have to jump over them; suddenly something is dripping from above and they have to get out of the way...[28]

This explanation of the musical script reveals a very intentional choreography in the manner in which the architectural experience transforms with the musical input as well as the way in which the architectural spaces impact the musical output. Daniel Ott, the musical curator, and composer of the musical score and scripting for this project discusses the specific numerical cues he takes from the architecture. This is quite in contrast to what happens with some other architecture works that are based on music such as the Phillips Pavilion and the Stretto House. Some numbers that Ott intentionally uses are time-based such as 153 exhibition days = 153 sounds, 23 weeks = 23 eruptions, others are more form based such as twelve stacks, three courts, the number of beam layers within the stack which are 4, 5, 6, 8, 10, or 11, or proportions that have to do with the floor plan. Here, the musical composition follows architectural decisions.

Not only is the experience of music in the Sound Box linked to movement but movement is also undoubtedly a critical part of the design and spatial experience of the pavilion and is even reflected in clothing that was designed for this project which according to Zumthor "reinforces this sense of mobility within the overall choreography."[29] Nevertheless, what is perhaps remarkable in terms of sound and performance is also at the level synchronic representation and diachronic experience. With the Sound Box, it is the interlacing of spatial representation and spatial experience. The plan of the stacks is reminiscent of a musical staff wherein the performance of the musicians and movement of the people become the notes within the structured space. At a sectional level, the compression ties become figuratively the bar lines and the perceptual and moving experience of the body through space makes the musical notes. At the level of abstract imagery, it is possible to suggest that when one considers the plan with the bars of the stacks in relation to the three spiral-shaped service units

routed from solid timber sheet coated with black acrylic paint, it is reminiscent of the music staff and notes. The vibrations created by the people moving through, the modulations of their voices that overlap with the choreographed basic sound sequences; improvisations and eruptions are all amplified and funneled through timber stacks and metal making the pavilion a sensitive architectural instrument that at times alludes to the literal aspect of the instrument and at others to the conceptual.

Architecture as Instrument

Zumthor, when discussing the resonance chamber effect in the Swiss Sound Box, writes, "the spatial and structural engineering is designed to amplify and direct the tone and timbre of the commissioned musical compositions."[30] This is not only true about the performative aspect of this building wherein modulation of sound is an important component in the experience of the building, it is also true according to the architect's description that "the image of a large sound-box was used as a basis for the design." It is the testing of architecture, construction, acoustics, and musical sounds in the full-scale model of a stack that leads to the discovery that two instruments – the dulcimer and the accordion (both of which are used in the basic sound) – have what Zumthor calls "a structure that shows a marked similarity to the structure of the Sound Box."[31] With Xenakis' work in the Philips Pavilion and later at Expo '70 Osaka there is a conscious effort to link music and architecture as an active immersive environment, even so far as stating that concert hall designers should seek inspiration in the art of instrument building. While there is no doubt that the form of the instrument is significant in the quality, timbre, and identity of sound, for Zumthor's work materiality and tectonics make the architecture into the fine-tuned instrument that Xenakis initiated.

So when one considers all the criticisms that pertain to the comparison between music and architecture, whether it is about the problematic analogy of pleasing proportions between the two media of expression when it comes to the manner in which senses perceive proportions differently as argued by Perrault; or the eighteenth-century ideas of subjectivity of beauty such as Burke's discussion on the sublime and beautiful that question beauty having anything to do with calculation and geometry; or what Wittkower refers as the Lord Kames "frontal attack against the translation of musical consonances into architecture" arguing that perspective interferes with our comprehension of architectural proportions since visual proportion in his opinion was not determined by precise numbers as those contained in harmonic ratios, given that perception of proportions is by moving in space as well as by laws of perspective; or the nineteenth-century discussions of Helmholtz that the ear is unable to pass on to the mind any information about mathematical ratios – it responds only to effect not the cause; none of these discussions deny harmonic proportions; the argument is simply directed against an equivalence – a belief that they were

the same as those on the musical scale. And, while the classical analysis of music shows that there is a relatively simple mathematical base to harmonic structure based on the proportions of tones, theories in contemporary music no longer believe that the recognized units of analysis – like tones, intervals, and chords – are also units of our perception. Rather these deliberations focus on more extensive and comprehensive events such as patterns, variations, and hierarchic structures. These considerations, therefore, point out that the key to correspondence between musical and visual form is not purely in the numbers as expounded by Alberti nor is it entirely dependent on the processes of sight and sound as described by some theorists such as Helmholtz, and while it is accepted following Henri Poincaré's work that there are underlying "resonances" at a formal level between mathematics and perception that can be considered much more "architectonic" in the sense of the term used by Adolf von Hildebrand and Schmarsow, it is in the "cognitive similarity of structure between the two media, in the principles and transformation by which holistic structures in each are created."[32] When considered in terms of the discourse on the comparison between music and architecture the Swiss Sound Box gives a new insight that can best be termed as "performative."

Ultimately, the understanding of this project, it is not about translation from one art form to another, rather, it points to facets within one medium that are highlighted with certain shared attributes between arts that architecture draws on and enhances. In comparing the Swiss Sound Box and the Philips Pavilion it would seem that the Swiss Sound Box, with the creation of a "gesamtkunstwerk" by combining multiple symbolic forms with the goal of a unified subjective experience, might not necessarily align with the idea of translation across symbolic forms as a means of securing each one's autonomy, and while it would seem that the Philips Pavilion because it actually incorporates both ideas in a distinct manner: the interior of the Pavilion conceived as an "experience" by Le Corbusier that involved the fusion of artistic media, and the exterior shaped by Xenakis based on the musical structure of his composition Metastasis, addresses the notion of the complete experience "gesamtkunstwerk" and the sense of autonomy quite distinctly in the interior vs. the exterior, a much more compelling case. Nevertheless, in the Swiss Sound Box the manner in which "gesamtkunstwerk" is achieved is critical especially when it comes to the internal logic of the medium of expression. I have argued that with the Swiss Sound Box the architecture is what guides and directs the other symbolic forms unlike the Philips Pavilion where each was designed independently. In the Sound Box the architecture becomes the vehicle through which other forms get expressed. The comprehension of the complete experience in the Sound Box is through movement within and not a static position. Movement then is critical not just for intelligibility of form, but also for the embodied experience of other forms of expression – a very architectural dimension.

In the case of the Swiss Sound Box, it is evident that ideas of proportions, massing, and numbers are part of the architect's basic palette and these patterns

can be seen across Zumthor's other projects such as the Thermal Baths in Vals and the Kunsthaus Bregenz – both designed prior to this pavilion. What makes the Swiss Sound Box special with respect to the relation between space and sound is more than the repertoire of formal concepts of proportion, mass, and number. In this project it is the notion of the variation of a theme at a formal and material level, and it is the tectonics of construction – stacking, layering, compression and tension in the creation of the stacks that encompasses structure and rhythm from the smallest joint to the largest compositional and spatial organization, all of which impact patterns of accessibility, connection, separation, sequencing, and grouping. But most significantly, all of these attributes create an intricate choreography of movement and spatial experience to make it an architecture of instrument.

Notes

1　Le Corbusier, *Modulor* (facsimile edition, Birkhäuser: Basel 2000), p. 74.
2　Peter Zumthor, *Atmospheres: architectural environments, surrounding objects* based on a lecture delivered on 1 June 2003 at the (Kunstscheune), Wendlinghausen Castle (Wege durch das Land) Festival of Literature and Music in East-Westphalia-Lippe (Basel: Birkhäuser, 2006) p. 29.
3　Steven Holl, "Stretto House" in Elizabeth Martin (ed.) *Architecture as a Translation of Music*, Pamplet Architecture 16 (Princeton, NJ: Princeton Architectural Press, 1994), pp. 56–59.
4　Rudolf Wittkower, *Architectural Principles in the Age of Humanism* (New York: Random House, 1962).
5　Marc Treib, *Space Calculated in Seconds* (Princeton, NJ: Princeton University Press, 1996), p. 36.
6　Treib, *Space Calculated in Seconds*, p. 98.
7　See details in Elizabeth Martin's *Architecture as a Translation of Music*, Pamplet Architecture 16 (Princeton Architectural Press, 1994).
8　The notion of architecture as instrument is present in some seventeenth- and eighteenth-century writings. For instance, Athanasius Kircher's seventeenth-century work discusses architectural devices that capture sound. Many of these old comparisons were based on the scientifically inaccurate idea that a building, or a component of a building, "resonates" (i.e. vibrates) in response to sounds produced inside, thereby amplifying them. A passage from Rousseau's definition of the musical term "orchestra" in which he discusses the architecture of an opera house is also based on a similar notion: "One must look first to the construction of the orchestra, that is, to the enclosure that contains it... Care is taken to make the casing [la caisse, literally "the box"] out of a light, resonant wood such as pine, to build the whole thing over a vaulted cavity, to separate the orchestra from the spectators by a partition placed in the parterre at a distance of one or two feet. So the physical material of the orchestra – bearing, so to speak, on the air, and touching almost nothing – vibrates and resonates without hindrance, and forms something like a great instrument that responds to all the others and augments their effect." [Jean-Jacques Rousseau, *Dictionnaire de Musique* (Paris: Veuve Duchesne, 1768), pp. 358–359.] While not an accurate premise, this idea was compelling enough that it was frequently repeated by architects.
9　Peter Zumthor, "Battery" Swiss Pavilion Expo 2000, Hanover Competition Entry 1997, *Peter Zumthor Works: buildings and projects 1979–1997;* photographs by Hélène Binet ; text by Peter Zumthor, Published by Baden: Lars Müller, c.1998.

10 Zumthor et al., *Swiss Sound Box*, p. 24.
11 See *Swiss Sound Box: A Handbook for the Pavilion of the Swiss Confederation at Expo 2000 in Hanover* by Peter Zumthor with Plinio Bachmann, Karoline Gruber, Ida Gut, Daniel Ott, and Max Rigendinger edited by Roderick Hönig (Basel: Birkhäuser, 2000).
12 *Klangkörper – Der Schweizer Pavillon an der Expo 2000 In Hannover*, Directed by: Bruno Moll. Written by: Bruno Moll, World Premiere: August 2000. Original Version: German, colour, Digi Beta, 52 min. Production: T&C Film AG, ARTE, Schweizer Radio und Fernsehen.
13 Zumthor et al., *Swiss Sound Box*, p. 24.
14 There is some level of interiority maintained with two central stacks and flanked courts where one does not have a view out but otherwise it is possible to see outside when one is within any other stack or courtyard.
15 Zumthor et al., *Swiss Sound Box*, p. 236.
16 Zumthor et al., *Swiss Sound Box*, p. 112.
17 Zumthor et al., *Swiss Sound Box*, p. 236.
18 Zumthor et al., *Swiss Sound Box*, p. 143.
19 Zumthor et al., *Swiss Sound Box*, p. 182.
20 Zumthor et al., *Swiss Sound Box*, pp. 182–183.
21 Sven Sterken, "Music as an Art of Space: Interactions between Music and Architecture in the Work of Iannis Xenakis" in *Resonance: Essays on the Intersection of Music and Architecture*, Volume 1 edited by Mikesch W. Muecke and Miriam S. Zach (Culicidae Architectural Press), p. 38.
22 Zumthor et al., *Swiss Sound Box*, p. 45.
23 Zumthor et al., *Swiss Sound Box*, p. 23.
24 Zumthor et al., *Swiss Sound Box*, p. 166.
25 Zumthor et al., *Swiss Sound Box*, p. 166.
26 Marc Treib's discussion of the design process in *Space Calculated in Seconds* makes this quite apparent.
27 Zumthor et al., *Swiss Sound Box*, p. 157.
28 Zumthor et al., *Swiss Sound Box*, pp. 157–160.
29 Zumthor et al., *Swiss Sound Box*, p. 164.
30 Zumthor et al., *Swiss Sound Box*, p. 193.
31 Zumthor et al., *Swiss Sound Box*, p. 194.
32 Stephen Grabow, "Frozen music: the bridge between art and science" in the *Companion to Contemporary Architectural Thought*, edited by Ben Farmer and Hentie Louw (London: Routledge, 1993) p. 440.

5

SPACE OF REPRESENTATION

The Generative Maps of
Perry Kulper and Smout Allen

"That's another thing we've learned from your Nation," said Mein Herr, "map-making. But we've carried it much further than you. What do you consider the largest map that would be really useful?"

"About six inches to the mile."

"Only six inches!" exclaimed Mein Herr. "We very soon got to six yards to the mile. Then we tried a hundred yards to the mile. And then came the grandest idea of all! We actually made a map of the country, on the scale of a mile to the mile!"

"Have you used it much?" I enquired.

"It has never been spread out, yet," said Mein Herr: "The farmers object: they said it would cover the whole country, and shut out the sunlight! So we now use the country itself, as its own map, and I assure you it does nearly as well. Now let me ask you another question. What is the smallest world you would care to inhabit…?"

<div align="right">Lewis Carroll "Sylvie and Bruno Concluded"</div>

In that Empire, the Art of Cartography attained such Perfection that the map of a single Province occupied the entirety of a City, and the map of the Empire, the entirety of a Province. In time, those Unconscionable Maps no longer satisfied, and the Cartographers Guilds struck a Map of the Empire whose size was that of the Empire, and which coincided point for point with it. The following Generations, who were not so fond of the Study of Cartography as their Forebears had been, saw that that vast Map was Useless, and not without some Pitilessness was it, that they delivered it up to the Inclemencies of Sun and Winters. In the Deserts of the West, still today, there are Tattered Ruins of that Map, inhabited by Animals and Beggars; in all the Land there is no other Relic of the Disciplines of Geography.

<div align="right">Suarez Miranda,Viajes de varones prudentes, Libro IV,Cap. XLV, Lerida, 1658
Borges "On Exactitude in Science"</div>

Based on an earlier writing by Lewis Carroll, this well-known extract by Borges from the short story "On Exactitude in Science" about the art of cartography

and the role of maps, while overtly referring to scale alludes to broader issues of representation and reality in addition to engaging and occupying representational space. Both narratives point to questions of spatial abstraction and the role of representation that is instrumental in creating it. These aspects become pronounced when it comes to architecture and it is this that the chapter focuses on. It examines mapping as a mode of representation, its role in the construction of the design brief and ultimately design generation. What is perhaps of significance to note at least for the purpose of this discussion is that the act of mapping suggests translation – translation from a phenomenon into visual abstraction. How this translation occurs is, therefore, critical when mapping is the apparatus through which design is generated.

Notations (symbols) and indexes are integral to this technique so Peirce's well-known categories of the sign directly apply to the act of mapping. Using symbols and indexes to depict patterns and relationships between elements in space, mapping has often been used to suggest ordering, classification, and revealing the invisible or comprehending the incomprehensible. As a mode of representation that uses notational systems, mapping when deployed in architectural drawing would be what Nelson Goodman would call allographic. Goodman in his distinction between the allographic and autographic arts discusses the unusual nature of architecture which has aspects of both: "The architect's papers are a curious mixture," he writes, further stating that "the specifications are written in ordinary discursive verbal and numerical language. The renderings made to convey the appearance of the finished building are sketches."[1] This unusual mixture makes certain architectural representations particularly interesting, since, for Goodman, it is the codified nature of graphic information present in architectural drawings that make them allographic in nature. This make mapping as a technique that influences design that has become more prevalent in last few decades particularly fascinating. This is apparent when one considers the creative use of data mapping in MVRDV's work or FOA's mapping of programmatic usage and spatial flow that inform the Yokohama Terminal design. My interest in this chapter is to examine certain drawings used in architectural design wherein the technique of mapping as a design tool seems specifically apparent. The notion that mapping is integral to design is especially prevalent in the writing of certain designers such as James Corner who stresses that, "the very basis upon which projects are imagined and realized derives precisely from how maps are made," further elaborating that "mapping is perhaps the most formative and creative act of any design process, first disclosing and then staging the conditions of the emergence of new realities."[2] It is this construction of "new realities" that makes this representative tool especially significant in design formulation. So the question becomes, how does mapping become a generative process? What is it in the representative tool kit of techniques that lends itself to mapping being generative?

Mapping as an act of visual translation could be in terms of specific information, site data, programmatic issues, or other analogical and metaphoric

aspects that are directly significant to context and program. This act of translation makes it an important generative tool in design. In this chapter, I make the case that Constant Nieuwyenhuys' collage-like New Babylon maps are certainly generative; Perry Kulper's drawings, I argue, can be considered as metaphorical maps that are instrumental in generating a design brief; Smout Allen's projects *Panorama Landmarks* and *Retreating Village* which transform architecture to an instrument of registering and mapping the landscape are almost a manifestation of the Carroll and Borges story, and finally, Lebbeus Woods' project, *System Wein*, is an enactment of a map.

Collage vs Montage Maps

Situationists treated maps as terrains for exploration that were appropriated and operated upon to give a new understanding of the city. This is evident in the now famous cut-up collage maps created by Debord and Jorn of Paris highlighting "psychogeographic" sites. The aim of these collage maps was to question the status-quo and deliberately distort the conventional understanding of the city. In a similar manner, Constant Nieuwyenhuys' New Babylon collage maps rearrange and reorder the existing city into a new city. The symbolic representation of New Babylon has cut-out sectors from maps of various cities in Europe that are overlapped and form ring-like entities which are connected by lines around a center. Overlapped gray boxes go across the collaged maps like connectors between the pieces.

The collage maps of New Babylon have all the notations of conventional maps since they are created from individual parts of existing maps to form a new whole that becomes the register of new ideas. This representational space has been called, "a calculated assault on disciplinary limits, and drawing is a key part of that arsenal."[3] While initially the drawings explored the spaces that had been generated, according to Wigley, as more collage techniques were added to these drawings, new kinds of spaces had been generated within them.[4] So while the use of maps was significant, it was the technique of collage that was instrumental in the generation of new kind of spaces and therefore, it is the transformation into collage maps that is important for design generation.

The representation technique of collage complements the idea of play that is embedded in the continual changes that the inhabitants of New Babylon could make within their architectural environment and naturally alters how one views the maps. The collage maps transform the understanding of this project from being viewed as a stable condition (that is almost crystallized and static) to depicting effects that are already present and would be in a continuously evolving condition. The New Babylon maps provide a structure or frame for a combinatorial game and a snapshot at a moment in time:

> The inhabitants drift by foot though the huge labyrinthine interiors, perpetually reconstructing every aspect of the environment by changing the

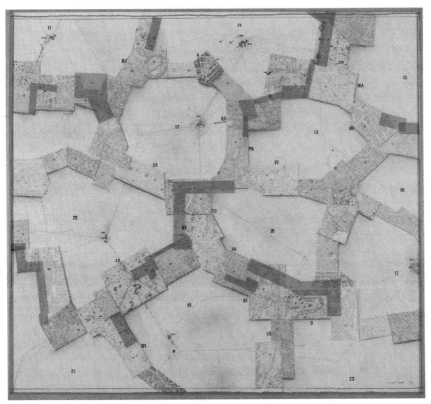

FIGURE 5.1 Constant Nieuwyenhuys, Symbolische voorstelling van New Babylon [Symbolic representation of New Babylon], 1969 (collage 48$\frac{1}{16}$ × 52$\frac{3}{8}$ in. Gemeentemuseum, The Hague)

lighting and reconfiguring the mobile and temporary walls. For this *homo ludens*, social life becomes architectural play and the multiply interpretable architecture becomes a shimmering display of interacting desires – a collective form of creativity, as it were, displacing the traditional arts altogether.[5]

This description is very much like a combinatorial game that points to a living map which is not frozen in representation but is constantly evolving. For Wigley this "blurriness" of what actually happens within the living space, an undefined indeterminacy seen in Constant's models and drawings, is set against the exacting and specific demonstrations of how the space is made possible. He writes, "inside, things are always blurry... Constant continually blurs both the play of desire, which cannot be specified without blocking it, and the support of that play, which cannot be represented without it being mistaken for frozen play."[6] The collage technique used in Constant's mapping highlights juxtapositions of materials and fragmentary conditions this is seen in the etched plastic and acrylic pieces with symbolic notations that are deployed in some

representations. The use of different traditional maps as well as other means of representation give the sense of various possibilities and project a sense of multiplicity of experiences as well.

With the New Babylon maps, one observes individual pieces that use conventional maps which have notational techniques that are essentially allographic nature but it is the nature of the overall composition using the collage technique that makes this generative mapping autographic. Constant's collage is another way of considering mapping that combines and exhibits information simultaneously, whether layered, or fragmented. The visual synchronicity – a simultaneous manner of revealing and juxtaposing information – seen in Constant's representations seems to be a hallmark and a significant trigger for design generation in the work of other designers as well.

In contrast to Constant's maps that use the collage technique, James Corner writes about his maps as montages. For Corner, the rhizomatic mapping process that he describes is as "a mode of work integral to collage" and functions "connotatively" which is by suggestion. This process is different to the typical mapping process that for Corner "systematizes its materials into more analytical and denotative schemas. Where mappings may become more inclusive and suggestive, then, is less through collage, which works with fragments, and more through a form of systematic montage, where multiple and independent layers are incorporated as a synthetic composite."[7] According to this distinction, data maps form a closed system that is systematic and analytical, moreover, denotative schemas through a "systematic montage" situate it more towards one end of the spectrum that constitutes disjointed notational systems while connotative schemas that are inherent in the collage technique – an autographic practice – situates it towards the other end of the spectrum. While Corner's distinction between collage and montage maps is accurate, where this distinction gets a little tricky is in the actual separation between denotative and connotative schemas in montage and collage. For instance, even if Corner considers his own work to be more akin to a systematic montage, one finds connotative aspects within it that have metaphorical projective capacities, and, while Corner himself admits that his own maps which subvert the geological maps are "not as open or rhizomatic as they might be owing to their thematic focus,"[8] since to a certain extent these are systematic, and analytical in conveying information, they also reveal connotative schemas. The mode in which they do so is through the employment of three operations: defining the field or geographic conditions, deterretorialization, and reterritorialization.[9] These methods, then, offer new readings in the manner in which cartographic relationships are established and are statements of projective capabilities of mapping. Quite elegant in themselves, one can argue that Corner's own maps are not strictly notational systems but can be considered as artifacts in their own right and in that sense more akin to paintings when considered in the spectrum from disjointed notational systems to dense systems. His maps reveal an interesting mix of the informative and the projective, the connotative and the denotative, the codified and the suggestive.

Maps as a Design Briefs in Perry Kulper's Work

Visual flights of the imagination, Perry Kulper's striking architectural drawings at first glance almost look like paintings. A closer look, however, unveils layers of relational meaning – they come across as maps complete with symbolic notations on the one hand to figurative imagery on the other hand. In Perry Kulper's case, his drawings that have attributes of mapping can be considered a device through which he develops the design brief. Here I'm using the art historian Michael Baxandall's explanation of "charge" and "brief" wherein he says: "The Charge is featureless. Character begins with the Brief."[10] The "charge" essentially refers to the typology or function and it is the local and circumstantial conditions that formulate the design brief. In the projects discussed further, I contend that the creative mapping of conditions becomes a way to develop not only the design "brief" but in some instances, such as the David's Island Project, the "charge" itself. Kulper's drawings have been referred to as a kind of personal cartography.[11] Three projects by Kulper are especially pertinent in this discussion: the David's Island project (drawings made: 1996–97), the Central California History Museum (drawings made: 2001–02, 2009–10), and the Fast Twitch Desert House (drawings made: 2004, 2008, 2010).

The David's Island competition project was an ideas competition without a prescribed program. Formulating the design brief was therefore an integral component of the representations. Historical events, indigenous populations, earlier building typologies and programs that occurred on the island, as well as the natural environment and geographical features, are all important features that are mapped. Drawings for this project therefore are distinctive mappings that constitute a layered construction, which registers various features, events, and significant landmarks of the island. To this system of layering there are also layers of photographs of found images and text. In addition, Kulper uses a combination of codified military and nautical cartography and notational systems that construct and question theoretical and ideological relations such as the very boundary and margins of events, ideas, and site. For him all aspects that are important to formulate both the design charge an brief are embedded in the construction of these collage drawings, including essential features of the site in terms of history, experience, and projected purpose,

> the islander's experience of remoteness and isolation, the propagation of maritime mythologies and folklore, the manifestations of successive insurgencies and divergent occupations, the cultural import of drift, migration and transience, the latent potential for constructed inundations, the real and imagined sensing of suppressive scopic (panoramic and panoptic) regimes, the representational practices and influences of nautical cartography, the prospective elusiveness of nocturnal ephemera and the literal and strategic deployment of military jargon,

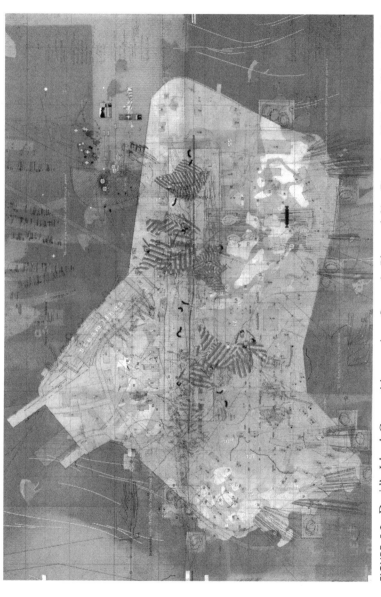

FIGURE 5.2 David's Island Competition project, Strategic Plot and Site Drawing, 1996–97, (24 × 36 in, materials: Mylar, x-rays, assorted found imagery; cut paper, foil, transfer letters, transfer film, tape, graphite, ink, courtesy Perry Kulper)

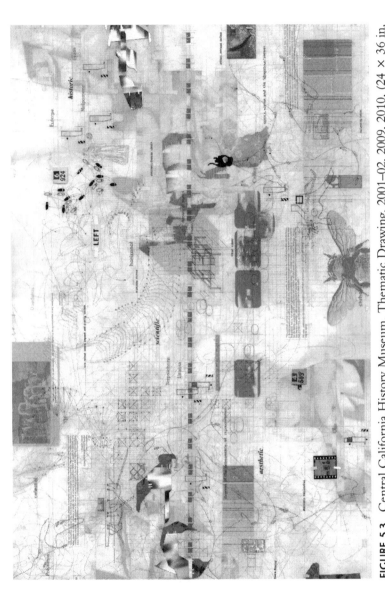

FIGURE 5.3 Central California History Museum, Thematic Drawing, 2001–02, 2009, 2010, (24 × 36 in, materials: Mylar, assorted found imagery, cut paper, acetate, transfer letters, tape, graphite, ink, courtesy Perry Kulper)

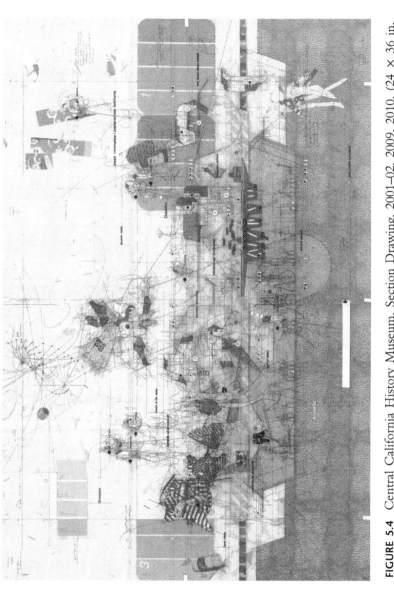

FIGURE 5.4 Central California History Museum, Section Drawing, 2001–02, 2009, 2010, (24 × 36 in, materials: Mylar, assorted found imagery, cut paper, acetate, transfer letters, tape, graphite, ink, courtesy Perry Kulper)

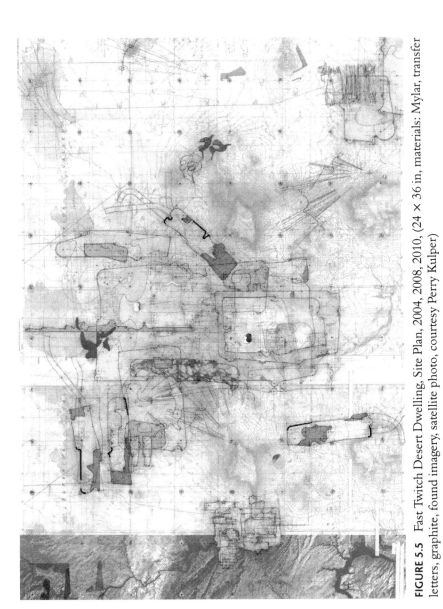

FIGURE 5.5 Fast Twitch Desert Dwelling, Site Plan, 2004, 2008, 2010, (24 × 36 in, materials: Mylar, transfer letters, graphite, found imagery, satellite photo, courtesy Perry Kulper)

Further stating that,

> a number of specific tactics are initiated, primarily through drawing. The Strategic Plot oscillates between concrete spatial proposals and notations for further development. One can inhabit and even get lost in various within different parts of the drawing, each part of the space of the representation generating its own story. The combination of different techniques of representation in the form of more disjointed ones, such notations, words, and more figurative ones that include photographs, and figurative drawings, that come together helps create these individual narratives that relate to each other, but at the same time can trigger their own individual narrative. Representational borders are opened with the hope of sustaining a more fluid ideological, critical and material amalgamation.

The very reference to the drawing as a "strategic plot" in itself is quite telling in that the plot signifies the manner in which the story is constructed and planned. It marks, lays out, and locates the underlying story but there is also another side to this meaning, that of intrigue and secrecy. While in Kulper's case it is the construction of the map, planning, and marking that creates the design brief and identifies where interventions are possible, there is an intrigue to uncovering and reading the layers to discover potential relationships. Here it also constructs and reveals the charge and develops the design brief.

There are some similarities in the approach and techniques of the David's Island drawings with the thematic drawing of Central California History Museum, especially when it comes to the construction of a layered collage and the use of notations. In this project multiple notational systems are employed that range from dance notations to scientific and architectural ones. It includes words, numbers, images, hieroglyphic characters, optical spectrums, repetitions, as well as classificatory systems. References and inspirations from mythology take the form of images and words. In this project there is a more analogical relation and metaphorical connection made between what is represented and conceptual ideas.[12] The density of information in the form of both discursive and presentational systems is suggestive of the varied features at play in the formulation of a design brief. Kulper, in his short description of this project, specifically alludes to the techniques of representation saying: "This way of working emerged as a way to circumvent a "crisis of representational reduction", lodged in many traditional architectural drawings. There is an effort in the making of the drawings to broaden the bandwidth of understanding about the content and structural make up of the proposal and an attempt to develop particular representational techniques appropriate to the phase of development of the work."[13] This "broadening of bandwidth" leads to "thick" drawings where layers of information translated visually augment patterns of relationships, creating a complex web of maps. In a sense, these maps become metaphorical spaces from which the design brief is constructed.

At first glance the Fast Twitch Desert Dwelling comes across as an elaborate mapping of an archeological dig complete with the surveyor grid, topographical contours, and aerial photographs of the landscape. Overlaid are mechanical drawings that seem to be inner workings of an instrument. This at a zoomed-out level also gives an impression of an archeological map showing vestiges of architectural ruins. Similar to the drawings Central California History Museum analogic references are an important part of this layered collage. Mapping in this case alternates between the registrations of the real landscape and that of the analogical mental landscape of metaphors.

In the description of Central California History Museum, Kulper uses the term "thickened surface." This term is particularly apt, not just conceptually but also perceptually and in terms of material qualities embedded within the drawings. The thematic drawings reveal the architect as a bricoleur and the heterogeneous expanse of tools and materials that are juggled in order to construct a layered collage underlying which one can see mapping as the organizing force that creates the patterns of relationships. For instance, in the strategic plot, it is not just the manner in which site information is mapped that does not seem to follow the norms of traditional mapping, but the mode in which it is layered that is unique. Instead of the more typical maps that refer to a concrete and real landscape, Kulper's drawings seem to project a more imaginative and invisible landscape and in the process create an interesting amalgam of the existing visible, the inaccessible invisible, and the projected imaginative. As artifacts in their own right they reveal a material palette that is a construction ranging from Mylar, graphite, ink, tape, found imagery, x-rays, foil, photographs, transfer letters, transfer film, and cut paper. In terms of techniques employed they run the gamut of manual to digital, and with respect to operations of representation they are combination of notational (symbols and text), indexes, images, traditional architectural drawing conventions, as well as mapping techniques. All of this lends a multiplicity of meaning to the work and transforms representation from being strategically framed communicative to being generative – an act that Kulper identifies as, ""local" "ecologies of potential" [that] emerge from this choreography, teasing out spatial possibilities from the drawings."[14] These drawings are not meant to be read as "building," rather they are more akin to modes of thinking wherein site data is layered with conceptual ways of developing the brief – non-linear lateral thinking that is so significant in design formulation. These works are both denotative and connotative. If one considers these with respect to Nelson Goodman's dense and discrete systems, Kulper's representational space, while using attributes of mapping, is unlike a discrete notational system of communication as in technical or instructional drawing but is a dense system that is autographic in nature. The act of layering is indicative of the transformation of material processes as well, and with the density of layering gives the maps a textured quality.

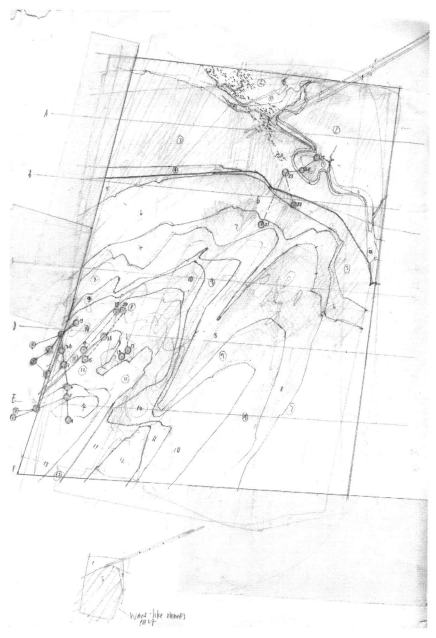

FIGURE 5. 6 Map revealing the slow shifting form of the dune landscape (courtesy Smout Allen)

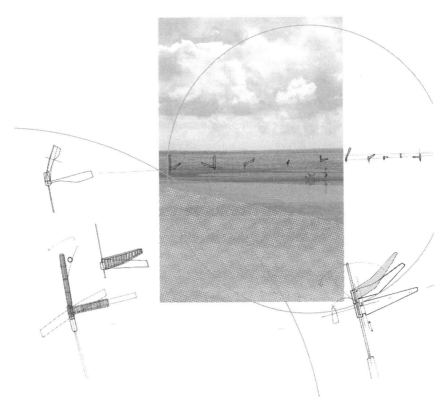

FIGURE 5. 7 Longshore drift, wind and tide is registered momentarily by markers placed in the intertidal zone (courtesy Smout Allen)

Architecture as Instruments of Denotation in Smout Allen's Projects

Giving a sensibility of kinetic instruments, Smout Allen's representations come across as instruments of mapping landscape and space. In fact, in an article that discusses the role of visual representation in their research and design inquiry, Mark Smout writes about the unique role that instruments play with respect to the occupation and experience of the horizon, specifically discussing three ballistic instruments that were designed by their firm.[15] One can observe ideas that migrate from these instruments to some of their *Panorama Landmarks* projects quite explicitly.

Two projects, "Dunes and Drift" and "Dunstable Downs Kite Farm" from the four *Panorama Landmarks* that share similarities of concept and representation, are especially fascinating when we consider the denotative capacity of maps as markers that register the changes in the landscape. Here architecture is more akin to instruments in landscape that map unseen forces and unstable landscapes. Both projects work with architecture as markers of

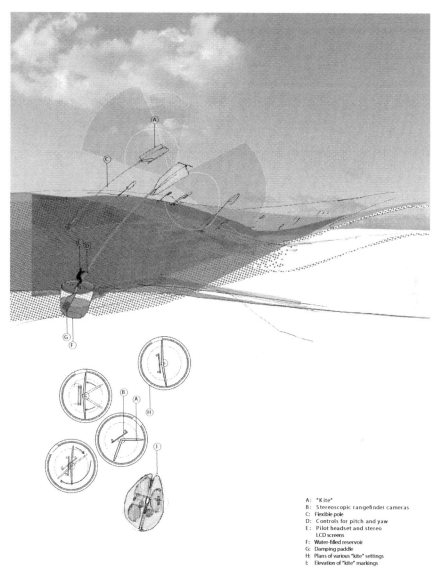

A: "Kite"
B: Stereoscopic rangefinder cameras
C: Flexible pole
D: Controls for pitch and yaw
E: Pilot headset and stereo
 LCD screens
F: Water-filled reservoir
G: Damping paddle
H: Plans of various "kite" settings
I: Elevation of "kite" markings

FIGURE 5.8 Dunstable Downs Kite Farm and plan diagrams of the "trimming of the sails" (courtesy Smout Allen)

the landscape almost like a surveyor's grid. In Dunes and Drift, the Norfolk coast drift markers are not stationary but transform themselves to register the shifting sea and wind. The upper wing reacts to the wind while the instrument acts as a rudder in the lower part responding to the shifting tide. Within the dunes too are markers that take the form of a tub which is revealed or hidden depending on the variation of sand that forms the dunescapes. In addition, they create a temporal marking with their usage when holidaymakers uncover the tub that holds a deck chair, a picnic rug, a shelter, and a cricket bat.[16]

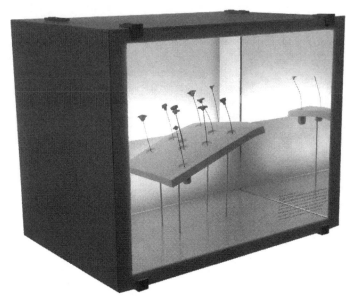

FIGURE 5.9 Model, Dunstable Downs Kite Farm (courtesy Smout Allen)

Shelters are environmental markers and register environmental conditions such as temperature fluctuations and UV light and thus work as instruments that record and can be deployed to create new maps. The Dunstable Downs Kite Farm shares similarities with Dunes and Drift. It takes advantage of wind currents created by the topography of Dunstable Downs. In this project, Smout Allen create markers in the landscape that they call "kites" – instruments that record the thermal movement as it rises from the plane. They describe the mechanism of these kites as being

> connected to the ground by a flexible pole. They are anchored to a pivoting base that is mounted in a water-filled reservoir to limit and slow movement. A pair of cameras mounted on each kite relays stereoscopic live images to the pilot's viewpoint, providing a three-dimensional panorama from the perspective of the kite. As the horizon appears to hover and glide, the pilot achieves the sensation of flying.[17]

The kites thus create a live performative map of the environmental conditions that would have otherwise been invisible to the naked eye while at the same time can actually record and transmit this data to create a new map in terms of data gathering which can be translated in visual representation. While both these projects encompass quite substantial geographical areas, the architectural design itself has a light touch when it comes to the representations and in terms of the actual footprint of individual elements that I refer to as markers on the landscape. It is through the repetition of these that maximum

impact is created and the landscape is controlled so to speak. Architecture here can be considered as devices that generate spatial mapping.

The manner in which both these projects are represented is quite revealing. There are key drawings with incisive architectural instruments within the landscape that have a pointed but light touch. The use of watercolor-like technique for the overview drawings lends a sense of ephemerality to the surrounding landscape. These drawings also give an overview of the architectural instruments in the panoramic landscape and their position with respect to the horizon. Nevertheless, a majority of drawings for each project are details of the architecture insertions that are technical in nature, very much in the vein of instruments, their construction, and their working. In that sense, they are very much in the vein of instructions of operation and thus allographic in nature. There is a kinetic aspect to these in that they focus on transformations of the instruments. Finally there are the models, which are framed by their careful placement within a box. The architects write that the Landmark boxes, specifically discussing the kites project, are backlit and mirrored "to indicate the panoramic gaze, reflected skies, and the repetition of elements of design." A deliberate symmetry is created with the mirroring so that the repetition of elements that occurs is not random but in fact follows a symmetrical order. The establishment of this ordering can be considered as much of an artifice as the surveyor's grid. The model within the mirrored glass-box also shows the ground plane lifted. The act of raising the ground place reveals the significance of the invisible. Here mapping, that plays such an important role in the design, is not just pertaining to the surface but to the hidden forces below the surface. What is especially telling is the manner in which these models are photographed – all published images show a three-quarter corner view. One would have to imagine that these models are meant to be observed at a level raised from the eyelevel to emphasize the multiplicity of reflections. The raising of the viewing level of the models undoubtedly emphasizes the lifting of the ground plane and the deliberate corner view ensures that only the instruments are reflected on the horizon giving a multiplier effect of an array of markers in the landscape.

Mapping as an analytical tool for documentation as well as design generation is evident in Smout Allen's "Retreating Village" project proposed for the village of Happisburgh on the North Norfolk coast which is gradually eroding with the rising sea levels. This scheme inhabits the disintegrating territory between the sea and what is now land but will be taken over gradually by the sea. The design works such that this village retreats as much as five meters each year by using an artificially created mechanical landscape of pulleys, rails, and other devices that support the new/transforming village and would be instrumental in its movement to safety. The predicted rise of the ocean is registered in the design of the artificial landscape and is apparent quite explicitly in the sectional drawings. Moreover, a careful scrutiny of the design drawings also reveals marks and meters that not only register but also trace the invisible fluctuating nature of the site, making them maps in their own right. The drawings and models of the

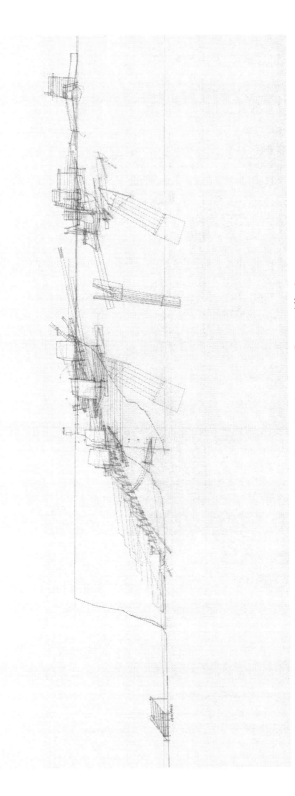

FIGURE 5.10 Cliff section showing repositioning and reconfiguration (courtesy Smout Allen)

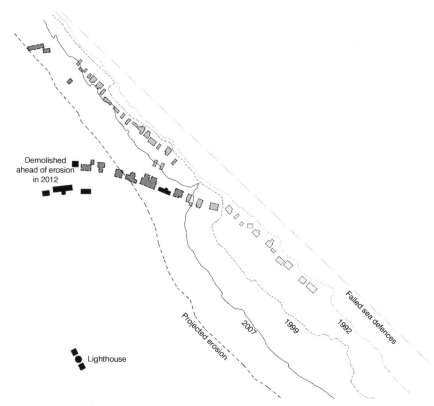

FIGURE 5.11 Map registering the erosion of Happisburgh

village show trajectories and tracings of the settlements prior to disintegration. These mappings become significant markers for the proposed mechanical systems that determine properties and infrastructure. Along with registering the existing environment and the anticipated future, one also identifies a mapping of memories through the representation of ghost structures such as the houses in plan and section. Mapping then is a denotative device to register past, current, and connotative of projected future conditions.

The mechanical landscape that is created by various devices such as pulleys, counterweights, rails, and winches, gives rise to a new operational territory but also preserves existing territory. The design and engineering decisions are determined by the existing deteriorating site conditions and also creating a new map in the process in that the new kinetic landscape that is created by the artifice of the new infrastructural devices holds both the new and the existing settlement. This is an exercise in mapping not only as a design generator but also as an amplifier of memories in the ghosts of earlier forms that are registered through enclosing older and existing forms within the new design. Specific design devices used – faggots, beams and arcs, skids, props, and buoys – are instruments that help safeguard the existing landscape and create a new landscape. They

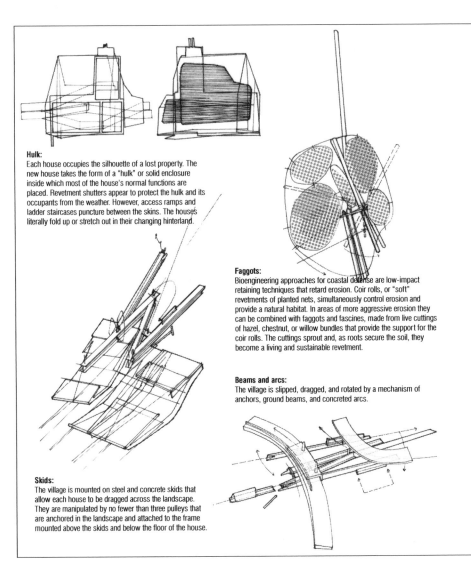

Hulk:
Each house occupies the silhouette of a lost property. The new house takes the form of a "hulk" or solid enclosure inside which most of the house's normal functions are placed. Revetment shutters appear to protect the hulk and its occupants from the weather. However, access ramps and ladder staircases puncture between the skins. The houses literally fold up or stretch out in their changing hinterland.

Faggots:
Bioengineering approaches for coastal defense are low-impact retaining techniques that retard erosion. Coir rolls, or "soft" revetments of planted nets, simultaneously control erosion and provide a natural habitat. In areas of more aggressive erosion they can be combined with faggots and fascines, made from live cuttings of hazel, chestnut, or willow bundles that provide the support for the coir rolls. The cuttings sprout and, as roots secure the soil, they become a living and sustainable revetment.

Beams and arcs:
The village is slipped, dragged, and rotated by a mechanism of anchors, ground beams, and concreted arcs.

Skids:
The village is mounted on steel and concrete skids that allow each house to be dragged across the landscape. They are manipulated by no fewer than three pulleys that are anchored in the landscape and attached to the frame mounted above the skids and below the floor of the house.

FIGURE 5.12 Mechanical devices that create and map the new landscape and built environment (courtesy Smout Allen)

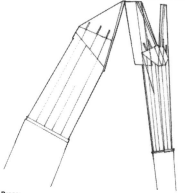

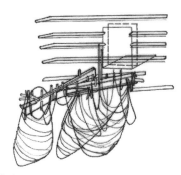

Props:
Temporary timber props strengthen the cliff in critical areas until they are eventually engulfed by the landscape.

Gardens:
Each house travels with a "garden" of rope that reinforces the surrounding soil. These three-dimensionally woven geotextile bags are connected to frames and fed out through "windows" in the revetments. For some villagers the baskets and rope gardens are used as allotments for prize-winning vegetables; for others they provide a personal space for sunbathing.

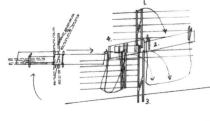

Frame:
The rope gardens are fed out on a counterbalanced ratchet whose equilibrium is interrupted by the movement of the village and the cliff edge.

Buoys:
The sea is populated by a swarm of floats that are flexible and dynamic to allow them to be reconfigured by the waves. The buoys act as beacons for the village to warn of inclement weather.

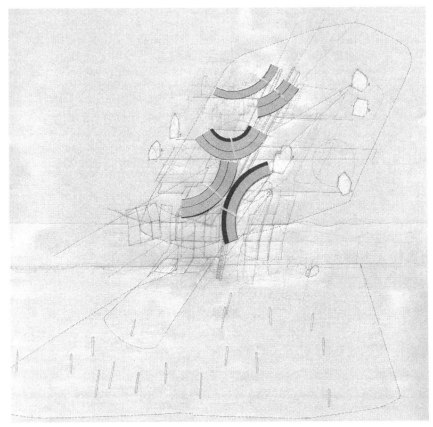

FIGURE 5.13 Beams, arcs and mattresses dominate the landscape; remnants remain of footings and paths that evoke the past life of Happisburgh (courtesy Smout Allen)

thus become instruments that map landscape and register changes within it and at the same time are instrumental in the creation of the new map that also forms the new landscape. So, in a sense, Smout Allen's work brings into focus architecture as an instrument of mapping that is both denotative of the existing but also connotative of the projected new.

In these projects, representations, either drawings that show details or models that show both the details and an overview, focus on the kinetic nature of the architectural instrument and its performance. The kinetic nature of elements also contributes to the sense of impermanence within a constantly changing landscape. The architecture of all three Smout Allen projects does not impress upon the viewer an idea of permanence. On the contrary, there is a deliberate language of transformation and change in the way these projects are designed and expressed. Both Dunes and Drift and the Kite Farm have a light touch in the manner in which they are represented while the Retreating Village "adopts a language of impermanence, of permeable screens, loose-fit structures and

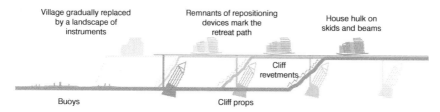

FIGURE 5.14 Diagram showing the mechanical devices that hold and shift the cliff section

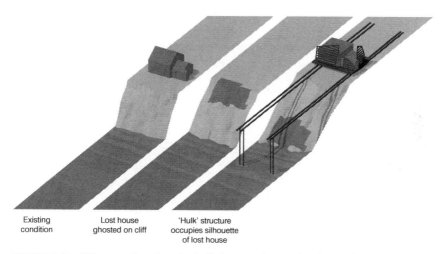

FIGURE 5.15 Diagram showing the hulk houses that evoke the old houses

cheap materials that complement and contribute to the nature of the restless landscape."[18] This constantly changing architecture and infrastructure, and in turn the map itself, is something that is reminiscent of Constant's New Babylon's continuously changing maps.

From Performative to Performance

Lebbeus Woods' collaboration with Christoph Kumpusch in the *System Wien* project,[19] thought by some as a performance art piece, can in fact be seen as a shift from mapping that has more aspects of codification of information to a position where mapping is performance and performance is mapping. He takes invisible forces at play within the city of Vienna and visually concretizes these in drawings that can be considered as having their own internal codification but might seem opaque to the viewer, especially as a translations of information or data. These maps are then enacted within the city.

In this project, the spatial organization of Vienna is seen as "organized energy", which is expressed as lines that the architects call *vectors*. An interesting choice of word in itself since it comes from the Latin *vehere*, which means "to carry" or "to

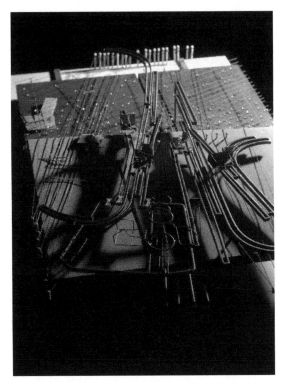

FIGURE 5.16 Model showing traces and trajectory of Happisburgh locked on to the frame of the cliff top (courtesy Smout Allen)

convey", it has an implicit idea of communication either directly or indirectly through social means whether it is a suggestion, gesture, behavior, or appearance. A form of mapping, these vectors are represented on drawings of the city as lines of force. These lines appear in photographs of the city as well, and later become instruments of performance. Woods discusses this performative aspect in terms of kinetic energy of the city:

> The vectors not only express energy, they embody energy. Like other constructive elements used to build the city, they are elements of a system organizing the mechanical, cognitive and affective energy it took to make them, palpable energy that remains potential in their residual forms. If we can see vectors as forms of potential and kinetic energy, then we can see buildings that way, too, and the city itself. If we can see these things not simply as objects, but as embodied energy, then we can see ourselves and others not as material objects, but as living systems interacting continuously with other systems, both animate and inanimate.[20]

A series of collages by Woods are aimed to show what he describes as the "invisible forces" present in Vienna that the architect operates upon in drawings and that

show propositions of activity which are eventually realized through performances within the cityscape. Dancers carrying props that represent vectors enact a live map in the city. The representations span from drawings and photographs of specific sectors in Vienna. These then go through transformations that express abstract vector drawings to photographs of the city and finally dancers within the city that are montaged onto street photographs with vectors and technical details of props that represent the vectors, thus enacting the abstractions of a map in space and reminding one of Lewis Carroll's *Sylvie and Bruno Concluded* and Borges writing "On Exactitude in Science" quoted at the beginning of this chapter.

While operations that push boundaries of traditional mapping are significant in most works discussed in this chapter and constitute an important aspect of projection, it is most instrumental as generative tool in the design formulation. This is especially evident in the work of Constant and Kulpers. With Smout Allen's work, architecture itself becomes a map and an instrument that creates the map, in that it becomes a device that registers, marks, and maps the landscape. While with Lebbeus Woods' *System Wien* project the map is enacted and becomes a performance in itself within the urban environment.

Translations from physical phenomena, visible and invisible features in the landscape, to a representational mode of mapping undoubtedly involves abstraction, while translations of information and data to a visual mode of mapping adds an additional filter. The manner in which this is achieved, in other words the techniques of mapping, is therefore crucial. It is in the construction of "new realities" that particular graphic means have been employed, many of which tend to use notational systems developed over time. These systems of representation, however, erroneously give a semblance of "truthfulness," "neutrality," with the demonstration of technical and scientific knowledge that often obscure the many subjective decision-making tendencies. Nevertheless, how one chooses the data, frames it, and specific techniques of representation that are used to express it, in itself becomes the critical point of translation. There is already an element of a projection involved in how information is denoted thereby creating the initial space of representation. In fact, Corner quite fittingly puts it when he says, "...mappings do not *represent geographies* or ideas; rather they *effect* their actualization."[21] So while selection and framing of data is the first step of the translation process, how it is represented is crucial to the manner in which the problem is formulated, the brief developed for design generation to occur. The role of mapping techniques is important in how spatial meaning is generated, and it is in the projective capacities of the medium that design formulation occurs.

Nelson Goodman, when discussing notational systems in his book *Languages of Art*, writes about music being an allographic art allowing for notation at one end of the spectrum, and painting/sculpture being an autographic art, at the other end of the spectrum, concluding that "architecture is a mixed and transitional case."[22] And while Goodman is discussing the direct relationship with the art form, in the case of architecture this becomes especially murky with drawings being the main mode of production for the end product which is the building. Even within architectural

drawing there are differences: construction drawings, on the one hand, are seen as a set of instructions, which can be replicated much like musical scripts and can be considered allographic in nature; nevertheless, on the other hand, conceptual drawings, such as those of Rossi for instance, while encoding ideas, are more akin to painting and autographic in nature. Keeping this in mind, one can argue that in mapping one tends to use a notational system that according to Goodman is *disjointed*, has *finite differentiation* or *articulation*,[23] and, therefore, could be considered as a discrete system. This is especially true considering that data, which is classified, ordered, and abstract, as in many conventional maps. Nevertheless, the maps discussed in this chapter are not conventional in nature and have the generative capability. These maps fall towards the spectrum of dense systems especially when one considers those that use montage and collage techniques. These are more analogous to the manner in which Goodman discusses paintings and sculpture, the autographic arts. In the examples discussed, the density of visual information that collapses space is in fact more instrumental in a generative sense. At least in the cases that are disscussed in this chapter we can assert that dense systems that are autographic in nature are the ones that are more generative and allow for multiple readings, in a sense, much closer to Deleuze and Guattari's dictum that "a map has multiple entryways."[24] Allographic schemas that use notational systems can be replicated and are wonderful tools of articulation, communication, and clarification, but are not necessarily conducive to the development of design briefs and therefore are not necessarily generative, at least when considered with respect to the cases referred to in this chapter. When it comes to generative notions, it is invariably a combination of multiple attributes that amalgamate to create a dense autographic schema that is important to design formulation.

Mapping as a representational tool absorbs the local and circumstantial conditions, which form an important process from which emergent properties create patterns of relationships and formal structures thereby making the process an important design generator. There is an aspect of displacement and transfer that occurs with representations that were discussed in this chapter. Bruno Latour, in his discussion of immutable mobility, equates this to the metaphorical ability that recombination, reshuffling, and superimpositions allow us to achieve:

> ... since these inscriptions are mobile, flat, reproducible, still and of varying scales, they can be reshuffled and *recombined*. Most of what we impute to connections in the mind may be explained by this reshuffling of inscriptions that all have the same "optical consistency." The same is true of what we call "metaphor." One aspect of these recombinations is that it is possible to *superimpose* several images of totally different origins and scales.[25]

The relational patterns therefore have this metaphorical ability that translates to their generative capability. In that these maps have a projective capacity to "construct something that is yet to come," they are similar to Deleuze's diagrammatic or abstract machine.[26]

Notes

1 Nelson Goodman, *Languages of Art* (Indiana: Hackett, 1976) p. 218.
2 James Corner, "The Agency of Mapping" in Denis Cosgrove edited *Mappings* (London: Reaktion, 1999), p. 216.
3 Mark Wigley, "Paper, Scissors, Blur" in Catherine de Zegher and Mark Wigley edited *The Activist Drawing: Retracing Situationist Architectures from constant's New Babylond and Beyond* (Cambridge, NY, London: The Drawing Center & MIT Press, 2001), p. 37.
4 Wigley, "Paper, Scissors, Blur," p. 33.
5 Catherine de Zegher, "Introduction" in Catherine de Zegher and Mark Wigley edited *The Activist Drawing: Retracing Situationist Architectures from constant's New Babylond and Beyond* (Cambridge, NY, London: The Drawing Center & MIT Press, 2001), p. 10.
6 Wigley, "Paper, Scissors, Blur," p. 50.
7 Corner, The Agency of Mapping, p. 245.
8 Corner, The Agency of Mapping, p. 249.
9 Corner, The Agency of Mapping, p. 231. Here he is using Deleuze and Guattari's discussion of rhizomatic mapping.
10 Michael Baxandall, *Patterns of Intention: On the Historical Explanation of Pictures* (Yale University Press: New Haven, 1985), p. 44.
11 Perry Kulper, "Representing beyond the surface" *Arc CA Drawn Out*, AIACC Design Awards Issue, 05.3, p. 19.
12 In the short description of this project Perry Kulper specifically discusses analogical references that are an inspiration for design such as Japanese kosode, dioramas, and operating theaters. He also writes about "metaphorical potential of varied mythological accounts" that are linked to the cultural roots of museums and to the agricultural region where Fresno is located.
13 In an email describing this project.
14 Kulper, "Representing beyond the surface," p. 18.
15 Mark Smout, "Out of the Phase: Making an Approach to Architecture and Landscape" in *Architecture Design* 78, issue 4, 2008, pp. 80–85.
16 Smout Allen, *Augmented Landscape, Pamplet Architecture 26* (Princeton: Princeton Architecture Press, 2007), pp. 26–29.
17 Smout Allen, *Augmented Landscape*, p. 35.
18 Laura Allen and Mark Smout, "Restless landscapes" conference paper *"In the Making"* (Copenhagen: Interactive Institute/Nordes catalogue & internet publication, 2005), pp. 1–5.
19 Lebbeus Woods, *System Wien*, edited by Peter Noever (Ostfildern-Ruit: Hatje Cantz; New York: D.A.P., 2005).
20 Lebbeus Woods writes about this in his blog: http://lebbeuswoods.wordpress.com/2009/06/05/architecture-of-energy/ Accessed on December 27, 2013.
21 James Corner, "The Agency of Mapping" in Mappings, p. 225.
22 Goodman, *Languages of Art*, p. 221.
23 I'm using notational system following Nelson Goodman in *Languages of Art* and while pictorial systems in his opinion fail on syntactic and semantic ground to be true notational systems, I'm expanding his idea to make a distinction between traditional mapping techniques and the more experimental ones that I have discussed in this chapter. While all types of mapping techniques discussed here would fall in the realm of dense systems and would necessarily be autographic in the Goodmanian sense, I'm trying to differentiate between them to clarify what I think are modes that are instrumental in generative design.
24 Gilles Deleuze & Felix Guattari, *A Thousand Plateaus*, translated by Brian Massumi (Minneapolis: University of Minnesota Press, 1987), pp. 12–13.
25 Bruno Latour, "Visualization and Cognition: Drawing Things Together," in H. Kuklick edited *Knowledge and Society Studies in the Sociology of Culture Past and Present*, Jai Press, volume 6, pp. 19–20.
26 Deleuze & Guattari, *A Thousand Plateaus*, p. 142.

6

SPACE OF MONTAGE

Movement, Assemblage, and Appropriation in Koolhaas' Kunsthal

Movement is a translation of space.[1]

Gilles Deleuze

Typically, when I asked him [Rem Koolhaas] about choosing between cinema and architecture, he replied that the two fields are more alike than they are different. "You are considering episodes, and you have to construct the episodes in a way that is interesting and makes sense or is mysterious," he said. "It's about montage also – whether it's making a book, a film or a building." Whatever the general similarities between the disciplines, it is more interesting to observe that Koolhaas practices architecture in the spirit in which a director makes a film. "It's very scripted, the way people move and the possibilities he leaves for people in his buildings," Vriesendorp points out. "The experiences are laid out. You go up and you have to look where you're meant to look. He sees a space and he sees what could happen – a scene in a space.[2]

From *Rem Koolhaas Builds*

There are always strengths and limitations in exercising analogical similarities between the fields of architecture and film and while similarities and differences between the two media have been wdiely discussed, it is the operation of montage between the two media that becomes truly significant in some of Koolhaas's work. Consider the manner in which Koolhaas introduces the Kunsthal, Rotterdam project in *S M L XL*:

Approach the building from the boulevard. Enter the ramp from the dike. It slopes down from the park. Halfway down enter the auditorium. It slopes in the opposite direction. A curtain is drawn blocking out daylight. At the bottom see a projection screen. Walk down. Turn the corner. Enter the

lower hall, facing the park. It is dark, with a forest of five columns. To the right, a slender aperture opens to a narrow gallery. Look up. Rediscover the ramp you used to enter. Walk up. A glass wall separates the people outside. At the top ...turn left. Enter the second hall. It is bright, with no columns. Look back. Exit under the balcony. See the auditorium, but don't walk that far. Instead, turn and take a third ramp. Halfway up, grope through a small dark room ...and emerge on a balcony that penetrates the second hall. Return to the ramp, run up, and emerge on the roof. Look down. Spiral back down to the beginning. Exit to the park. Pause. Turn the corner. Pass the restaurant underneath the auditorium. Keep going.[3]

The description of the building has a photomontage layout and a simultaneous narrative that runs parallel to the manner in which one would actually experience a walk through the building. It intriguingly reminds one of Choisy's analysis and diagrams of perceptual experience of the Acropolis in *Histoire de l'architecture* that plays such a significant part in Eisenstein's writing on montage and the role of movement in the spatial experience. In fact, Eisenstein called the walk of the Athens Acropolis "the perfect example of one of the most ancient films,"[4] thereby relating the perceptual and peripatetic aspect embedded within architecture and the built environment to film editing techniques.

Eisenstein's discussion of movement and montage drawing on Choisy's walk at the Acropolis is no doubt significant when it comes to any architectural discussion of montage. In this case, montage created by a conceptual juxtaposition of shots to create an elegant sequence – a diachronic spatial unfolding which in turn simultaneously and synchronically creates an assemblage of the architectural experience and enriches our understanding of the Acropolis.[5] The notion of movement is intrinsically related to the idea of path with which Eisenstein starts his discussion of montage and architecture: "the word path is not used by chance," he writes when talking about cinema, "nowadays it is the imaginary path followed by the eye and the varying perceptions of an object

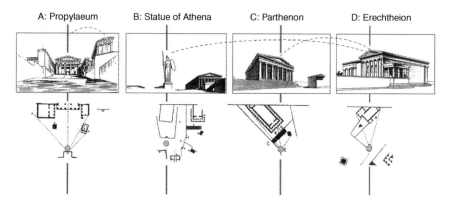

A: Propylaeum B: Statue of Athena C: Parthenon D: Erechtheion

FIGURE 6.1 Diagram based on Choisy's perceptual experience of the Acropolis

FIGURE 6.2 Axonometric of Kunsthal, Rotterdam

that depend on how it appears to the eye. Nowadays it may also be the path followed by the mind across a multiplicity of phenomena, far apart in time and space, gathered in a certain sequence into a single meaningful concept; and these diverse impressions pass in front of an immobile spectator."[6] There are two important issues of note in this statement; the first is the significance of the path, both in a conceptual and physical sense; the second is the multiplicity of phenomena to create a meaningful concept. While Eisenstein borrows the idea of the path from Choisy's architectural discourse, the cinematic path in fact becomes a pronounced feature in architectural discussion, especially with Corbusier's *promenade architecturale* and later with more overt suggestion to cinematic techniques in Tschumi's Manhattan Transcripts and explicit reference to "cinematic promenade" in Parc de la Villette. The second issue, that of establishing a single meaningful concept from a "multiplicity of phenomena," that Eisenstein talks about can be related to Ernst Cassirer's reasoning that the apprehension of a spatial "whole" can be achieved through presupposing the formation of temporal series. In his discussion of symbolic form, Cassirer emphatically states: "form then appears as potential motion, while motion appears as potential form."[7] This idea of experiencing the spatial whole through movement is crucial when considered in relation to Eisenstein's position stated previously when discussing physical and conceptual motion that creates "diverse impressions," perceptual shifts in position to create a "meaningful idea" are particularly of interest when we speak of construction of spatial montage.

For Eisenstein, Choisy's analysis brings to the forefront a particular sequential connection of spatial and formal entities to create an overall comprehensive experience that is comparable to a cinematic montage which is also "a means to 'link' in one point – the screen – various elements (fragments) of a phenomenon

FIGURE 6.3 Circulation of Kunsthal

filmed in diverse dimensions, from diverse points of view and sides."[8] In a sense, sharing similarities to Choisy's architectural experience which is formed through carefully choreographed oblique fragmentary views of discrete building facades that constructs a particular spatial composition of the Acropolis, Koolhaas's sequential layout of Kunsthal in *S M L XL* is comparable to what might be a walk-through experience of the building mainly with a deliberate montage of photographs that are inset into a larger interior experience of each space. In *S M L XL*, in addition to the verbal and photographic description of the walk through the building, one also finds parallel black and white photographs that are either views of the same space or spaces above and below and an intriguing dialogue from Samuel Beckett's *Waiting for Godot* that runs in parallel to the photo-narrative. It is the juxtaposition and tension of various conditions that creates the montage effect in the Kunsthal, much like Eisenstein's description of the montage effect: "when the tension within the movie frame reaches a climax and cannot increase any further, then the frame explodes, fragmenting itself into two pieces of montage." When we consider various aspects of the Kunsthal it initially appears that montage was the driving factor. Consider for instance the diverse structural conditions that come together in this building; the columns in Hall 1 break from the static condition to alternate and form a dynamic experience within the space; structural conditions in individual halls and spaces follows their own logic. Different structural systems that come together to form a whole in the Kunsthal can also be seen as an exemplification of this

FIGURE 6.4 Juxtaposition of structural systems, Kunsthal

FIGURE 6.5 Diversity of columns at the Front Façade, Kunsthal

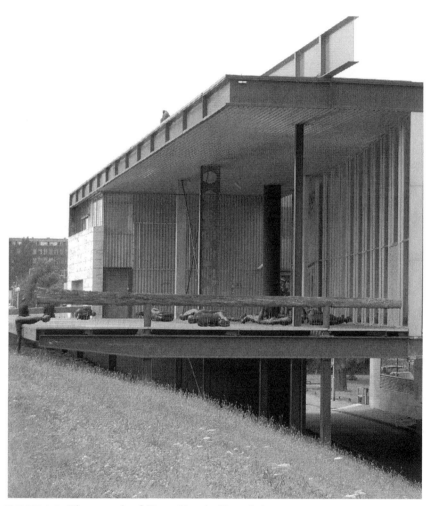

FIGURE 6.6 Photograph of Front Façade, Kunsthal

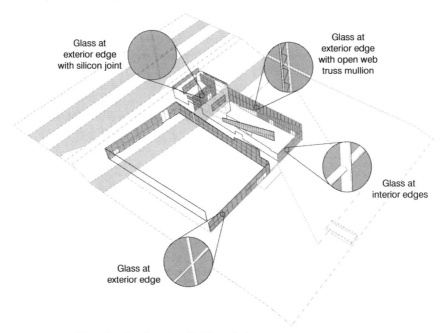

Glass at
exterior edge
with silicon joint

Glass at
exterior edge
with open web
truss mullion

Glass at
interior edges

Glass at
exterior edge

FIGURE 6.7 Variation in glass details, Kunsthal

montage condition. Cecil Balmond in writing on the structure of the thin red line in Kunsthal's Hall 2 says: "Why not structure as an animation that provokes synthesis?" further saying: "Altogether there are four proposals to be made in the Kunsthal: *I: Brace II: Slip III: Frame IV: Juxtaposition*…Strange as it is exciting, raising questions about a bigger adventure, structure *talks* in the Kunsthal. The dialogue is with architecture; one discipline provokes the other."[9] One can make an argument that the choice of the four proposals sets up a dynamic play, each structural system offers a different sensibility and approach to the architectural problem, and each individual one can clearly be identified within the synthetic whole.

Juxtaposition occurs not only at the structural level but also at the material level and quite deliberately so. Some writers have likened this to deliberate "shocks and jolts."[10] A building that can be seen on some level as a commentary on the architectural discourse from the overall spatial organization to materials and details. For instance, Kunsthal's four different column types at the front façade have been pointed out by critics, "four different column types that, in their uniqueness can only be read as quotations from a previous time. A cruciform column, two black square columns, a white square column paired with a flat, white, perforated one."[11] The differences and variations at the level of details with materials are similarly quite telling in this project. While in many buildings one tends to see the repetition of details with certain materials, in the Kunsthal, by contrast, even with seemingly similar material combinations there are differences in details. Consider the manner in which transparent glass is

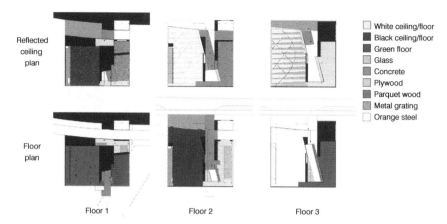

FIGURE 6.8 Material variations – horizontal surfaces, Kunsthal

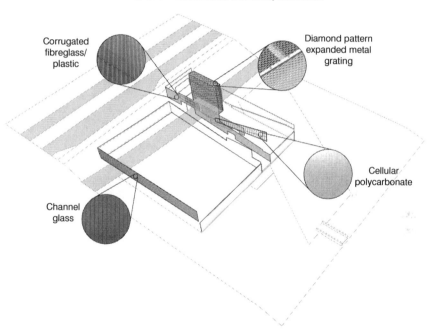

FIGURE 6.9 Material variations – translucent vertical surfaces, Kunsthal

detailed in the Figure 6.7 on the rear elevation it is detailed on one side in the interior plane and on the other side on the exterior plane. On the elevation at the auditorium glass is on the exterior edge with an open web truss mullion, while at the front façade plane it is detailed with a silicone joint at the exterior edge.

What is perhaps of interest in the manner in which montage is employed in Kunsthal is best revealed by a comparison to a discussion of montage by Stan Allen, who in his analysis of Corbusier's Carpenter Center says: "Montage, in other words, is not so much a synthetic mounting of one image on top of another as it is

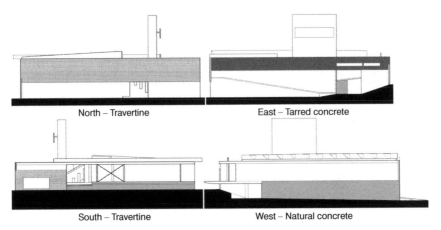

North – Travertine East – Tarred concrete

South – Travertine West – Natural concrete

FIGURE 6.10 Material variations – opaque surfaces elevations, Kunsthal

an analytic that releases a multiplicity of dimensions and simultaneous meanings from a given figure."[12] This idea of montage is evident throughout the Kunsthal especially when one considers the deliberate distillation of modernist history and design. Kenneth Frampton has compared it to Corbusier's unbuilt project Palais des Congrès, Strasbourg, especially when it comes to idea of the *promenade architecturale* and the architectural device that encapsulates it as well as pointing to some other formal similarities.[13] Jeff Kipnis has also compared it to Mies National Gallery in Berlin.[14] Such references with Corbusier and Mies, the two stalwarts of the modernist movement, are not surprising and also present in other projects by Koolhaas. Consider the discrete elevation of each side of the Kunsthal box, unlike most buildings, with the Kunsthal each elevation seemingly belonging to a different building but in this case at one level it alludes to a Miesian pristine box complete with the play on Miesian columns (see southern elevation), at another level, the elevation, instead of putting up a facade, it reveals the section as in the auditorium elevation (see eastern elevation) and is truly "an analytic that releases a multiplicity of dimensions and simultaneous meanings." This analytic release is also obvious in the allusion to the interior curvilinear broken eggshell auditorium of Corbusier's Millowner's Association building that is detailed such that it seems to be floating on the floor through the temporary creation of volume that is created with the drawing of Petra Blaisse's curtain. It is also apparent in the wooden columns of the hall that Frampton points to as alluding to Dalí's paranoid critical method reminiscent of disembodied trees in the park. As in many other architectural projects, columns are the primary actors,[15] the wooden trees, the slanting ones in the auditorium, the play on Miesian ones at the entrance, the circular ones at the ramps, each following their own logic. Much like Tatlin's corner and counter reliefs wherein the compositions were assembled through material fragments, each alluding to their own histories and discourses, the Kunsthal deliberately makes references to specific icons of architectural discourse through certain iconic elements, spatial organization and compositional operations, and material and details. It is important to bear in mind that for Eisenstein, who made the term "montage" synonymous

for a specific technique of film editing, it is also linked to the Russian term for "aesthetic form, obraz (which means 'image' as well), is itself a cross between the concept of 'cut' [obrez] and 'disclosure' [obnaruzhenei]..."[16] so the cuts aimed at revealing connections that in Eisenstein that contribute to the overall meaning, and with Koolhaas, the disclosure is in unveiling connections to other icons of modernism and the architectural discourse in general.

That montage techniques are already present in ancient architecture and its experience is obvious in Eisenstein's use of architectural analogy of Choisy's Acropolis experience, but is there a modern sensibility in the manner in which this is employed in the Kunsthal? The answer might be that the modern sensibility is that of deliberate appropriation. In the Kunsthal, as in some other works by Koolhaas, there is an appropriation of "motifs" that refer to other works whether in the form of the Miesian column or the Corbu auditorium. This modern sensibility of allegorical appropriation and montage as envisaged by Walter Benjamin also became an important dimension with contemporary art production in the twentieth century, as discussed at length by Benjamin Buchloh and therefore that one can see parallels to ideas within architecture should not be a surprise. In fact, for Buchloh, while one sees parallel

> development of a theory of montage in the writings of numerous authors since the late 1910s: Sergei Eisenstein, Lev Kuleshov, and Sergei Tretiakov in the Soviet Union; Bertolt Brecht, Heartfield, and Walter Benjamin in Weimar Germany; and later, Louis Aragon in France. It is the theory of montage as it is developed in the later writings of Walter Benjamin, in close association with his theories on allegorical procedures in Modernist art, that is of significance if one wants to arrive at a more adequate reading of the importance of certain aspects of contemporary montage, its historical models, and the meaning of *their* transformations in contemporary art.[17]

The diversity in material and sensibility of each elevation of the Kunsthal have been likened by some critics to Jean Luc Godard's filmic jump-cut wherein "time between frames vanishes, no longer providing a continuous narrative sequence and momentarily dislocating the viewer with new visual information."[18] Considering that the criteria for jump-cut is generally that there is continuity of viewpoint and discontinuity of duration, in the Kunsthal this is achieved architecturally in its spatial organization and continuity of movement, the dislocation that ensues through assortment of elements such as the column, and also in the variety and manner in materials and details, and the manner in which they occur. The continuous narrative is created by the ramp which is both a formal unifier and a divider that cuts the building into discrete spaces. It can be seen as an apparatus that creates divisions but at the same time becomes a device that weaves these discontinuous conditions. So when Koolhaas writes,

> We would keep the same square as a general envelope. The square would be crossed by two routes: one, the existing road running east–west; the other, a public ramp running north–south, the entrance to both the park and the

Kunsthal. These crossings would divide the square into four parts. The question then became: How to imagine a spiral in four separate squares?[19]

It is through the operatiove device – the ramp. In the Kunsthal the ramp is not just a device that connects you to different areas but is itself part of a heightened spatial experience. Here, the ramp is analogous to a narrative thread in the architecture, a path that leads through disparate experiences of each hall with its own structural system to the finale of the roof garden much akin to what Koolhaas calls: "A story," that "does not have to be told in words, but is simply shown by movement, so that the path has a beginning, and leads somewhere."[20] The ramp in Kunsthal becomes not only the operative device, "the path," but in a way expands and contracts to encompass discrete and discontinuous spaces and become integral to various experiences within the journey and a spiral through four separate squares. Much like the dialogue between the two main characters in *Waiting for Godot*, a text that runs parallel to the verbal description of the movement in *S M L XL*, the photographic layout of the Kunsthal, the cross ramp cuts through the Kunsthal and also weaves spiraling through and navigating spaces within the building. And, much like the characters in the Beckett play who are loitering by the withered tree are waiting for salvation that never comes, meaning in Kunsthal lies in the analytic dimension that refers to other iconic projects and commentaries within the architectural discourse.

Zaum Language and Montage

The choice of selecting and placing the dialogue from *Waiting for Godot*, a play that has been called one of the most important works of the twentieth century, within Kunsthal's photographic walk-through layout in *S M L XL* is especially significant considering that throughout this play there are various instances wherein the dialogue appears disjointed, paradoxical, contradictory, and at times incoherent. In fact, in Act II of the play, Lucky's speech comes across as rambling nonsense language without structure or punctuation, much in the vein of the Russian futurist poet and playwright Khlebniov's "zaum" language. This language that he developed with Kruchonykh originated as a "suprarational" or transcendental language of the future, which they called "zaum" which meant beyond sense (*um* – significance or meaning and *za* – beyond). Creating a language based on the roots of words and sounds indicated by individual letters, they believed that it would forcefully convey emotions as well as abstract meaning and bring to the forefront words and letters as objects that can be manipulated to express meaning. Here vowels were thought in terms of space and time, and construction was understood in material terms and not as timeless abstraction. Montage-like in nature, the sound and structure of words are of paramount importance in this language. The notion that stable sound material could be uncovered beneath the seemingly disorganized surface variety of language is considered by many critics as a vital and immediate contribution to Malevich's Suprematist style of abstract

painting, as well as to the contructivist art of Tatlin. Embedded in these linguistic constructions of assemblage and cutting that Khlebnikov develops are ideas of montage that undoubtedly had an influence on many designers and theorists including Eisenstein's work on montage. In fact, in *Eisenstein, Cinema, and History* James Goodwin quotes Eisenstein in assessing his development through the montage process in *October* where Eisenstein says "methodology has taken precedence over the construction of the work," further stating that,

> Construction is the principle of *Potemkin*, while this innovation in methodology he likens to *zaum*…Rather than a construction of affective meaning, *October's* intellectual montage is a methodology of de-familiarization and re-association intended to demonstrate a logic above the seeming transparency of reified social forms."[21]

Montage and Layered Space in *Zangezi*

As discussed initially with Choisy's influence, the architectural underpinning of Eisenstein's ideas are now common knowledge but what is perhaps less discussed is the possible linguistic impact of the Russian futurist poet and playwright Khlebnikov's work on Eisenstein, including what some scholars have called "the 'montage' effect" of Khlebnikov's works especially the "disjointed structure" as "distinctly reminiscent of the 'shifted' perspective in Cubist paintings."[22] With Khlebnikov's *zaum* language one observes that the montage effect generates simultaneity of meaning that is brought about with the deliberate juxtaposition of disjointed words. The preponderance of phonetic origins of lexicons in his work can also be suggestive of sound montage.

The crystallization of Khlebnikov's work can be seen in a fascinating poem called *Zangezi*. This poem was based on some of his earlier works and has been specifically referred to as having been built on a principle of montage.[23] This work is significant not only due its deployment of montage but due to its architectural dimension the construction of whic has been referred by some to the notion of language as built out of "blocks of space" and "particles of movement".[24] This poem was published shortly before his death in 1922. Often referred to as a "supertale" (sverkhpovest), *Zangezi* exemplifies the languages that connect the universe but has no real plot and action. In its construction it is made out of independent sections; Khlebnikov called it, a "supersaga," and "an architecture composed of narratives." Constructed of twenty different narratives conceived as planes or surfaces (*ploskosti*), each representing languages that form a pattern of relationship in the universe,[25] this poem has been described by its own author as analogous to architecture: "a story is made of words, the way a building is made of construction units," further stating, "equivalent words, like minute building blocks serve as construction units of a story."[26] Each of the 20 sections has a distinct theme, for example, the first three sections are languages of different kinds ranging from that of bird sounds to the language of people, the fourth plane deals with theories of

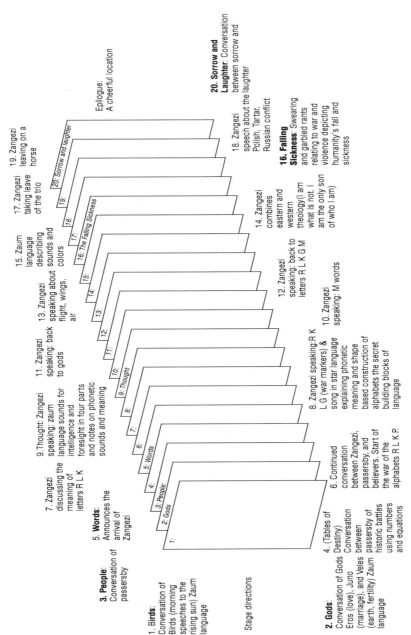

FIGURE 6.11 Compositional diagram of *Zangezi*

historical events in relation to numerical equations, the sixth introduces linguistic and implicit national protagonists with the letters R, L, K, P, G, the seventh one has the war of the alphabets, the eighth has the language of the stars where each letter and sound of the alphabet is in fact an arrangement of points in space, while the last one having the contrast of Laughter and Sorrow is in fact a theatrical metaphor, "a crystallization of all human endeavor in the struggle of Laughter with Death."[27]

At the level of the overall construction each plane works as an individual construct and much like *Zaum* language significance is given to phonetic utterances and meaning attributed to word roots. Many of Khlebnikov's poems play with what can be termed as the "morphological" and the "phonological" structures of language and meaning. He makes frequent use of forms that tend to produce maximum ambiguity, such as neologisms, homonyms, and puns. Montage in terms of cutting and assembling is an inherent part of this process. For Khlebnikov, not only could the structure of a word be examined and its latent meanings laid bare, but also new words could be created on the models of existing ones. Much of his writing, therefore, has to do with texture of language, with poetry as made words.[28] The influence of patterns and tropes from folklore and chants, incantations can be seen throughout this work. In his poems, such as *Incantation by Laughter*, he constructs composite and complicated patterns of modifications of the Russian word for laughter "smekh" by adding prefixes and suffixes that reveal various shades of meaning. What is especially significant in this regard is the repetitive and evolving sounds which are scarcely intelligible. As Milner very aptly says:

> Its repetitive transformations emphasize inexorably the sound of the root word so that this takes precedence over its meaning…This process of referring almost instantaneously from a word's structure to its meaning has been interrupted by Khlebnikov through insistent repetition and through the sequence of shifts in the role and implications imposed upon the root in use…sound then supersedes sense.[29]

The physical structure in a way gives its meaning by creating the sound that is like laughter, therefore focusing attention on the materiality of the word. The deliberate fragmenting, cutting, and an attention to rhythmic aspects of sound can be seen in the works of visual artists and architects. For instance, Tatlin's corner and counter reliefs can be seen as an exemplification of Klebnikov's Zaum language. In *Zangezi*, this strategy is employed in plane VII with consonants, plane VIII with phonetic free and re-associations, and with mystic syllables in plane IX. Not only then can one see montage through *zaum* language within individual planes as in "Plane One: The Birds", but with the deliberate use of earlier poems to create this "supersaga" there is also an element of appropriation, albeit of his own work. An aspect emphasized by some scholars who write: "Zangezi preoccupied the poet from 1920–21, and was "collated and decided" in January 1922," further stating that it was "a summary of Khlebnikov's *oeuvre*, being composed of fragments, many already written, representing not just each of Khlebnikov's genre – lyrical, narrative, theoretical – but every plane of his language…"[30]

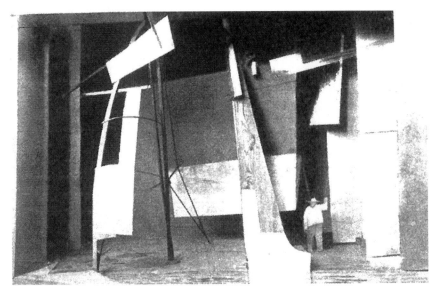

FIGURE 6.12 Vladimir Tatlin's model of the set for *Zangezi*, 1923, whereabouts unknown; shows the twentieth section of the poem with the figure on left representing Laughter and on the right, Sorrow (reproduced from Fülop-Miller, *Mind and Face of Bolshevism*, 1927)

Collage and Set-design for *Zangezi*

Significantly, the theater production of *Zangezi* by Tatlin employs the idea of layering and montage in a very fascinating manner. Not only did Tatlin produce the play, but he also directed, acted, and designed the sets and costumes of *Zangezi* which was performed as a homage to Khlebnikov after his death.[31] The performance was held in conjunction with an exhibition of Tatlin's reliefs and other works emphasizing the link between Khlebnikov and Tatlin's work.[32] The sets were based on Khlebnikov's attitude to words as the expressive elements and the fundamental building units of literary works as evident in Tatlin's writing on *Zangezi*: "the performance of '*Zangezi*' is based on the principle: 'The word is the building unit, the material is the unit of organized space… he [Khlebnikov] looks at the word as plastic material.'[33] The properties of this material make it possible to manipulate it for the building of the 'government of language'. This view of Khlebnikov's gave me the opportunities for working on the production. Parallel to the word structure I decided to introduce a material construct."[34] To focus further on this aspect, a projector was used much like a spotlight to reveal the properties of the material in addition to directing the spectator's attention. Its highlighting of specific areas introduced a certain sense of order and sequence but at the same time the play on the emphasizing areas by focusing light on them could then be understood as a diachronic feature that constructs meaning much like the assemblage of montage shots in a film.

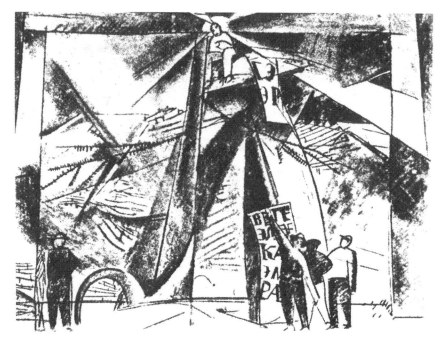

FIGURE 6.13 Vladimir Tatlin's sketch of the set for *Zangezi*, 1923 (reproduced from Fülop-Miller, *Mind and Face of Bolshevism*, 1927)

A closer examination of Tatlin's drawings and few photographs of remaining maquettes of the set design reveal a strong emphasis on layering and overlapping planes assembled of geometric shapes to create a layered effect. This strategy has a direct relationship with Khlebnikov's composition of *Zangezi* that is designed in 20 planes alluding to the title itself which can be translated as "a stack of word planes". The idea of layering is carried further to costume design. The two existing costume designs for Laughter and Sorrow show not only their correspondence with Khlebnikov's description but also an interesting analogy to the set design that is supposed to represent the same plane, i.e. Plane 20. The left part of the set corresponds to the formal aspects of Laughter while the left connects to that of Sorrow. The concave shape on the left with circular wire joining the vertical elements around the center corresponds to the curved profile and the circular with the circular element in the costume design of Laughter; similarly one can trace formal correspondences for Sorrow. The costume designs have a sense of a masque-like quality on the actors, for example, for Laughter, the vertical element connects to the circular wires on one side and the face on the other, similarly for Sorrow the entire ensemble is like a planer wood-like appearance with the face masque. The masque-like appearance adds another dimension of overlapping layers to the already layered sets.

With Khlebnikov having a considerable influence on various artists and architects including Tatlin, it would not be far-fetched to consider the ideas

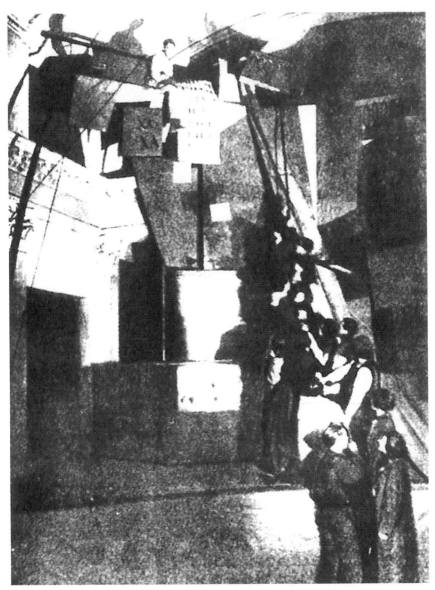

FIGURE 6.14 Vladimir Tatlin in the first performance of *Zangezi,* 1923

of montage in phonetic, linguistic, operational, compositional, and material terms having an influence later on Eisenstein. In fact, Naum Kleiman has attributed to Viktor Shklovsky, the Russian critic and writer who was a close friend of Eisenstein, the statement reminding Eisenstein, "Remember you are the Khlebnikov of Russian film. Do not neglect your task."[35] While Eisenstein identifies Japanese writing being primarily representational as being identified with montage and thereby transferred to the cultural system that also includes

haiku poetry, Sharaku's prints, and Kabuki theater, featuring montage properties and, therefore, cinematographic in nature,[36] it can be probably be directed towards non-representational modes of production such as Khlebnikov's *zaum* language. So while much of the discussion regarding montage has naturally focused on Eisenstein and rightfully so, Khlebnikov's work is quite significant even when it comes to Koolhaas' Kunsthal and it would not be far-fetched to compare Koolhaas' way of alluding to and commenting on Modernist iconic architecture through deliberate use of elements as in the columns, or vestiges of other works in terms of the play of architectural palette, or even material conditions, to Khlebnikov's use of morphological and phonological structures of words and their roots alluding to their meaning and deliberate combinatory conditions to create new words and new meanings.

There are similarities in the composition at the level of the parts and the whole both in the theater production as seen in costume design to set design and in the poem as seen in the assembly of words and the overall composition of planes. One observes quite obvious formal and material similarities between costume and set design of *Zangezi* and Tatlin's corner and counter reliefs that can also be seen in this light and understood as compositions in space that have significant montage operations. So even when Eisenstein compares ideas of montage in architecture and cinema in his discussion of the Acropolis experience as "a montage sequence for an architectural ensemble… subtly composed, shot by shot,"[37] with Koolhaas' work there is obviously a modern sensibility in the manner in which he deploys montage strategies and procedures that in this discussion I relate this to Khlebnikov and Tatlin's work. However, it is in its appropriation of "motifs" or a specific references to a design palate of modernist icons within architecture that one observes what the montage actually achieves – "an analytic that releases a multiplicity of dimensions and simultaneous meanings." Here montage is experienced fundamentally through movement and achieved through appropriation and re-assembly. In a sense, this is reminiscent of Walter Benjamin's discussion of modernity or more appropriately "the modern" through the allegorical appropriation and montage that is present in his analysis of some "motifs" in Baudelaire.[38] Montage then, as a procedure of fragmentation, appropriation, and re-presentation, changes how we experience a work and activates a new space of communication within and across media.

Notes

1 Gilles Deleuze discussing Bergson's theses in *Cinema 1: The Movement – Image* translated by Hugh Tomlinson and Barbara Habberjam (London: Athlone Press, 1986), p. 8.
2 Arthur Lubow, "Rem Koolhaas Builds" in *The New York Times Magazine*, July 9, 2000, p. 7.
3 Rem Koolhaas, Bruce Mau, and Hans Werlemann, *S M L XL* (New York, Rotterdam: Monacelli Press, 1995) pp. 432–465.

4 Sergei M. Eisenstein, "Montage and Architecture" (CA. 1937) with an introduction by Yve-Alain Bois in *Assemblage 10*, December 1989, p. 117.
5 This was initially discussed by John Peponis in a PhD seminar at Georgia Institute of Technology in 1994. See chapter on "Parthenon and the Erection: the spatial formation of space, politics, and myth" in Sophia Psarra, *Architecture and Narrative: The Formation of Space and Cultural Meaning* (London & New York: Routledge, 2009) pp. 19–43.
6 Eisenstein, "Montage and Architecture," p. 116.
7 Ernst Cassirer, *The Philosophy of Symbolic Forms*, volume 1: Language (New Haven: Yale University Press, 1955), p. 100.
8 Sergei M. Eisenstein, "El Greco y el cine" (1937–41), in *Cinématisme: Peinture et cinema*, ed. François Albera, translated by Anne Zouboff (Brussels: Editions complexe, 1980), pp. 16–17.
9 Cecil Balmond, *Informal* (London & New York: Prestel, 2007) pp. 71–72.
10 Veronica Patteeuw, *Considering Rem Koolhaas and the Office for Metropolitan Architecture* (New York: NAi, 2003), p. 59.
11 Cynthia Davidson, "Koolhaas and the Kunsthal: History Lesions" in *ANY*, 21.39.
12 Stan Allen, "Le Corbusier and Modernist Movement: The Carpenter Center for Visual Arts" in *Essays: Practice, architecture technique and representation* (New York: Routledge, 2009), p. 105.
13 Kenneth Frampton, "Rem Koolhaas Kunsthal a Rotterdam" in *Domus* 1993.
14 Jeffrey Kipnis, "Recent Koolhaas" in *El Croquis* 79, 1996, pp. 26–37.
15 See chapter on Danteum in this book.
16 James Goodwin, *Eisenstein, Cinema, and History* (Campaign, IL: University of Illinois Press, 1993), p. 96.
17 Benjamin Buchloh, "Allegorical Procedures: Appropriation and Montage in Contemporary Art," in *Artforum*, Volume XXI No. 1, September 1982, p. 44.
18 Davidson, "Koolhaas and the Kunsthal: History Lesions", 21.39.
19 Koolhaas et al., *S M L XL*, p. 431.
20 Interview with Rem Koolhaas, Interviewer Hilde Bouchez in *A+U*, 2005 no. 4–19, p. 93.
21 Goodwin, *Eisenstein, Cinema, and History*, p. 94.
22 Raymond Cooke, *Velimir Khlebnikov: A Critical Study*, Cambridge Studies in Russian Literature (Cambridge: Cambridge University Press, 2006), p. 23.
23 Robert Leach, *Revolutionary Theatre* (London & NY: Routledge, 1994), p. 154.
24 Krzysztof Ziarek, *The Historicity of Experience: Modernity, the Avant-Garde, and the Event* (Evanston, IL: Northwestern University Press, 2001), p. 193.
25 For example, plane one is the language of birds, plane two is the language of gods, plane three is that of people, then there is the astral language, zaum language, and so on.
26 Velimir Khlebnikov, *The King of Time. Selected Writings of the Russian Futurian*. Translated by Paul Schmidt and edited by Charlotte Douglas (Cambridge: Harvard University Press, 1985), p. 191.
27 Khlebnikov, "To the Artists of the World" in *The King of Time*, p. 190.
28 Khlebnikov, *The King of Time*, p. 13.
29 John Milner, *Vladimir Tatlin and the Russian Avant-Garde* (New Haven: Yale University Press, 1983), p. 12.
30 Donald Rayfield, "Zangezi" in the *Reference Guide to Russian Literature* edited by Neil Cornwell (Oxon, New York: Routledge, 2013), p. 442.
31 This performance took place on 9th May 1923 at the Petrograd Museum of Artistic Culture.
32 Tatlin, while writing about this aspect in his article *On Zangezi* says that "On May 9...a performance+lecture+exhibition of material constructions is taking place." V. Tatlin, "On Zangezi" translated in *Tatlin* edited by Larissa Zhadova (New York: Rizzoli International Publications, 1988).

33 In the introduction of *Zangezi*, a poem written by Velimir Khlebnikov, he writes about the analogous nature of literature and architecture: "a story is made of words, the way a building is made of construction units," further, he says, "equivalent words, like minute building blocks serve as construction units of a story."

34 Vladimir Tatlin, "On Zangezi" translated in *Tatlin* edited by Larissa Zhadova (New York: Rizzoli International Publications, 1988).

35 Nikita Lary writes about this in "Shklovsky: The Good and Awkward Friend" in *Eisenstein at 100: A Reconsideration* edited by Albert J. LaValley, Barry P. Scherr (NJ: Rutgers University Press, 2001), p. 123. In his discussion regarding the support that Shklovsky had been able to give Eisenstein in his theoretical work especially at "one critical juncture; the story comes to us from Naum Kleiman. It was a New Year's Day, 1933. Eisenstein was in no mood to celebrate: he had returned to Moscow following the abrupt termination of the Qué viva México! Project; the script "MMM" had been refused; he had no contracts at a time when others were working. Coming home from a party and passing through the artists' compound in which they both lived, Shklovsky noticed lights on in Eisenstein's apartment, knocked at his door and chided him for staying home. Then Shklovsky added: "Remember you are the Khlebnikov of Russian film. Do not neglect your task.""

36 Yve-Alain Bois, Introduction to Sergei Eisenstein's "Montage and Architecture" in *Assemblage 10*, December 1989, p. 112.

37 Sergei M. Eisenstein, "Montage and Architecture" (CA. 1937) with an introduction by Yve-Alain Bois in *Assemblage 10*, December 1989, p. 117.

38 This modern sensibility of allegorical appropriation and montage as envisaged by Walter Benjamin also become interesting with contemporary art production is discussed extensively by Benjamin Buchloh in "Allegorical Procedures: Appropriation and Montage in Contemporary Art," in *Artforum*, Volume XXI No. 1, September 1982, pp. 43–56.

BIBLIOGRAPHY

Adorno, Theodor W. and Susan Gillespie. "On Some Relationships between Music and Painting". *The Musical Quarterly*, Vol. 79, No. 1, Spring, 1995, pp. 66–79.

Alberti, Leon Battista. *On Painting*. Translated by John Spencer. New Haven, CT: Yale University Press, 1956.

Alighieri, Dante. *The Divine Comedy*. Translation and commentary by Charles Singleton in six volumes. Bollingen Series LXXX, Princeton, NJ: Princeton University Press, 1970.

Alighieri, Dante. *Convivio*. Translated by William Walpond Jackson. Oxford: Clarendon Press, 1909.

Alighieri, Dante. "Epistle to Lord Can Grande della Scala", in Giuseppe Mazzotta's *Critical Essays on Dante*. Translated and published originally in *The Letters of Dante* edited by Paget Toynbee. Boston, MA: G.K. Hall and Co., 1991 [Oxford: Clarendon Press, 1920].

Alighieri, Dante. "Quæstio de Aqua et Terra". Translated by A.G. Ferrers Howell and Philip H. Wicksteed in *A Translation of the Latin Works of Dante Alighieri*. London: J.M. Dent and Sons, 1925.

Alighieri, Dante. *La Vita Nuova*. Translated by Mark Musa. Bloomington, IN: Indiana University Press, 1962.

Allen, Isabel. "Creating Space Out of Text: Perspectives on Domestic Regency Architecture or Three Essays on the Picturesque". *Journal of Architecture* Vol. 2, No. 1, Spring, 1997, pp. 59–82..

Allen, Laura and Mark Smout, "Restless landscapes" conference paper *In the Making*. pp. 1–5. Copenhagen: Interactive Institute/Nordes, 2005.

Allen, Stan. "Piranesi's 'Campo Marzio': An Experimental Design" *Assemblage* Vol. 10, December 1989, pp. 70–109.

Allen, Stan. *Practice: Architecture Technique + Representation*. New York: Routledge, 2009.

Antoniades, Anthony. *Epic Space: Towards the Roots of Western Architecture*. New York: Van Nostrand Reinhold, 1992.

Antoniadis, E.M. *Ekphrasis of Hagia Sophia,* Volumes 1, 2, 3, and Supplement. Athens: B. Gregoriades and Sons, 1983 [original, Athens 1907–1909].

Aristotle. *The Complete Works of Aristotle*. Edited by Jonathan Barnes, Volume 1 and 2, Bollingen Series LXXI*2. Princeton, NJ: Princeton University Press, 1984.

Arnheim, Rudolf. *Visual Thinking*. Berkeley, CA: University of California Press, 1970.

Auerbach, Erich. *Mimesis*. New York: Princeton University Press, 1964.

Bakhtin, Mikhail. *The Dialogic Imagination*. Edited by Michael Holquist, translated by Caryl Emerson and Michael Holquist. Austin, TX: University of Texas Press, 1981.

Bakhtin, Mikhail and Pavel Medvedev. *The Formal Method in Literary Scholarship: A Critical Introduction to Sociological Poetics*. Translated by Albert J. Wehrle. Baltimore, MD and London, Johns Hopkins University Press, 1978 [originally published in USSR in 1928].

Balmond, Cecil. *Informal*. London and New York: Prestel, 2007.

Bann, Stephen and John Bowlt (ed.). *Russian Formalism: A Collection of Articles and Texts in Translation*. New York: Harper and Row, 1973.

Barbi, Michele. *Life of Dante*. Translated and edited by Paul G. Ruggiers. Berkeley, CA: University of California Press, 1954.

Barthes, Roland. *Image—Music—Text*. New York: Hill and Wang, 1977.

Barthes, Roland. *The Responsibility of Forms: Critical Essays on Music, Art, and Representation*. Translated from the French by Richard Howard. New York: Hill and Wang, 1985.

Baxandall, Michael. *Patterns of Intention: On the Historical Explanation of Pictures*. New Haven, CT: Yale University Press, 1985.

Bedard, Jean-Francois (ed.). *Cities of Artificial Excavation: The Work of Peter Eisenman, 1978–1988*. Montreal and New York: CCA and Rizzoli International Publications, 1994.

Benjamin, Walter. *Illuminations*. Edited by Hannah Arendt and translated by Harry Zohn. New York: Schocken Books, 1969.

Berger, John. *Ways of Seeing*. Harmondsworth: Penguin Books, 1972.

Berger, John. *Selected Essays*. Edited by Geoff Dyer. London: Vintage, 2003.

Bergin, Thomas. "Hell: Topography and Demography" in Mark Musa (ed.), *Essays on Dante*. Bloomington, IN: Indiana University Press, 1965.

Bergin, Thomas. *Perspectives on the Divine Comedy*. New Brunswick, NJ: Rutgers University Press, 1967.

Bergson, Henri. *Matter and Memory*. Translation by Nancy Margaret Paul and W. Scott Palmer. New York: Zone Books, 1988.

Birnbaum, Martin. "William Blake and Other Illustrators of Dante" in *Jacovleff and Other Artists*. New York: Paul A. Struck, 1946.

Blake, William. *Illustrations to the Divine Comedy*. London: National Art Collections Fund, 1922.

Bloomfield, Morton Wilfred. *The Seven Deadly Sins*. Lansing, MI: Michigan State University Press, 1952.

Boccaccio, Giovanni. *The Life of Dante [Trattatello in Laude di Dante]* Translated by Vicenzo zin Bollettino. Volume 40 Series B, Garland Library of Medieval Literature. New York and London: Garland Publishing, 1990.

Bonsanti, Giorgio. *The Basilica of St. Francis of Assisi: Glory and Destruction*. Photographs by Ghigo Roli and translated by Stephen Sartarelli. New York: Harry N. Abrams, 1998.

Borges, Jorge Luis. *Labyrinths*. New York: New Directions, 1962.

Borges, Jorge Luis. "The *Divine Comedy*" in *Seven Nights*. Translated by Eliot Weinberger. New York: New Directions Books, 1984.

Borges, Jorge Luis. *Collected Fictions*. Translated by Andrew Hurley. Harmondworth: Penguin Books, 1999.

Borges, Jorge Luis. "The Translators of the Thousand and One Nights" in Lawrence Venuti (ed.), *The Translation Studies Reader*. London and New York: Routledge, 2000.

Botticelli, Sandro. *The Drawings by Sandro Botticelli for Dante's Divine Comedy.* Introduction by Kenneth Clark. New York: Harper and Row and London: Thames and Hudson, 1976.

Brieger, Peter, Millard Meiss, and Charles Singleton. *Illuminated Manuscripts of the Divine Comedy* Volume I: Text, Volume 2: Plates. Bollingen Series LXXXI. Princeton, NJ: Princeton University Press, 1969.

Broadbent, Geoffrey, Richard Bunt, and Charles Jenks. *Signs, Symbols, and Architecture.* Chichester and New York: John Wiley and Sons, 1980.

Bronowski, Jacob. *The Visionary Eye: Essays on Arts, Literature, and Science.* Cambridge, MA: MIT Press, 1978.

Brooke, Peter. *The Empty Space.* New York: Atheneum, 1978.

Bryson, Norman. *Word and Image.* Cambridge: Cambridge University Press, 1981.

Buchloh, Benjamin. "Allegorical Procedures: Appropriation and Montage in Contemporary Art," in *Artforum*, Vol. XXI, No. 1, September, 1982, pp. 43–56.

Burckhardt, Jacob. *The Architecture of the Italian Renaissance.* Translated by J. Palmes. Chicago, IL: Chicago University Press, 1985.

Calvino, Italo. *Invisible Cities.* New York: Harcourt Brace Jovanovich, 1974.

Calvino, Italo. *If on a Winter's Night a Traveler...* New York: Harcourt Brace Jovanovich, 1981.

Calvino, Italo. *Six Memos for the Next Millennium.* Cambridge, MA: Harvard University Press, 1985.

Calvino, Italo. *The Uses of Literature.* New York: Harcourt Brace Jovanovich, 1986.

Cambon, Glauco. *Dante's Craft: Studies in Language and Style.* Minneapolis, MN: University of Minnesota Press, 1969.

Cannon, JoAnn. *Italo Calvino: Writer and Critic.* Ravenna: A. Longo Editore, 1981.

Carroll, Lewis. *The Complete Works of Lewis Carroll.* New York: Barnes and Noble, 2005.

Cassarà, Silvio (ed.). *Peter Eisenman Feints.* Milan: Skira, 2006.

Cassirer, Ernst. *An Essay on Man: An Introduction to a Philosophy of Human Culture.* New Haven, CT: Yale University Press, 1944.

Cassirer, Ernst. *The Philosophy of Symbolic Forms. Volume 1: Language, 2: Mythical Thought, and 3: The Phenomenology of Knowledge.* New Haven, CT: Yale University Press, 1955.

Charlton, H.B. *"Romeo and Juliet" as an Experimental Tragedy.* Annual Shakespeare Lecture of the British Academy. Folcroft, PA: Folcroft Press, 1939.

Choisy, Auguste. *Histoire de l'architecture.* 2 Vols. Paris: Gauthier-Villars, 1899.

Chomsky, Noam. *Syntactic Structures.* The Hague: Mouton, 1962.

Chomsky, Noam. *Aspects of the Theory of Syntax.* Cambridge, MA: MIT Press, 1969.

Chomsky, Noam. *Topics in the Theory of Generative Grammar.* Boston, MA: De Gruyter, 1978.

Cogan, Marc. *The Design in the Wax: The Structure of the Divine Comedy and its Meaning.* Notre Dame, IN: University of Notre Dame Press, 1999.

Cole, Douglas. (ed.). *Twentieth Century Interpretations of Romeo and Juliet: A Collection of Critical Essays.* Upper Saddle River, NJ: Prentice-Hall, 1970.

Comparetti, Domenico. *Virgil in the Middle Ages.* Translated by E.F.M. Benecke. London: Swan Sonnenschein, New York: Macmillan, 1895.

Conant, Kenneth John. *Benedictine Contributions to Church Architecture.* Latrobe, PA: Archabbey Press, 1949.

Conant, Kenneth John. *Carolingian and Romanesque Architecture, 800 to 1200.* Harmondsworth: Penguin, 1973.

Cook, Peter. *Drawing: The Motive Force of Architecture.* (Architectural Design Primer), London: Wiley, 2008.

Cooke, Catherine (ed.). *Russian Avant-Garde Art and Architecture*. London: Academy Editions and Architectural Design, 1983.

Cooke, Catherine. *Russian Avant-Garde: Theories of Art, Architecture and the City*. London: Academy Editions, 1995.

Cooke, Raymond. *Velimir Khlebnikov: A Critical Study*. Cambridge Studies in Russian Literature. Cambridge: Cambridge University Press, 2006.

Corner, James. "The Agency of Mapping: Speculation, Critique and Invention" in Denis Cosgrove (ed.), *Mappings*. London: Reaktion, 1999.

Corner, James (ed.). *Recovering Landscape: Essays in Contemporary Landscape Architecture*. Princeton, NJ: Princeton Architectural Press, 1999.

Cornwell, Neil (ed.). *Reference Guide to Russian Literature*. New York: Routledge, 2013.

Cosgrove, Denis. "Maps, Mapping, Modernity: Art and Cartography in the Twentieth Century," in Martin Dodge, Rob Kitkin, and Chris Perkins (eds), *The Map Reader: Theories of Mapping, Practice and the Cartographic Representations*. Oxford: Wiley Blackwell, 2011.

Croce, Benedetto. *The Poetry of Dante*. Translated by Douglas Ainslie. New York: Henry Holt and Co., 1922.

Croce, Benedetto. *Aesthetic as Science of Expression and General Linguistic*. Translated by Douglas Ainslie. London: Macmillan and Co., 1929.

Curtius, Ernst Robert. *European Literature and the Latin Middle Ages*. Translated from German by Willard R. Trask. Bollingen Series XXXVI. New York: Pantheon Books, 1953.

Davidson, Cynthia. "Koolhaas and the Kunsthal: History Lesions", *ANY*, Vol. 21, 1997, pp. 36–41.

Debord, Guy. "Introduction à une critique de la géographie urbaine," *Les Lèvres Nues*, no. 6 (September 1955) translated by Paul Hammond as "Introduction to a Critique of Urban Geography," in Libero Andreotti and Xavier Costa (eds), *Theory of the Dérive and Other Situationist Writings on the City*. Barcelona: Museu d'Art Contemporani de Barcelona, 1996, pp. 18–21.

Deleuze, Gilles. *Cinema 1: The Movement – Image*. Translated by Hugh Tomlinson and Barbara Habberjam. London: Athlone Press, 1986.

Deleuze, Gilles. *Cinema 2: The Time Image*. Translated by Hugh Tomlinson and Barbara Habberjam. London: Athlone Press, 1989.

Deleuze, Gilles and Felix Guattari. *A Thousand Plateaus*. Translated by Brian Massumi. Minneapolis, MN: University of Minnesota Press, 1987.

de Zegher, Catherine. "Introduction" in Catherine de Zegher and Mark Wigley (eds), *The Activist Drawing: Retracing Situationist Architectures from Constant's New Babylon and Beyond*. New York and Cambridge, MA: The Drawing Center, MIT Press, 2001.

Didron, Adolpe Napoleon. *Christian Iconography: History of Christian Art in the Middle Ages*. Translated by E.J. Millington. New York: F. Ungar, 1965 [London, 1851].

Dinsmore, Charles Allen. *Life of Dante Alighieri*. New York: Houghton Mifflin, 1919.

Duby, Georges. *Foundations of a New Humanism, 1280–1440*. Translated by Peter Price. Geneva: Skira, 1966.

Dunbar, Flanders H. *Symbolism in Medieval Thought*. New Haven, CT: Yale University Press, 1929.

Eagleton, Terry. *Literary Theory*. Minneapolis, MN: University of Minnesota Press, 1983.

Eco, Umberto. "Function and Sign: Semiotics of Architecture", *Via 2*. Philadelphia, PA: University of Pennsylvania, 1973.

Eco, Umberto. *Art and Beauty in the Middle Ages*. Translated by Hugh Bredin. New Haven, CT: Yale University Press, 1986.

Eco, Umberto. *Semiotics and the Philosophy of Language*. Indianapolis, IN: Indiana University Press, 1986.

Eco, Umberto. *Six Walks in the Fictional Woods*. Cambridge, MA: Harvard University Press, 1994.

Eichenbaum, Boris. "The Theory of the 'Formal Method'" in *Russian Formalist Criticism: Four Essays*. Translated and introduced by Lee Lemon and Marion Reis. Lincoln, NE: University of Nebraska Press, 1965 [originally published in 1922].

Eisenman, Peter. "Notes on Conceptual Architecture: Towards a definition" *Design Quarterly*, 1970, pp. 78–79.

Eisenman, Peter. "From Object to Relationship" *Perspecta* No. 13–14, 1971, pp. 36–75.

Eisenman, Peter. *Moving Arrows, Eros and Other Errors: An Architecture of Absence*. London: Architectural Association, 1986.

Eisenman, Peter. "Moving Arrows, Eros and Other Errors" *Precis*, Vol. 6, 1987, pp. 138–143.

Eisenman, Peter. *Giuseppe Terragni: Transformations, Decompositions, Critiques*. New York: Monacelli Press, 2003.

Eisenstein, Sergei M. "El Greco y el cine" (1937–41), in *Cinématisme: Peinture et cinema*. Edited by François Albera and translated by Anne Zouboff. Brussels: Editions Complexe, 1980.

Eisenstein, Sergei M. "Montage and Architecture" (c. 1937) with an introduction by Yve-Alain Bois in *Assemblage*, No. 10, December, 1989, pp. 110–131.

Elrich, Victor. *Russian Formalism: History – Doctrine*. The Hague: Mouton and Co., 1963.

Erskine, John. "Romeo and Juliet" in *The Delight of Great Books*. Indianapolis, IN: Bobbs-Merrill, 1928.

Etlin, Richard. *Modernism in Italian Architecture, 1890–1940*. Cambridge, MA: MIT Press, 1991.

Evans, Blakemore G. (ed.). *The Riverside Shakespeare*. Boston, MA: Houghton Mifflin, 1974.

Evans, Blakemore G. (ed.). *Romeo and Juliet*. Cambridge, MA: Cambridge University Press, 1984.

Evans, Robin. *The Projective Cast*. Cambridge, MA: MIT Press, 1995.

Evans, Robin. *Translations from Drawing to Building*. Cambridge, MA: MIT Press, 1997.

Ferrante, Joan. "A Poetics of Chaos and Harmony" in Rachel Jacoff (ed.), *The Cambridge Companion to Dante*. Cambridge: Cambridge University Press, 1993.

Foucault, Michel. *The Order of Things: An Archaeology of the Human Sciences*. New York: Vintage Books, 1973.

Foucault, Michel. *This is Not a Pipe*. Letters and illustrations by Rene Magritte and translated by J. Harkness. Berkeley, CA: University of California Press, 1983.

Frampton, Kenneth. "Rem Koolhaas, Kunsthal a Rotterdam" in *Domus*, No. 747, 1993, pp. 38–47.

Frank, Joseph. *Through the Russian Prism: Essays on Literature and Culture*. Princeton, NJ: Princeton University Press, 1990.

Frank, Joseph. *The Idea of Spatial Form*. New Brunswick, NJ: Rutgers University Press, 1991.

Frankl, Paul. "The Secret of the Medieval Masons", in *Art Bulletin* Vol. 27, No. 1, 1945, pp. 46–60.

Frankl, Paul. *The Gothic: Literary Sources and Interpretations through Eight Centuries*. Princeton, NJ: Princeton University Press, 1960.

Freccero, John (ed.). *Dante: A Collection of Critical Essays*. Englewood Cliffs, NJ: Prentice-Hall, 1965.

Freccero, John. "The Dance of the Stars: *Paradise* X" in *Dante: The Poetics of Conversion* Cambridge, MA: Harvard University Press, 1986, pp. 221–244.

Freccero, John. "Introduction to Inferno", in Rachel Jacoff (ed.) *The Cambridge Companion to Dante*. Cambridge: Cambridge University Press, 1993.

Frye, Northrop. *Anatomy of Criticism: Four Essays*. Princeton, NJ: Princeton University Press, 1957.

Frye, Northrop. *Fables of Identity: Studies in Poetic Mythology*. New York: Harcourt Brace and World, 1963.

Gamard, Elizabeth Burns. "Virgil/Beatrice: Remarks on Discursive Thought and Rational Order in Architecture". *Journal of Architectural Education*, Vol. 48, No. 3, February, 1995, pp. 154–167.

Gass, William. "Invisible Cities" *Via*, No. 8, 1986, pp. 135–155.

Genette, Gérard. *Narrative Discourse: An Essay in Method*. Translated by Jane E. Lewin. Ithaca, NY: Cornell University Press, 1983.

Genette, Gérard. *Fiction and Diction*. Translated by Catherine Porter. Ithaca, NY: Cornell University Press, 1993.

Genette, Gérard. "Time and Narrative" in Michael Hoffman and Patrick Murphy (eds), *Essentials of the Theory of Fiction*. Durham, NC: Duke University Press, 1996 .

Gervase Mathew. *Byzantine Aesthetics*. London: J. Murray, 1963.

Giedion, Sigfried. *Space Time and Architecture*. Cambridge, MA: Harvard University Press, 1941 [3rd edn. 1954].

Gombrich, Ernst. *Meditations on a Hobby Horse and Other Essays on the Theory of Art*. London: Phaidon, 1963.

Gombrich, Ernst. *The Image and the Eye: Further studies in the Psychology of Pictorial Representation*. Ithaca, NY: Cornell University Press, 1982.

Goodman, Nelson. *Languages of Art*. Indianapolis, IN: Hackett, 1976.

Goodman, Nelson. *Ways of Worldmaking*. Indianapolis, IN: Hackett, 1978, 1984.

Grabar, André. *Christian Iconography: A Study of its Origins*. Princeton, NJ: Princeton University Press, 1968.

Grabow, Stephen. "Frozen Music: The Bridge between Art and Science" in Ben Farmer and Hentie Louw. (eds), *The Companion to Contemporary Architectural Thought*. London: Routledge, 1993.

Guillerme, Jacques. "The Idea of Architectural Language: A Critical Inquiry" Translated by Hélène Lipstadt and Harvey Mendelsohn. *Oppositions*, No. 10, Fall, 1977, pp. 21–26.

Guzzardo, John. *Dante: Numerological Studies*. American University Studies, Series II Romance Languages and Literature Volume 59. New York: Peter Lang, 1987.

Halio, Jay L. (ed.). *Shakespeare's Romeo and Juliet: Texts, Contexts, and Interpretation*. Newark, DE: University of Delaware Press, 1995.

Hall, Michael. *The Structure of Love: Representational Patterns and Structure of Shakespeare's Love Tragedies*. Charlottesville, VA: University Press of Virginia, 1989.

Hart, Clive. *Structure and Motif in Finnegans Wake*. Evanston, IL: Northwestern University Press, 1962.

Hawkes, Terence. *Metaphor*, London: Routledge, 1989.

Hays, K. Michael (ed.). *Architecture Theory Since 1968*. Cambridge, MA: MIT Press, 2000.

Hays, K. Michael. *Architecture's Desire: Reading the Late Avant-Garde*. Cambridge, MA: MIT Press, 2009.

Herding, Klaus and Berhnard Stumpfhaus (eds) *Pathos, Affekt, Gefühl: Die Emotioen in den Künsten*. Berlin: Water de Gruyter, 2004.

Hildebrand, Adolf. *The Problem of Form in Painting and Sculpture*. Translated by Max Meyer and Robert Morris Ogden. New York: G.E. Stechert and Co., 1932.

Hjelmslev, Louis. *Prolegomena to a Theory of Language*. Translated by Francis J. Whitfield. Madison, WI: University of Wisconsin Press, 1961.

Hoffman, Michael J. and Patrick D. Murphy (eds). *The Essentials of the Theory of Fiction*. Durham, NC: Duke University Press, 1996.

Homer. *The Odyssey*. Translated by E.V. Rieu. London: Penguin Books, 1991.

Hopper, Vincent Foster. *Medieval Number Symbolism*. New York: Columbia University Press, 1948.

Horn, Walter and Ernest Born. "The Origins of the Bay System" in *The Plan of St. Gall: A Study of the Architecture and Economy of Life in a Paradigmatic Carolingian Monastery*. Translated by Charles W. Jones. Berkeley, CA: University of California Press, 1979.

Hosley, Richard (ed.). *The Tragedy of Romeo and Juliet*. The Yale Shakespeare. New Haven, CT: Yale University Press, 1964.

Hume, Kathryn. *Calvino's Fictions: Cogito and Cosmos*. Oxford: Clarendon Press, 1992.

Jacoff, Rachel. "Introduction to *Paradiso*" in Rachel Jacoff (ed.), *The Cambridge Companion to Dante*. Cambridge: Cambridge University Press, 1993.

Jakobson, Roman. "On Linguistic Aspects of Translation" in Reuben Brower (ed.), *On Translation*. Harvard Studies in Comparative Literature, 23. Cambridge, MA: Harvard University Press, 1959.

Jakobson, Roman. "On the Verbal Art of William Blake and Other Poet-Painters". *Linguistic Inquiry*, Vol. 1, No. 1, January, 1970, pp. 3–23.

Jakobson, Roman. *Selected Writings. Vol. 2. Words and Language*. The Hague: Mouton Press, 1972.

Jakobson, Roman. "Linguistics and Poetics" in Krystyna Pomorska and Stephen Rudy (eds), *Language in Literature*. Cambridge, MA: Belknap Press of Harvard University, 1987.

Jakobson, Roman and Morris Halle. *Fundamentals of Language*. The Hague: Mouton, 1956.

Jameson, Fredric. *The Prison-House of Language: A Critical Account of Structuralism and Russian Formalism*. Princeton, NJ: Princeton University Press, 1972.

Jay, Martin. "Scopic Regimes of Modernity" in Hal Foster (ed.), *Vision and Visuality*. Seattle, WA: Bay Press, 1988.

Jencks, Charles and George Baird (eds). *Meaning in Architecture*. New York: George Braziller, 1970.

Kanekar, Aarati. "Visualizing the Invisible: A Study of Narrative and Compositional Structure in Calvino's *Invisible Cities*" paper presented at "Contesting Absences: Exploring Unexamined Influences", ACSA West Regional Meeting, 1999.

Kanekar, Aarati. "Diagram and Metaphor in Design: The Divine Comedy as a Spatial Model," *Philosophica*, Vol. 69, No. 1, (Special issue: Diagrams and the Anthropology of Space), 2002, pp. 37–58.

Kanekar, Aarati. "La construction spatiale du sens en architecture: Un projet transdisciplinaire" in *TLE (Théorie Littérature Enseignement)*, 2002, pp. 139–156.

Kanekar, Aarati. "Designing Games: Structure, Playability, and Intelligibility." *Proceedings of the 4th International Space Syntax Symposium*, London: UCL Space Syntax Laboratory, 2003, pp. 25.1–25.16.

Kanekar, Aarati. "From Building to Poem and Back: The Danteum as a Study in the Projection of Meaning Across Symbolic Forms". *Journal of Architecture*, Vol.10, No. 2, 2005, pp. 135–159.

Kanekar, Aarati. "Between Drawing and Building". *Journal of Architecture*, Vol. 15, No. 6, December, 2010, pp. 771–794.

Kanekar, Aarati. "Detours through Autonomy: Mismappings in Translating the Divine Comedy" in *Perspecta,* No. 46, 2013, pp. 262–283.

Keynes, Sir Geoffrey. *Drawings of William Blake.* New York: Dover Publications, 1970.

Khlebnikov, Velimir. *The King of Time: Selected Writings of the Russian Futurian.* Translated by Paul Schmidt and edited by Charlotte Douglas. Cambridge, MA: Harvard University Press, 1985.

Kipnis, Jeffrey. "Recent Koolhaas" in *El Croquis,* No. 79, 1996. pp. 26–37.

Kittler, Friedrich A. *Discourse Networks 1800/1900.* Translated by Michael Metteer. Stanford, CA: Stanford University Press, 1992.

Klein, Robert. *Form and Meaning: Essays on the Renaissance and Modern Art.* Translated by Madeline Jay and Leon Wieseltier. New York: Viking Press, 1979.

Kleiner, John. *Mismapping the Underworld: Daring and Error in Dante's Divine Comedy.* Stanford, CA: Stanford University Press, 1994.

Klonsky, Milton. *Blake's Dante: The Complete Illustrations to the Divine Comedy.* New York: Harmony Books, 1980.

Knoespel, Kenneth. "When the Sky Was Paper: Dante's Cranes and Reading as Migration" in Paolo Cherchi and Antonio Mastrobuono (eds), *Lectura Dantis Newberryana: Lectures Presented at the Newberry Library, Chicago, 1985–87.* Volume II. Evanston, IL: Northwestern University Press, 1990.

Koolhaas, Rem. "Interview with Rem Koolhaas. Interviewer Hilde Bouchez", *A+U,* No. 8, 2005, pp. 90–93.

Koolhaas, Rem, Bruce Mau, and Hans Werlemann. *S M L XL.* New York: Monacelli Press, 1995.

Krautheimer, Richard. *Early Christian and Byzantine Architecture.* The Pelican History of Art. Harmondsworth: Penguin Books, 1965.

Kulper, Perry. "Representing Beyond the Surface", *Arc CA,* Vol. 5, No. 3 (Drawn Out, AIACC Design Awards Issue), 2005.

Kundera, Milan. *Art of the Novel.* Translated by Linda Asher. New York: Perennial Library, 1988.

Lampugnani, Vittorio Magnago. "Gruppo 7" in *Encyclopedia of 20th-Century Architecture.* New York: Harry N. Abrams, 1986.

Landino, Cristoforo. "The Divine Origin of Poetry" in *Critical Essays on Dante.* Translated by John S. Smurthwaite. Boston, MA: G. K. Hall and Co., 1991 [originally published as introduction to *Dante con l'Esposizione di Cristoforo Landino.* Venice, 1564].

Lang, Susanne, "Cosmology and Carthography: The Occident", *Encyclopedia of World Art.* New York: McGraw Hill, 1959.

Langer, Susanne K. *Philosophy in a New Key: A Study in the Symbolism of Reason, Rite, and Art.* Cambridge, MA: Harvard University Press, 1942.

Langer, Susanne K. *An Introduction to Symbolic Logic.* New York: Dover Publishers, 1967 [originally published by George Allen and Unwin, Oxford, 1937].

Lary, Nikita. "Shklovsky: The Good and Awkward Friend" in Albert J. LaValley and Barry P. Scherr (eds), *Eisenstein at 100: A Reconsideration.* New Brunswick, NJ: Rutgers University Press, 2001.

Latour, Bruno. "Visualization and Cognition: Drawing Things Together" in H. Kuklick (ed.), *Knowledge and Society Studies in the Sociology of Culture Past and Present,* Vol. 6, Greenwich, CT: Jai Press, 1986, pp. 1–40.

Lawlor, Robert. *Sacred Geometry: Philosophy and Practice.* New York: Thames and Hudson, 1989.

Le Corbusier. *Modulor.* Facsimile edition. Basel: Birkhäuser, 2000.

Le Goff, Jacques. *The Birth of Purgatory*. Translated by A. Goldhammer. Chicago, IL: University of Chicago Press, 1984.

Leach, Robert. *Revolutionary Theatre*. New York and London: Routledge, 1994.

Lendvai, Ernö. "Duality and Synthesis in the Music of Béla Bartók" in Gyorgy Kepes (ed.) *Module, Proportion, Symmetry, Rhythm*. New York: G. Braziller, 1966.

Lesser, George. *Gothic Cathedrals and Sacred Geometry*. Vols 1 and 2. London: Alec Tiranti, 1957.

Lessing, Gotthold Ephraim. *Laocoön: An Essay on the Limits of Painting and Poetry*. Translated by Edward Allen McCormick. Baltimore, MA, The Johns Hopkins University Press, 1984 [originally published 1766].

Levi-Strauss, Claude. *The Savage Mind*. Chicago, IL: University of Chicago Press, 1962.

Levin, Harry. "Form and Formality in *Romeo and Juliet*" in Alvin B. Kernan (ed.), *Modern Shakespearean Criticism: Essays in Style, Dramatrugy, and the Major Plays*. New York: Harcourt Brace Jovanovich, 1970.

Levy, Gertrude Rachael. *The Myths of Plato*. Hertford, NC: Barnes and Noble, 1970.

Lindberg, David. *Studies in the History of Medieval Optics*. London: Variorum Reprints, 1983.

Lindberg, David and Geoffrey Cantor. *The Discourse of Light from the Middle Ages to the Enlightenment*. Los Angeles, CA: University of California, 1985.

Lodder, Christina. *Russian Constructivism*. New Haven, CT: Yale University Press, 1983.

Logan, J.L. "The Poet's Central Numbers", *MLN*, Vol. 86, No.1, 1971, pp. 95–98.

Lotman, Yury. *The Analysis of the Poetic Text [Analiz poeticheskogo teksta]*. Edited and translated by D. Barton Johnson. Ann Arbor, MI: Ardis, 1976.

Lotman, Yury. *The Structure of the Artistic Text*. Translated by Gail Lenhoff and Ronald Vroon. Ann Arbor: University of Michigan, 1977.

Lotman, Yury and Boris Uspenski. "Binary Models in the Dynamics of Russian Culture" in Alexander and Alice Nakhimvosky (eds), *The Semiotics of Russian Cultural History*. Ithaca, NY: Cornell University Press, 1985.

Lubow, Arthur. "Rem Koolhaas Builds" *The New York Times Magazine*, July 9, 2000.

McLuhan, Marshall. *Understanding Media: The Extensions of Man*. Cambridge, MA: MIT Press, 1994, 1964.

Mahood, M.M. "Romeo and Juliet" in James L. Calderwood and Harold E. Toliver (eds), *Essays in Shakespearean Criticism*. Englewood Cliffs, NJ: Prentice-Hall 1970.

Mainstone, Rowland J. *Hagia Sophia: Architecture, Structure and Liturgy of Justinian's Great Church*. London: Thames and Hudson, 1988.

Mango, Cyril. *The Art of the Byzantine Empire 312–1453: Sources and Documents*. Englewood Cliffs, NJ: Prentice-Hall, 1972.

Mango, Cyril. *Byzantine Architecture*. New York: Harry N. Abrams, 1975.

March, Lionel. *Architectonics of Humanism: Essays on Number in Architecture*. London: Academy Editions, 1998.

March, Lionel and Judith Sheine (eds). *R.M. Schindler: Composition and Construction*. London: Academy Editions, 1993.

Martin, Elizabeth (ed.). *Architecture as a Translation of Music*. Pamphlet Architecture 16. Princeton, NJ: Princeton Architectural Press, 1994.

Mathew, Gervase. *Byzantine Aesthetics*. London: J. Murray, 1963.

Mathews, Thomas F. *The Early Churches of Constantinople: Architecture and Liturgy*. University Park, PA: Pennsylvania State University Press, 1971.

Mazzotta, Giuseppe (ed.). *Critical Essays on Dante*. Boston, MA: G.K. Hall and Co., 1991.

Michelis, Panayotis. *Aisthêtikós: Essays in Art, Architecture, and Aesthetics*. Detroit, MI: Wayne State University Press, 1977.

Milner, John. *Vladimir Tatlin and the Russian Avant-Garde*. New Haven, CT: Yale University Press, 1983.

Mitchell, W.J. Thomas. "Spatial Form in Modern Literature: Towards a General Theory" *Critical Inquiry*, Vol. 6, Spring, 1980, pp. 539–567.

Mitchell, W.J. Thomas. *Iconology: Image, Text, Ideology*. Chicago, IL: University of Chicago Press, 1986.

Mitchell, W.J. Thomas. *Picture Theory: Essays on Verbal and Visual Representation*. Chicago, IL: University of Chicago Press, 1994.

Moore, Edward. *The Astronomy of Dante*. Studies in Dante, 3rd series. Oxford: Clarendon Press, 1903.

Moore, Olin H. *The Legend of Romeo and Juliet*. Columbus, OH: Ohio State University Press, 1950.

Morey, Charles Rufus. "The Genesis of Christian Art" in *Early Christian Art*, 2nd edition, New York: Norton, 1953.

Motte Jr., Warren (ed. and trans.). *Oulipo: A Primer of Potential Literature*. Lincoln, NE: University of Nebraska Press, 1986.

Muecke, Mikesch W. and Miriam S. Zach (eds). *Resonance: Essays on the Intersection of Music and Architecture*. Ames, IA: Culicidae Architectural Press, 2007.

Orr, Mary Acworth. *Dante and the Early Astronomers*. London: Wingate, 1913 [reissued Port Washington, NY: Kennikat Press, 1969].

Panofsky, Erwin. *Meaning in the Visual Arts: Papers In and On Art History*. Garden City, NY: Doubleday, 1957.

Panofsky, Erwin. *Gothic Architecture and Scholasticism*. New York: Meridian Books, 1957.

Panofsky, Erwin. *Idea: A Concept in Art Theory*. Translated by J.J.S. Peake. Columbia, SC: University of South Carolina Press, 1968.

Patteeuw, Veronica. *Considering Rem Koolhaas and the Office for Metropolitan Architecture*. New York: NAi, 2003.

Paz, Octavio. *The Other Voice: Essays on Modern Poetry*. New York: Harcourt Brace Jovanovich, 1990.

Peirce, Charles Sanders. *Collected Papers of Charles Sanders Peirce*. Edited by Charles Hartshorne and Paul Weiss. Cambridge, MA: Harvard University Press, 1960.

Pennick, Nigel. *Sacred Geometry: Symbolism and Purpose in Religious Structures*. San Francisco, CA: Harper and Row, 1982.

Peponis, John. *Descriptions of Space: The Architectural Formation of Meaning*. Athens: Alexandria Editions, 1997.

Peponis, John. "Spatial Construction of Meaning: Formulation". *Journal of Architecture*, Vol. 10, April, 2005, pp. 119–133.

Pike, Burton. *The Image of the City in Modern Literature*. Princeton, NJ: Princeton University Press, 1981.

Piranesi, Giovanni Battista. *The Polemical Works*. Edited by John Wilton-Ely. Farnborough: Gregg International, 1972.

Plato. *Plato's Cosmology: The Timaeus of Plato*. Translated by Francis Macdonald Cornford. London: Routledge and Kegan Paul, 1948.

Plato. "Phaedrus". *Collected Dialogues of Plato*. Edited by Edith Hamilton and Huntington Cairns. Bollingen Series LXXI. New York: Random House, 1963.

Plato. *The Republic*. Translated by Desmond Lee. New York and London: Penguin Books, 1987.

Pope-Hennessy, John. *A Sienese Codex of the Divine Comedy*. Oxford and London: Phaidon Press, 1947.

Procopius of Caesarea. *Buildings*. Translated by H.B. Dewing. Cambridge, MA: Harvard University Press, 1996.

Psarra, Sophia. *Architecture and Narrative: The Formation of Space and Cultural Meaning*. London and New York: Routledge, 2009.

Rice, David Talbot. *A Concise History of Painting from Prehistory to the Thirteenth Century*. London: Thames and Hudson, 1967.

Rodley, Lyn. *Byzantine Art and Architecture*. Cambridge: Cambridge University Press, 1994.

Rossi, Aldo. *A Scientific Autobiography*. New York and Cambridge, MA: Institute of Architecture and Urban Studies and MIT Press, 1981.

Rowe, Colin. *The Mathematics of the Ideal Villa and Other Essays*. Cambridge, MA: MIT Press, 1976, 1989.

Rykwert, Joseph. *The Dancing Column: On Order in Architecture*. Cambridge, MA: MIT Press, 1998.

Saussure, Ferdinand de. *Course in General Linguistics*. Edited by Charles Bally and Albert Sechehaye. New York: McGraw-Hill, 1959.

Sayers, Dorothy. *Further Papers on Dante*. Westport, CT: Greenwood Press, 1957.

Schumacher, Thomas L. "From Gruppo 7 to the Danteum: A Critical Introduction to Terragni's Relazione Sul Danteum" *Oppositions,* No. 9, 1977, pp. 89–107.

Schumacher, Thomas L. *The Danteum: A Study in the Architecture of Literature*. Princeton, NJ: Princeton Architectural Press, 1985.

Schumacher, Thomas L. *Surface and Symbol*. New York: Princeton Architectural Press, 1991.

Schumacher, Thomas L. *The Danteum: Architecture, Poetics, and Politics under Italian Fascism*. Princeton, NJ: Princeton University Press, 1993.

Scnapp, Jeffrey. "Introduction to *Purgatorio*" in Charles Singleton (ed.), *The Cambridge Companion to Dante*. Cambridge, MA: Harvard University Press, 1975.

Scruton, Roger. *The Aesthetics of Architecture*. Princeton, NJ: Princeton University Press, 1979.

Scruton, Roger. *The Aesthetics of Music*. Oxford: Oxford University Press, 1999.

Shklovsky, Victor. "Art as Technique" in *Russian Formalist Criticism: Four Essays*. Translated and introduced by Lee Lemon and Marion Reis. Lincoln, NE: University of Nebraska Press, 1965.

Silentiarius, Paulus. "Description S. Sophiae" in *The Art of the Byzantine Empire 312–1453: Sources and Documents*. Translated and edited by Cyril Mango. Dumbarton Oaks, NJ: Prentice-Hall, 1972.

Singleton, Charles. "The Poet's Number at the Center," *MLN*, Vol. 80 No. 1, January, 1965, pp. 1–10.

Singleton, Charles (ed.). *Companion to the Divine Comedy*. Cambridge, MA: Harvard University Press, 1975.

Singleton, Charles. "Symbolism" in *Dante Studies: Commedia. Elements of Structure*. Baltimore, MD: Johns Hopkins University Press, 1977 [original publication 1954].

Singleton, Charles. "Pattern at the Center" in *Dante Studies: Commedia. Elements of Structure*. Baltimore, MD: Johns Hopkins University Press, 1977 [original publication 1954].

Smout, Mark. "Out of the Phase: Making an Approach to Architecture and Landscape" in *Architecture Design* Vol. 78, No. 4, 2008, pp. 80–85.

Smout, Allen. *Augmented Landscape*, Pamphlet Architecture 26. Princeton, NJ: Princeton Architecture Press, 2007.

Strzygowski, Josef. *Origin of Christian Church Art*. Translated by O.M. Dalton and H.J. Braunholtz. Oxford: Clarendon Press, 1923.

Tafuri, Manfredo. "Giuseppe Terragni: Subject and 'Mask'" in *Oppositions*, No. 11, Winter, 1977, pp. 1–25.

Tafuri, Manfredo. *Theories and History of Architecture*. Translated by Giorgio Verrecchia. New York: Harper and Row, 1980.

Tafuri, Manfredo. *The Sphere and the Labyrinth: Avant-Gardes and Architecture from Piranesi to the 1970s*. Translated by Pellegrino d'Acierno and Robert Connolly. Cambridge, MA: MIT Press, 1990.

Tatlin, Vladimir. "On Zangezi" in *Tatlin*. Translated and edited by Larissa Zhadova. New York, Rizzoli International Publications, 1988.

Taylor, Charles and Patricia Finley. *Images of the Journey in Dante's Divine Comedy*. New Haven, CT: Yale University Press, 1997.

Thomas, Anabel. "Florence: Baptistery" in "Florence, §IV, (i)(c), Cathedral Painting," *The Grove Dictionary of Art*, London: Macmillan, 1996.

Todorov, Tzvetan. "On Some Approaches to Russian Formalism" in Stephen Bann and John E. Bowlt (eds), *Russian Formalism*. New York: Harper and Row, 1973.

Todorov, Tzvetan. "Reading as Construction" in Michael Hoffman and Patrick Murphy. (eds), *Essentials of the Theory of Fiction*. Durham, NC: Duke University Press, 1996.

Tomashevsky, Boris. "Thematics" in *Russian Formalist Criticism: Four Essays*. Translated and introduced by Lee Lemon and Marion Reis. Lincoln, NE: University of Nebraska Press, 1965.

Treib, Marc. *Space Calculated in Seconds*. Princeton, NJ: Princeton University Press, 1996.

Tschumi, Bernard. *Architectural Manifestoes*. Exhibition 8–28 February 1979, manifestoes 6, 7, 8. London: Architectural Association, 1979.

Tschumi, Bernard. *The Manhattan Transcripts*. London: Academy Editions, St. Martin's Press, 1981.

Tschumi, Bernard. *The Discourse of Events*. London: Architectural Association, 1983.

Tschumi, Bernard. "Joyce's Garden" *A+U* No. 9, 1988, p. 29.

Venturi, Robert. *Learning from Las Vegas*. Cambridge, MA: MIT Press, 1972.

Venuti, Lawrence (ed.). *The Translation Studies Reader*. New York and London: Routledge, 2000.

Vickers, Nancy. "Dante in the Video Decade", in Theodore J. Cachey, Jr. (ed.), *Dante Now: Current Trends in Dante Studies*. Notre Dame, IN: University of Notre Dame Press, 1995.

Vidler, Anthony. "The End of the Line" *A+U* No. 8, August, 1988, pp. 47–64.

Vidler, Anthony. *The Architectural Uncanny: Essays in the Modern Unhomely*. Cambridge, MA: MIT Press, 1992.

Vidler, Anthony. *Warped Space: Art, Architecture, and Anxiety in Modern Culture*. Cambridge, MA: MIT Press, 2002.

Virgil. *Aeneid*. Translated by John Dryden. London and New York: Penguin, 1997.

Volkmann, Ludwig. *Iconografia Dantesca*. Leipzig: Breitkopf Hartel, 1897.

von Simson, Otto. *The Gothic Cathedral: Origins of Gothic Architecture and the Medieval Concept of Order*. Bollingen Series XLVIII. Princeton, NJ: Princeton University Press, 1988.

Vossler, Karl. *Mediaeval Culture: An Introduction to Dante and His Times*. Volumes 1 and 2. Translated by William Lawton. New York: Harcourt, Brace and Company, 1929.

Weiss, Beno. *Understanding Italo Calvino*. Columbia, SC: University of South Carolina Press, 1993.

Weyl, Hermann. *Symmetry*. Princeton, NJ: Princeton University Press, 1952.

Whiteman, John. "Site Unscene – Notes on Architecture and the Concept of Fiction". *AA Files*, No. 12, 1986, pp. 76–84

Wigley, Mark. "Paper, Scissors, Blur" in Catherine de Zegher and Mark Wigley (eds), *The Activist Drawing: Retracing Situationist Architectures from Constant's New Babylon and Beyond*. New York and Cambridge: The Drawing Center, MIT Press, 2001.

Wilton-Ely, John. *Piranesi: The Complete Etchings*. San Francisco, CA: Alan Wofsy Fine Arts, 1994.

Wittgenstein, Ludwig. *Philosophical Grammar*. Oxford: Blackwell, 1974.

Wittkower, Rudolf. *Architectural Principles in the Age of Humanism*. New York: Random House, 1962.

Wölfflin, Heinrich. *Renaissance and Baroque*. Translated by Kathrin Simon. Ithaca, NY: Cornell University Press, 1966.

Woods, Lebbeus. *System Wien*. Edited by Peter Noever. New York: D.A.P., 2005.

Worringer, Wilhelm. *Form in Gothic*. Translated by Sir Herbert Read. London: Alec Tiranti, 1957.

Zevi, Bruno. *The Modern Language of Architecture*. Seattle, WA: University of Washington Press, 1978.

Zhadova, Larissa (ed.). *Tatlin*. New York: Rizzoli International Publications, 1988.

Ziarek, Krzysztof. *The Historicity of Experience: Modernity, the Avant-Garde, and the Event*, Evanston, IL: Northwestern University Press, 2001.

Zumthor, Peter. *Peter Zumthor Works: Buildings and Projects 1979–1997*. Baden: Lars Müller, 1998.

Zumthor, Peter. *Swiss Sound Box: A Handbook for the Pavilion of the Swiss Confederation at Expo 2000 in Hanover*. Edited by Roderick Hönig. Basel: Birkhäuser, 2000.

Zumthor, Peter. *Atmospheres: Architectural Environments, Surrounding Objects*. Basel: Birkhäuser, 2006.

Zumthor, Peter. *Thinking Architecture*. Translated by Maureen Oberli-Turner (essays 1988–1996), Catherine Schelbert (essays 1998–2004). Basel: Birkhäuser, 2006.

Web resources

Dante Alighieri, online at http://www.geocities.com/Athens/9039/ Accessed December 1999.

Digital Dante on ILTweb Digital Dante Project (www.ilt.columbia.edu/projects/dante/images). Accessed December 1999.

Epistle to Lord Can Grande della Scala was actually written by Dante himself. For details refer Barlow Lectures delivered at University College London on 17–18 March 1993 by Professor Robert Hollander of Princeton University also available on web. (http://www9.georgetown.edu/faculty/jod/cangrande.english.html) Accessed December 2013.

Salvadore Dalí's illustrations, online at narthex.com and on ILT Digital Dante project. Accessed December 1999.

Renaissance Dante in Print (1472–1629), online, put together by the University of Notre Dame, ARFTL Project of the University of Chicago, the Denvers Program and the Newberry Library (http://www.nd.edu:80/~italnet/Dante/). Accessed December 2013.

Music

Bartók. Béla. *Music for Strings, Percussion and Celesta*, New York Philharmonic Orchestra, Leonard Bernstein (conductor), 1992 (Sony Classical).

Liszt, Franz, *Dante Symphony* and *Dante Sonata*, Berlin Philharmoniker, Daniel Barenboim (conductor and piano), 1994 (TELDEC).

Ott, Daniel. *Klangkörperklang*, Ensemble directed by Daniel Ott, 2002 (Muszikszene).

Schoenberg, Arnold. *Moses und Aron*, Royal Concertgebouw Orchestra, Pierre Boulez (conductor), 1996 (Deutsche Grammophon).

Varèse, Edgar. *Complete Orchestral Works* ASKO Ensemble and Royal Concertgebouw Orchestra, Riccardo Chailly (conductor), 2004 (Decca).

Xenakis, Iannis. *Eonta / Metastasis / Pithoprakta*, Orchestre National de L'O.R.T.F., Maurice Le Roux (conductor), 1993 (Chant du Monde).

Film

A TV Dante, directed by Peter Greenaway and Tom Phillips, 2011 (Digital Classics).

Klangkörper – Der Schweizer Pavillon an der Expo 2000 in Hannover, directed and writtten by Bruno Moll, 2000 (T&C Film AG).

INDEX

Introductory note: When the text is within a table, the number span is in italic, e.g. *Romeo and Juliet* (Shakespeare): visual analysis *54–8*, *61–5*. When the text is within a figure, the number span is in bold, e.g. Acropolis **135**, 137, 143, 151. When the text is within a note, this is indicated by page number, "n", note number, e.g. Deleuze, G. 132, 133n9, 134.